BEAUTY DESIGN

daab

INTRODUCTION

The need for individuality, personality, and change makes up a central part of our lives and is especially what we associate with the term BEAUTY. In a market with increasingly similar products, today's discriminating customer desires extra values such as events, history and purpose in life – regardless of whether it is a visit to a perfumery, fitness studio or a beauty salon. Many hairdressers today are style guides, fitness studios are "in" meeting places and perfumeries are even places of culture. Taken to the extremes, one can purchase designer furniture in these establishments, they organize private showings on the evening before an exhibition opens, readings, and concerts. Here shopping becomes more than a means to an end. It is pleasure, communication, personal experience, and reward. The customer enjoys being in exclusive simplicity and celebrates the combination of luxury and asceticism, whether it is presented as a poetic dream world or a futuristic fantasy. The concept is decisive: thus, these establishments are becoming more and more stages for show and personal experience with unusual style variants and a selection of colors, materials and light. This ranges from the inventory of a flea market to a Disney-style fairy tale backdrop to a stylish spaceship look, antique furniture can go with designer armchairs – exactly like brick walls and hardwood floors can go together with colored Plexiglas. Minimalism but with flowing forms, more a lounge than a salon; extravagant as well as simple – anything goes.

The beauty market is developing and booming world wide. Wellness programs allow one to rediscover one's own body and inspire us to look towards inner tranquility. This trend demands architecturally-holistic approaches which recognizes the unity of the room, the beauty experience and the perception of one's own body. The balance between body, mind, and spirit can only be found in an esthetic atmosphere. Thus the hairdresser on the corner is turning into an extraordinary wellness oasis – often created by outstanding designers and architects, among these are David Chipperfield, Antonio Citterio, Cho Slade and Andrée Putman. Architects, designers, and industry often face these challenges together, the results are quite individual and unique. Over 60 successful projects are presented extensively and for the first time in this volume with exclusive photos and even including some of the plans.

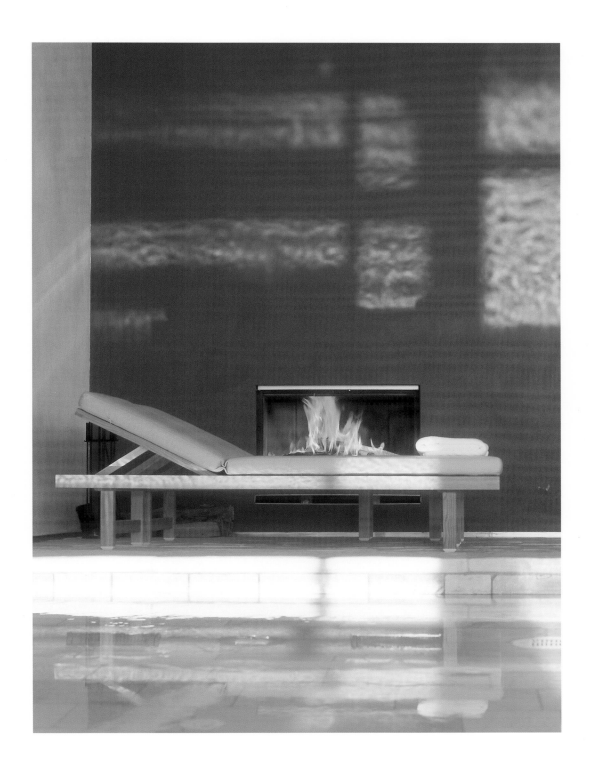

Das Bedürfnis nach Individualität, Persönlichkeit und Veränderung bildet einen zentralen Punkt in unserem Leben und das gilt auch im Besonderen, was wir mit dem Begriff BEAUTY verbinden. Egal ob es ein Besuch bei Parfümerie, Kosmetik- und Fitnessstudio oder beim Friseur ist, der konsumverwöhnte Kunde möchte in einem Markt zunehmend ähnlicher Produkte Zusatzwerte wie Erlebnisse, Geschichten und Lebensinhalte finden. Mancher Friseur ist inzwischen Styleguide, Fitnessstudios sind Szene-Treffpunkte und Parfümerien gar Orte der Kultur. Auf die Spitze getrieben werden in den Einrichtungen eigens entworfene Möbel verkauft, abends Vernissagen, Lesungen oder Konzerte veranstaltet. Hier ist Shopping mehr als ein Mittel zum Zweck. Es ist Freude, Kommunikation, Erlebnis und Belohnung. Der Kunde gefällt sich in teurer Schlichtheit und zelebriert die Kombination aus Luxus und Askese, sei sie als poetische Traumwelt präsentiert oder als futuristische Phantasie ausgeformt. Das Konzept entscheidet: So werden die Einrichtungen immer mehr zur Bühne für Show und Erlebnis mit ausgefallenen Stilvarianten und einer Auswahl von Farben, Materialien und Licht. Das kann vom Flohmarkt-Inventar über eine Märchenkulisse im Stile Disneys bis zur durchgestylten Raumschiff-Optik gehen, antike Möbel können mit Designer-Sesseln harmonieren – genauso wie Backsteinwände und Holzdielen zusammen mit eingefärbtem Plexiglas. Minimalistisch, aber mit fließenden Formen, mehr Lounge als Salon; Extravagantes wie schlichtes – alles ist erlaubt.

Der Schönheitsmarkt entwickelt sich und boomt weltweit. Verwöhnprogramme lassen den eigenen Körper wieder entdecken und inspirieren zur inneren Einkehr. Dieser Trend verlangt nach architektonisch ganzheitlichen Ansätzen, die den Raum, das Beauty-Erlebnis und das Körperempfinden als Einheit im Blick haben. Balance zwischen Körper, Geist und Seele ist nur in einer ästhetischen Umgebung zu finden. So wandeln sich der Friseur an der Ecke zu herausragenden Erholungsräumen – oftmals entworfen von angesagten und bedeutenden Designer und Architekten, dazu gehören unter anderen David Chipperfield, Antonio Citterio, Cho Slade und Andrée Putman. Architekten, Designer und Industrie stellen sich dieser Herausforderung häufig gemeinsam, die Ergebnisse sind meist individuell wie einmalig. In dem vorliegenden Band werden erstmals und umfassend über 60 erfolgreiche Projekte mit exklusiven Photos und teilweise mit Plänen vorgestellt.

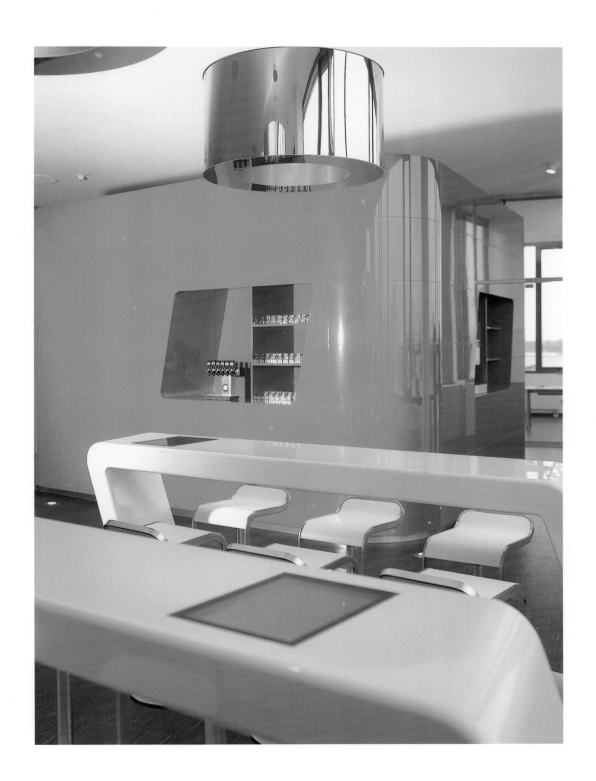

Le besoin d'individualité, de personnalité et de changement joue un rôle prépondérant dans notre vie et cela est particulièrement vrai pour tout ce qui a trait à la BEAUTE. Qu'il se rende dans un parfumerie, un institut de beauté, dans un studio de remise en forme ou chez le coiffeur, le client consommateur souhaiterait trouver dans un marché proposant de plus en plus de produits identiques des valeurs additionnelles telles que des expériences, des histoires et des modes de vie différents. Certains coiffeurs se sont transformés en conseillers en style, les studios de remise en forme sont des lieux de rencontre et les parfumeries sont même des lieux de culture. Les choses peuvent être poussées à l'extrême lorsque ces établissements vendent des meubles qu'ils ont conçus, organisent le soir des vernissages, des lectures ou des concerts. Le shopping perd ici de son aspect purement utilitaire et nécessaire. Il allie joie, communication, expérience et récompense. Le client se plaît dans une simplicité onéreuse et célèbre le mariage du luxe et de l'ascétisme, qu'il soit présenté comme un monde poétique de rêves ou conçu comme le produit d'une imagination futuriste. C'est le concept qui décide : les établissements sont de plus en plus souvent une scène pour spectacles et événements avec des variantes de style singulières et un choix de couleurs, matériaux et lumières. Cela peut aller de l'inventaire d'un marché aux puces jusqu'à l'optique d'un vaisseau spatial hyperstylée en passant par un décor de contes de fée dans le style Disney, les vieux meubles peuvent harmoniser avec des fauteuils de designer – tout comme des murs en briques et des planchers en bois avec du plexiblas coloré, des tables minimalistes, mais avec de belles formes, pour former plus un lounge qu'un salon ; extravagant mais simple – tout est permis.

Le marché de la beauté évolue et connaît un véritable essor dans le monde entier. Des programmes de traitement bienfaiteur vous font redécouvrir votre propre corps et vous incitent à la détente. Cette tendance exige des approches architecturales d'ensemble pour qui l'espace, l'expérience de la beauté et les sensations physiques forment une unité. Un équilibre entre le corps, l'esprit et l'âme n'est possible que dans un environnement esthétique. Ainsi le coiffeur au coin de la rue propose désormais de merveilleuses salles de détente – souvent conçues par des designers et des architectes à la mode et de renom comme par exemple David Chipperfield, Antonio Citterio, Cho Slade et Andrée Putman. Les architectes, les designers et l'industrie relèvent souvent ce défi ensemble, les résultats sont la plupart du temps aussi individuels qu'uniques en leur genre. Vous trouverez dans cet ouvrage pour la première fois une présentation approfondie de 60 projets réussis avec des photos exclusives ainsi que, parfois aussi, avec des plans.

La necesidad de individualidad, la personalidad y los cambios conforman un aspecto central de nuestra vida, lo cual también se manifiesta de un modo especial en lo que solemos entender con el concepto de BEAUTY. Tanto si se trata de una visita a una perfumería, a un estudio de cosmética o de fitness o bien a una peluquería, el consumidor acostumbrado a la alta calidad desea cada vez más encontrar en el mercado productos en relación a unos valores extra como experiencias, historias y contenidos vitales. Algunos peluqueros se ha convertido entre tanto en un styleguide, los estudios de fitness son escenas y puntos de sencuentro y las perfumerías llegan incluso a ser instituciones de cultura. Llevando ello a un extremo se venderán en los locales muebles de diseño propio, por las tardes se celebrarán exposiciones de pintura, lecturas literarias o conciertos. A este respecto el shopping es más que un medio para alcanzar ciertos fines, es antes bien alegría, comunicación, vivencias y sentirse recompensado. Al cliente le gusta la sencillez cara y aprueba la combinación de lujo y ascética bien sea en forma de presentación de un lírico mundo de ensueños o de fantasía futurista. La concepción es decisiva, de modo que los locales se convierten cada vez más en escenarios de shows y vivencias con sofisticadas variaciones estilísticas y una selección de colores, materiales y luces. Este cúmulo puede ir desde el inventario de un mercadillo pasar por un escenario de cuentos en estilo Disney y llegar hasta unas apariencias estéticas que sugieran una nave espacial. Los muebles antiguos pueden conjugarse con sillones de moderno diseño igual que pueden armonizarse paredes de ladrillo cocido y paneles de madera con plexiglás pintado. Todo está permitido: la llamada estética minimalista de fluidas formas, un salón que más bien parece un lounge; impresiones tanto extravagantes como de sencilla elegancia.

El mercado de la belleza se encuentra en pleno boom a lo largo y ancho de todo el mundo. Existen programas para agasajar y redescubrir el propio cuerpo y que nos inspiran a retornar a nuestro íntimo interior. Esta tendencia requiere unas miras arquitectónicas integrales que confieran unidad y visión de conjunto al local, a la experiencia beauty y a las sensaciones corporales. El equilibrio entre el cuerpo, la mente y el alma solamente puede tener lugar en un ambiente estético. De este modo la peluquería de la esquina se transforma en unos extraordinarios locales de recreo que frecuentemente son concebidos por prestigiosos diseñadores y arquitectos entre los que cuentan, entre otros, David Chipperfield, Antonio Citterio, Cho Slade y Andrée Putman. Tanto los arquitectos como los diseñadores y la industria se enfrentan a este reto frecuentemente unidos y los resultados de esta cooperación llevan las más veces la impronta de lo individual y singular. En el presente tomo se presentan por primera vez detalladamente más de 60 proyectos de éxito con fotos exclusivas y, parcialmente, incluso con planes.

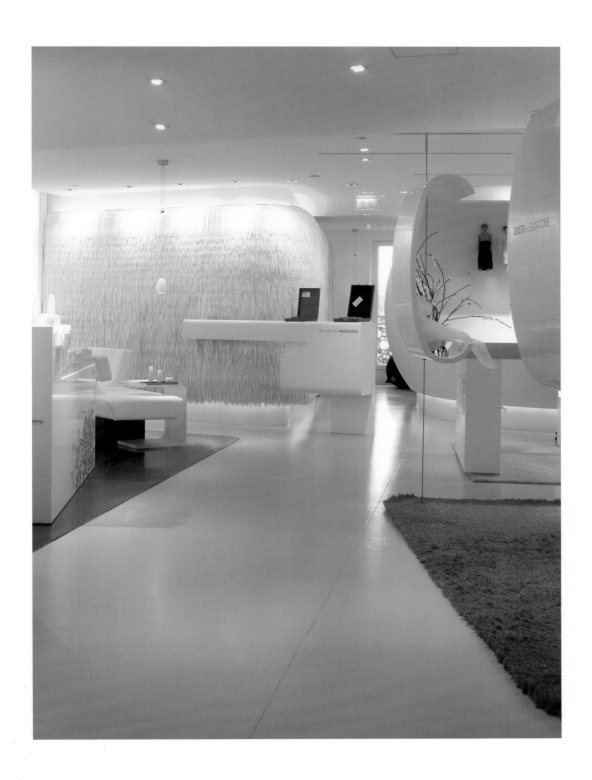

La ricerca d'individualità, personalità e cambiamento, rappresenta un punto centrale nella ns. vita, in particolare per tutto quanto associamo alla nozione del BEAUTY. In visita alla profumeria, dall'estetista, in palestra o dal parrucchiere, il consumatore esigente cerca valori supplementari quali un'esperienza, una storia e contenuti di vita, su un mercato che offre prodotti sempre più simili. Oggi troviamo parrucchieri che sono diventati styleguide, palestre che sono locali di scena e addirittura profumerie quali luoghi di cultura. Lì il culmine è raggiunto con la vendita di mobili creati ad hoc o quando di sera vi si organizzano vernissages, letture o concerti. Qui lo shopping è più che un solo mezzo per raggiungere lo scopo. Rappresenta anzi gioia, comunicazione, esperienza e ricompensa. Il cliente si compiace della costosa semplicità e celebra la combinazione tra lusso e ascesi, sia essa presentata come il mondo poetico dei sogni oppure elaborata come una fantasia futuristica. Conta il concetto: così i locali si trasformano sempre di più in un palcoscenico per lo show e l'esperienza da vivere, con straordinarie variazioni di stile e colori, materiali e luci selezionati. Può passare dall'inventario da mercato delle pulci alle quinte da fiaba nello stile Disney o dall'aspetto nello stile astronave fino ai mobili antichi abbinati a poltrone dei grandi stilisti – così come muri interni in mattoni e pavimenti di legno che si accordano al plexiglas colorato. Tutto è permesso: lo stile minimalista, ma con forme flessuose, più lounge che salone; lo stravagante e la semplicità.

Il mercato della bellezza è in forte crescita in tutto il mondo. Programmi per il benessere fanno riscoprire il proprio corpo ed ispirano alla meditazione. Questo trend richiede un approccio architettonico complessivo, che contempla lo spazio, l'esperienza beauty e le sensazioni del corpo come un'unità. Soltanto in un ambiente estetico si riesce a trovare l'equilibrio tra corpo, mente ed anima. Così il parrucchiere all'angolo si trasforma distinguendosi come spazio di riposo – sovente disegnato da designer e architetti famosi tra cui David Chipperfield, Antonio Citterio, Cho Slade e Andrée Putman. Architetti, stilisti e l'industria di frequente affrontano insieme tale sfida ed i risultati sono spesso individuali ed unici. In questo volume si presentano per la prima volta oltre 60 progetti di successo con esclusive fotografie ed in parte con le rispettive planimetrie.

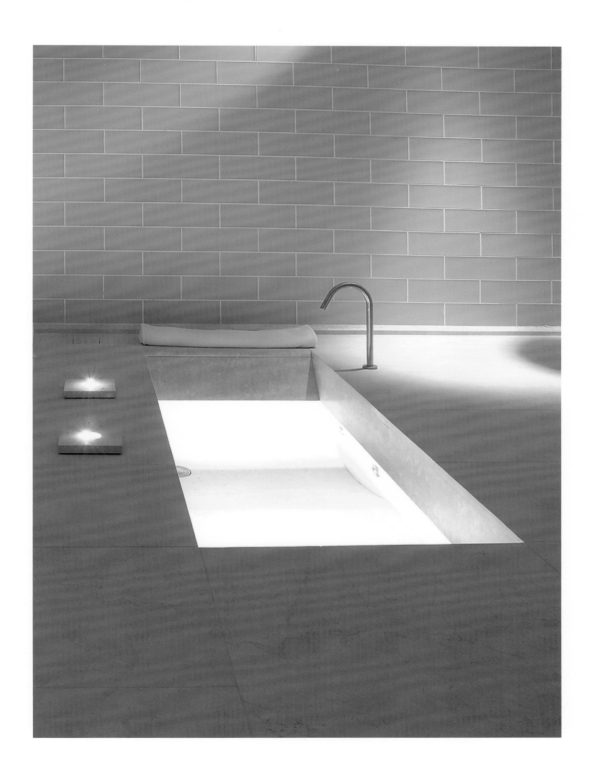

COSMETICS

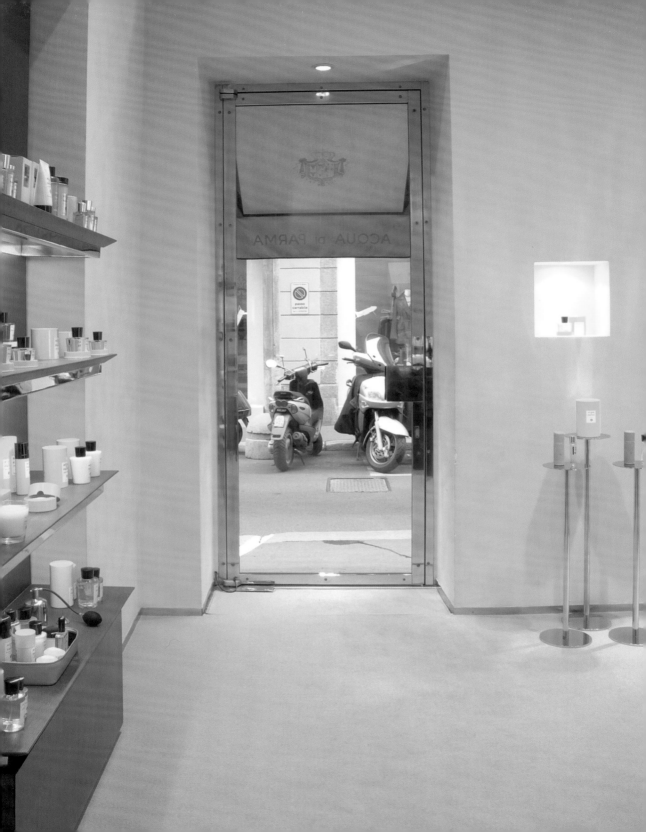

Acqua di Parma
Milan, Italy | 1998
Photos: Andreas Burz

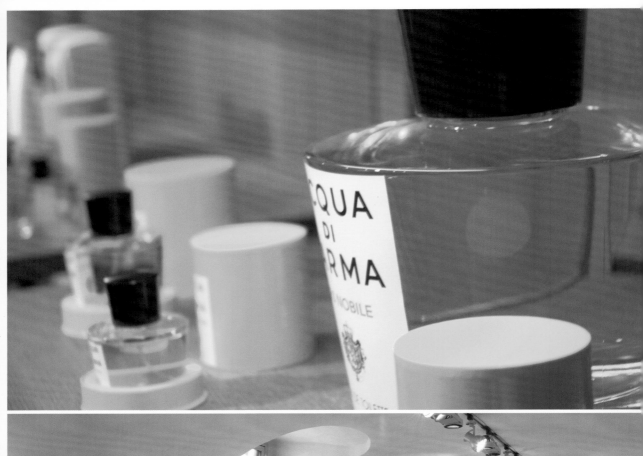
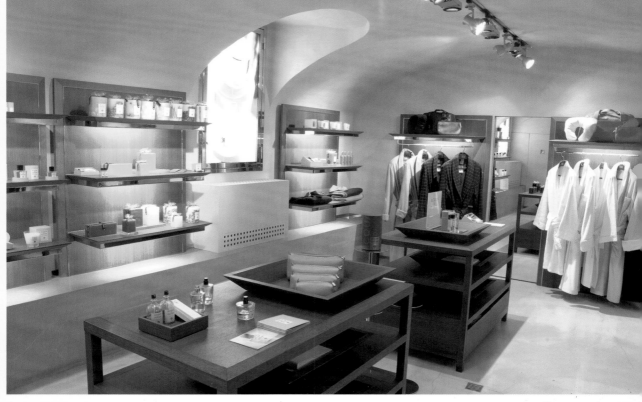

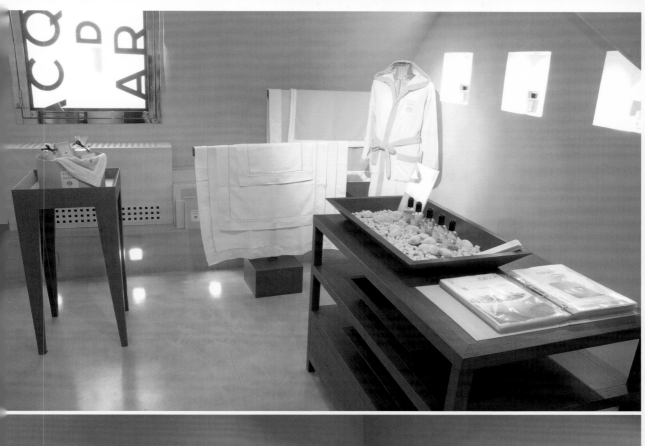
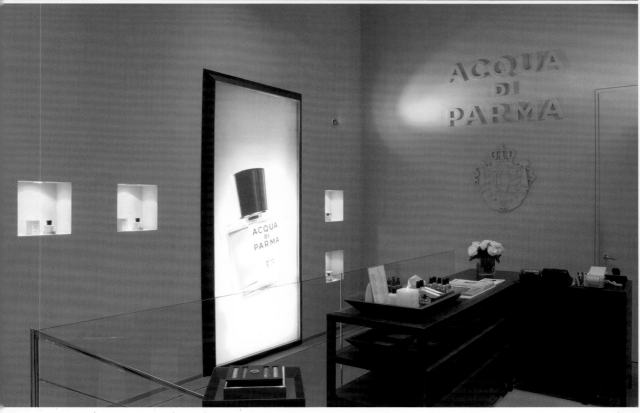

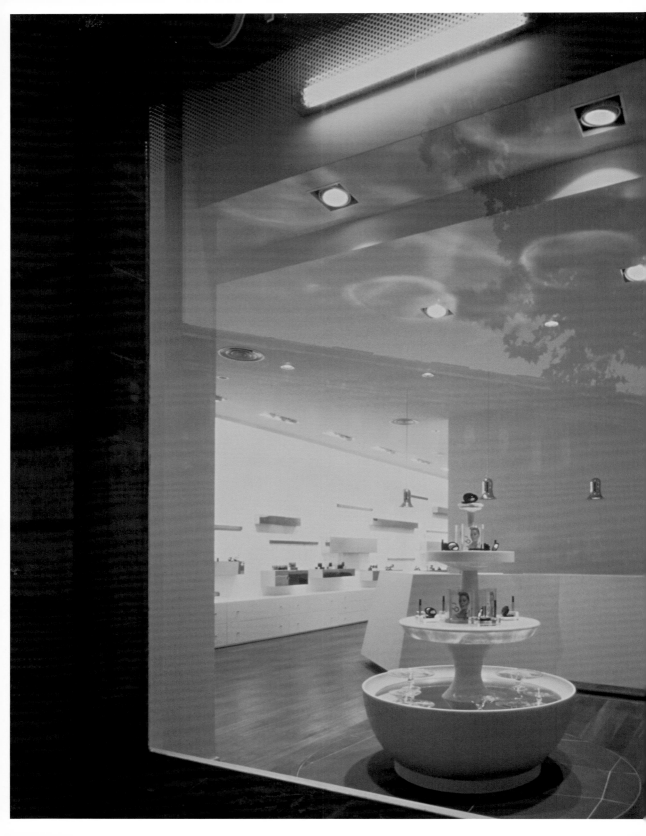

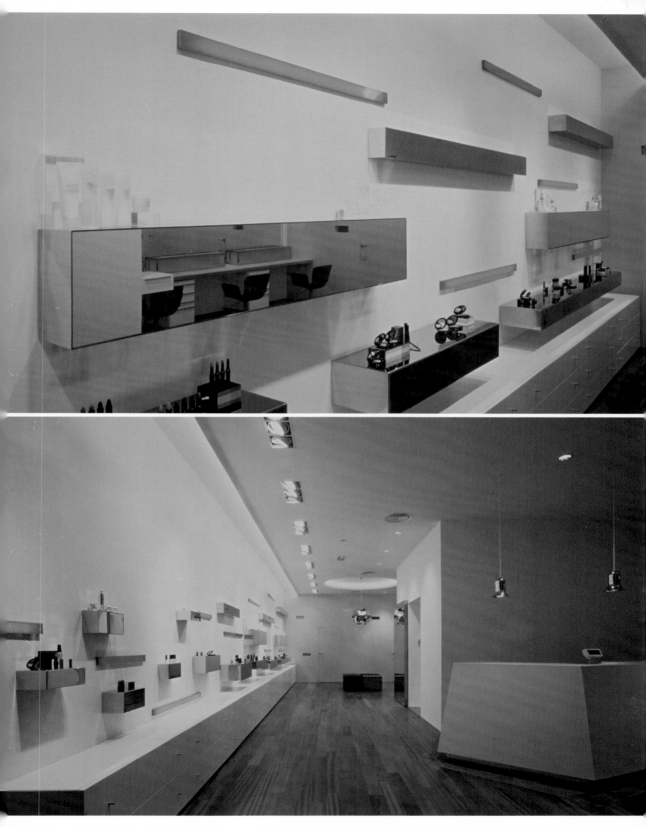

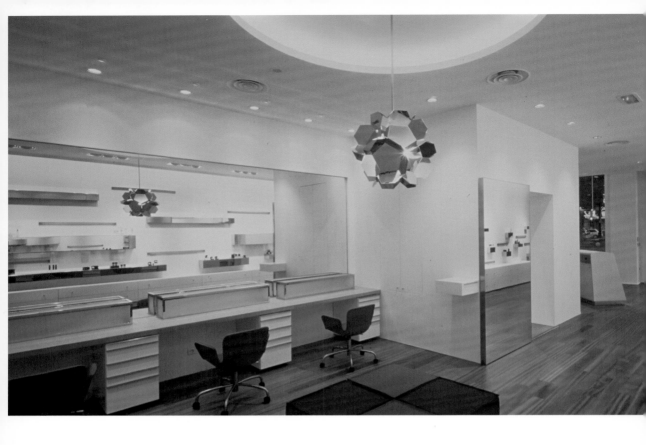

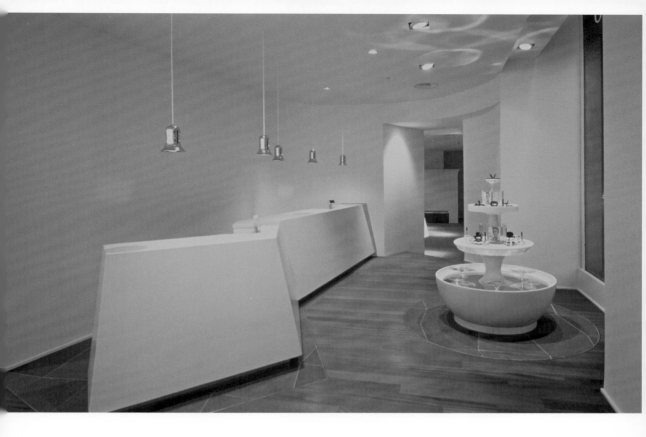

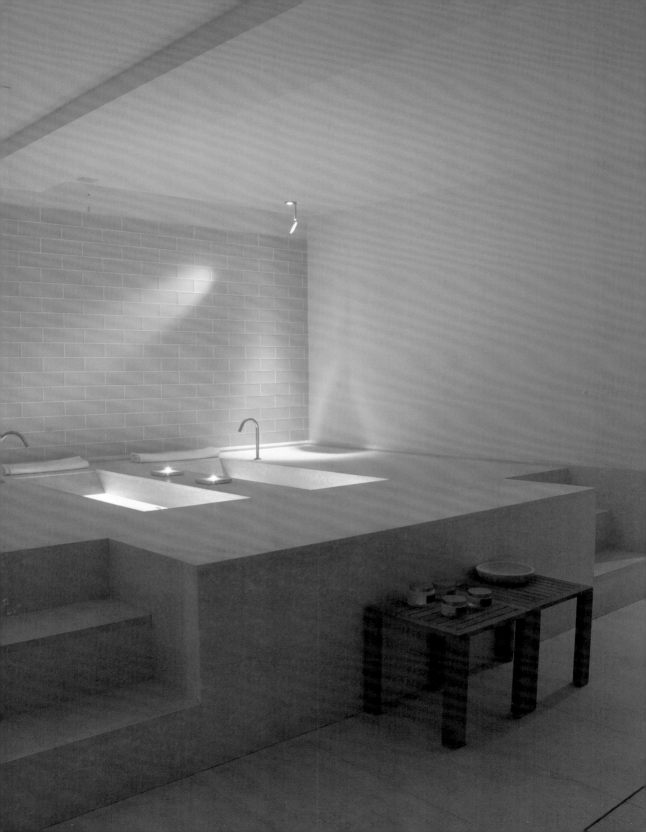

ALESSANDRO AGRATI | MILAN
Habits Culti
Milan, Italy | 2004
Photos: Andreas Burz

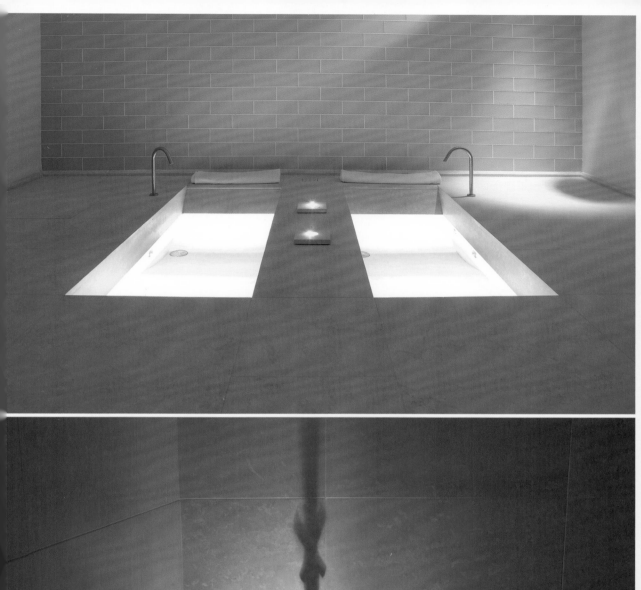
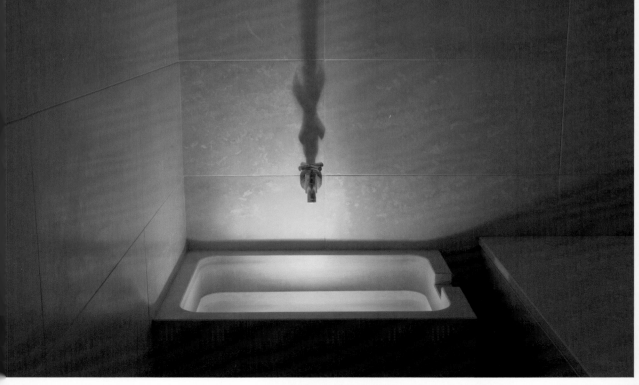

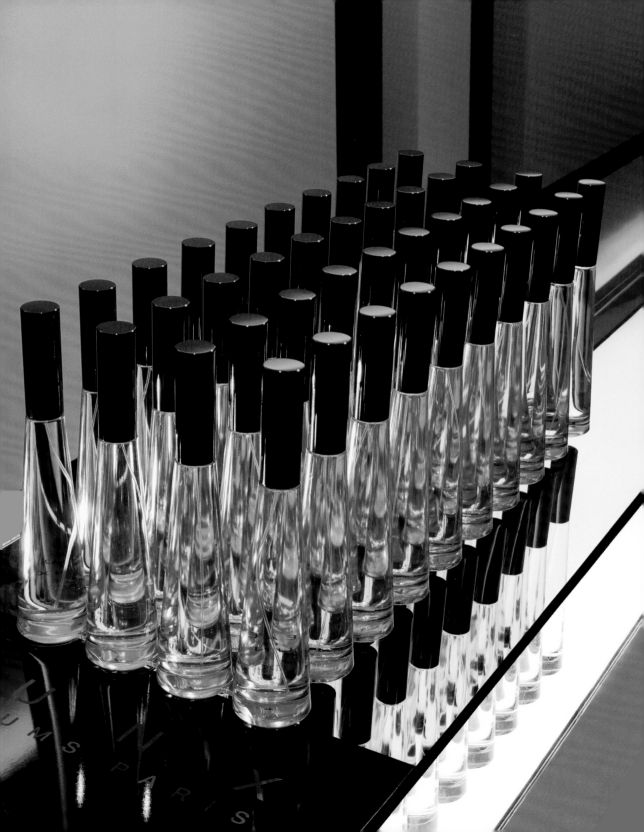

**JACQUELINE & HENRI BOIFFILS WITH FABIENNE CONTE-SEVIGNE
AND FRANCIS GIACOBETTI | PARIS**
IUNX PARFUMERIE
Paris, France | 2003
Photos: Sophie Frachon Communication, Francis Giacobetti

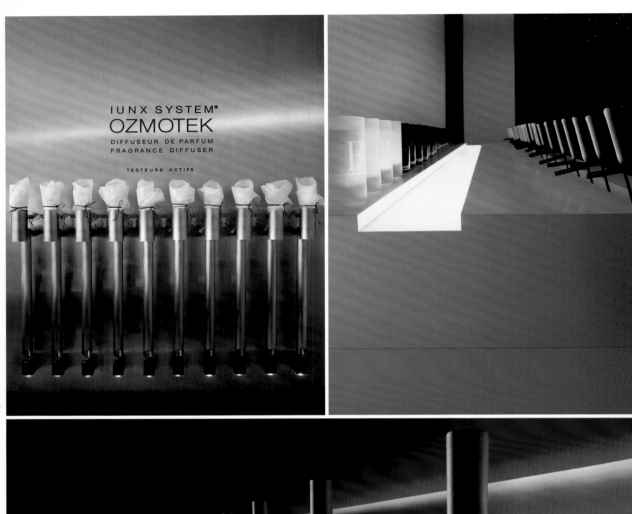

IUNX SYSTEM®
OZMOTEK
DIFFUSEUR DE PARFUM
FRAGRANCE DIFFUSER

TESTEURS ACTIFS

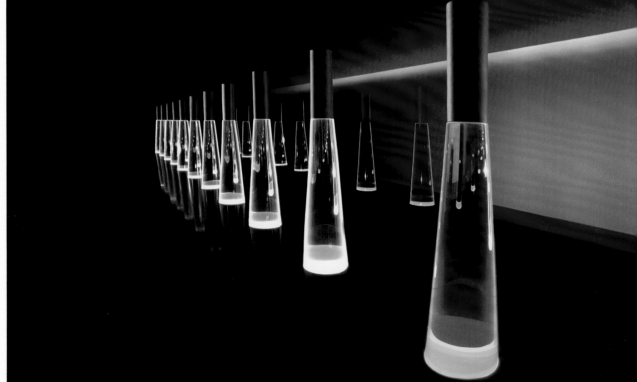

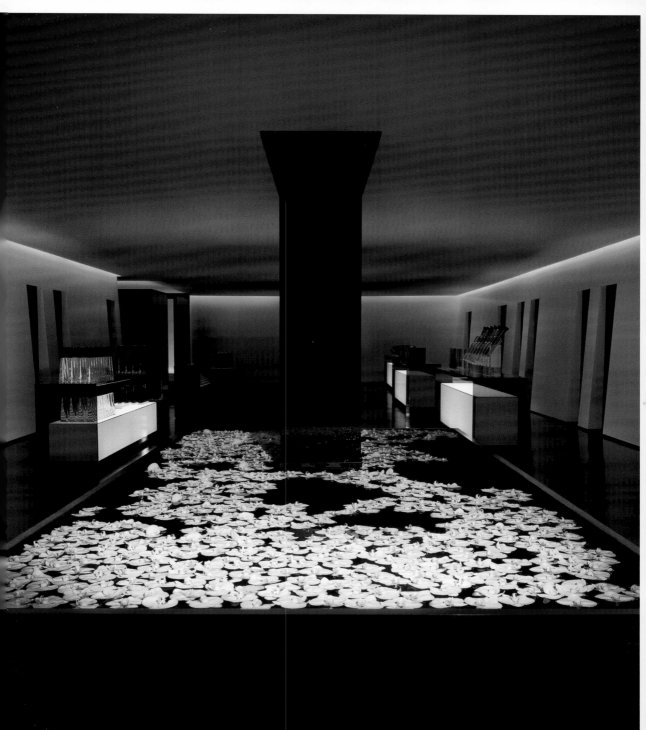

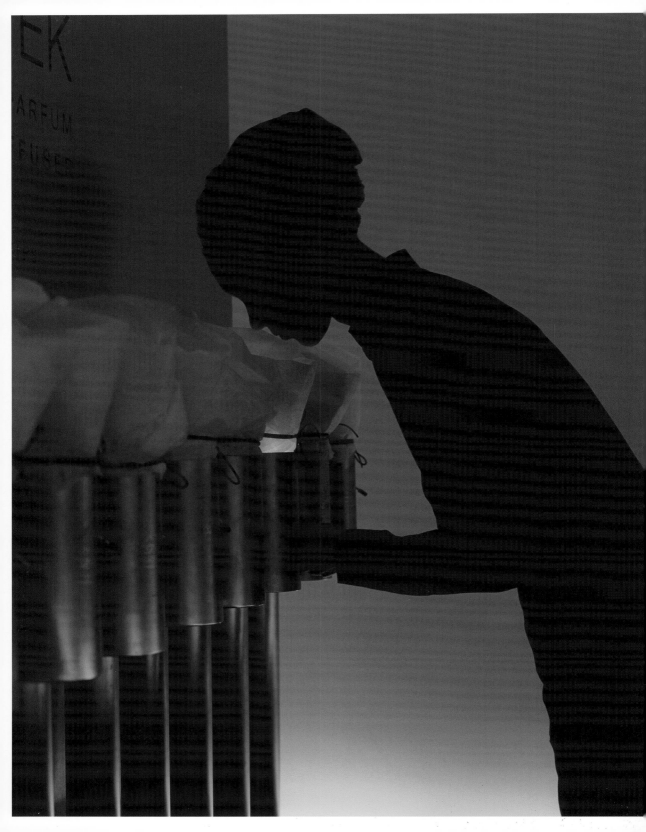

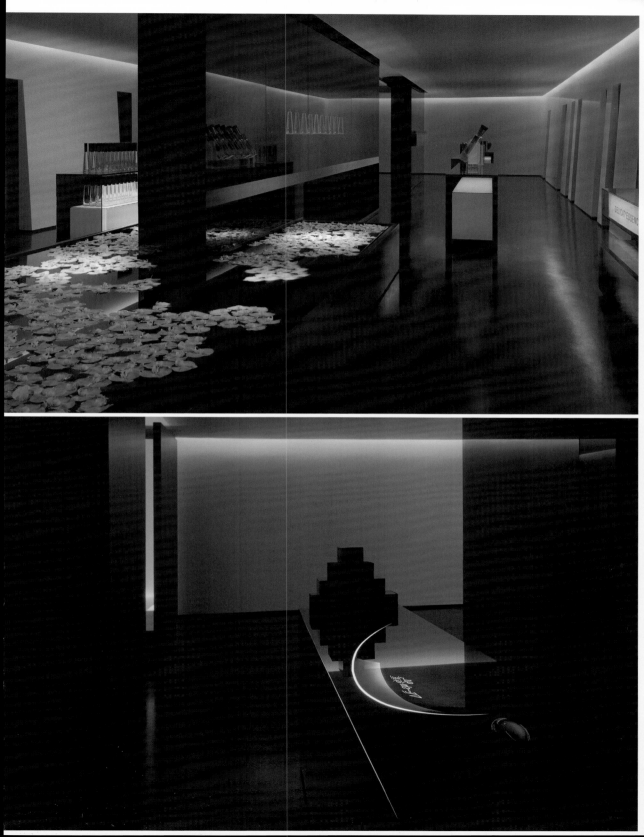

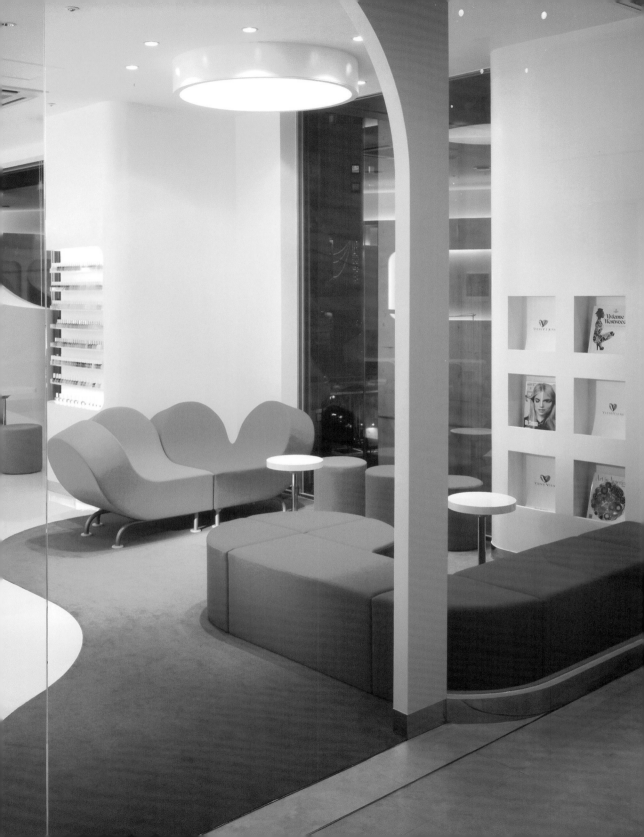

CLAUDIO COLUCCI DESIGN | TOKYO
Viens Viens
Tokyo, Japan | 2005
Photos: Nacása & Partners Inc.

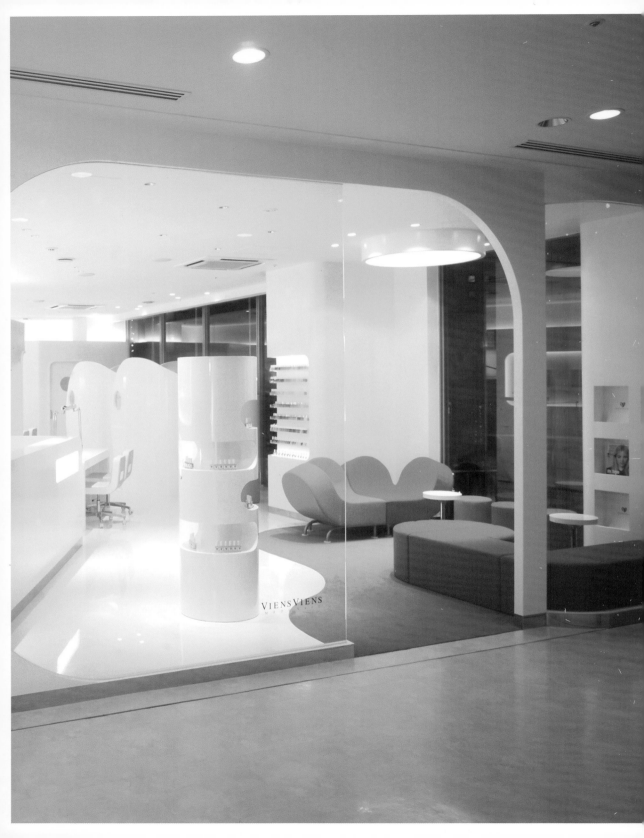

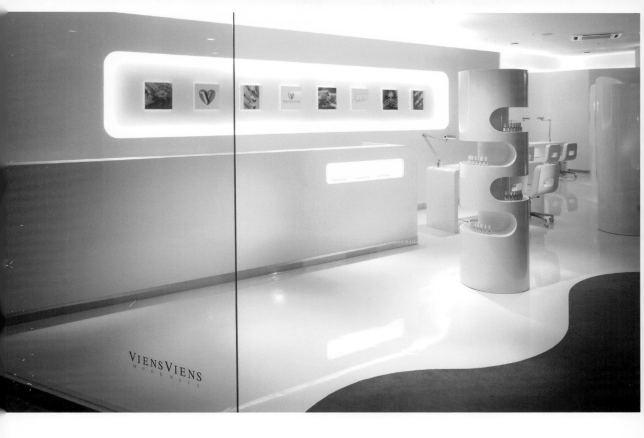

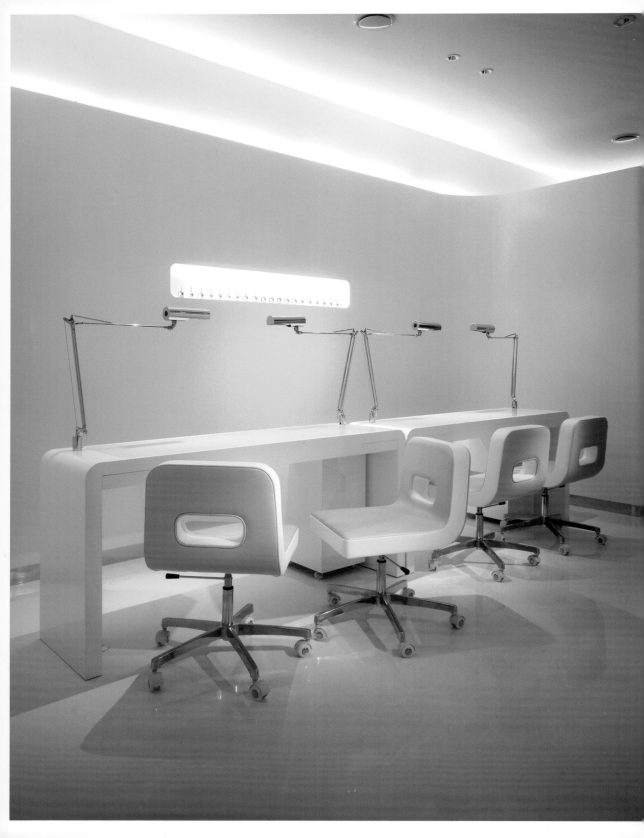

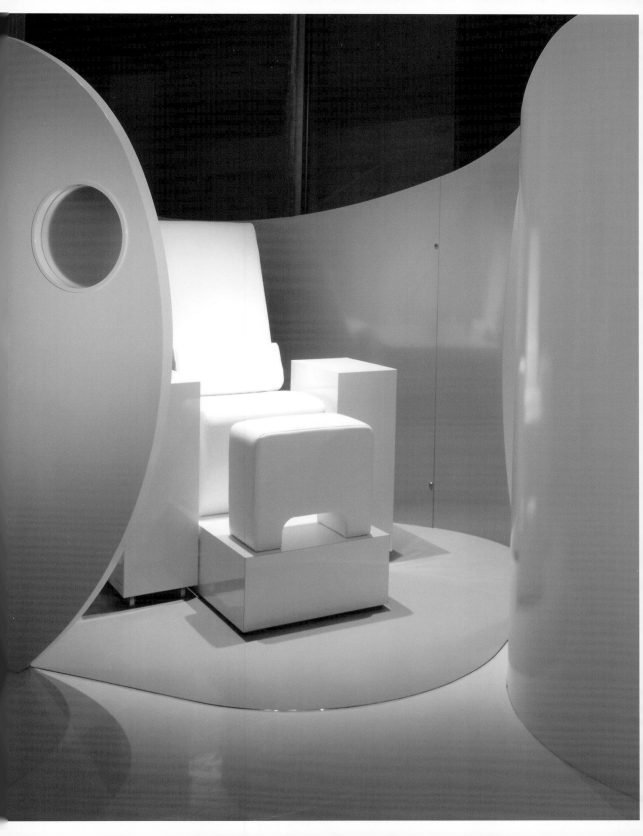

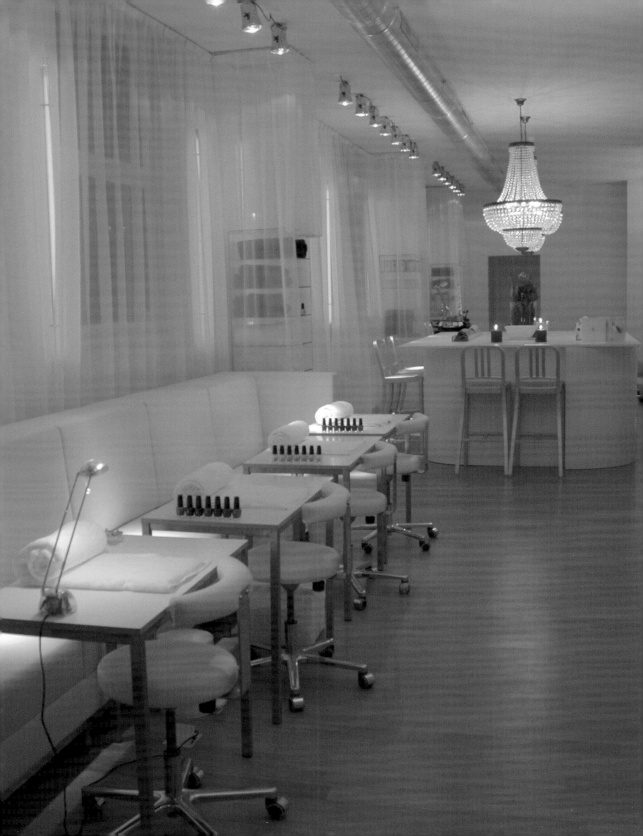

CONCRETE ARCHITECTURAL ASSOCIATES | AMSTERDAM
Soap Treatment Store
Amsterdam, The Netherlands | 2005
Photos: Reineke Ekering

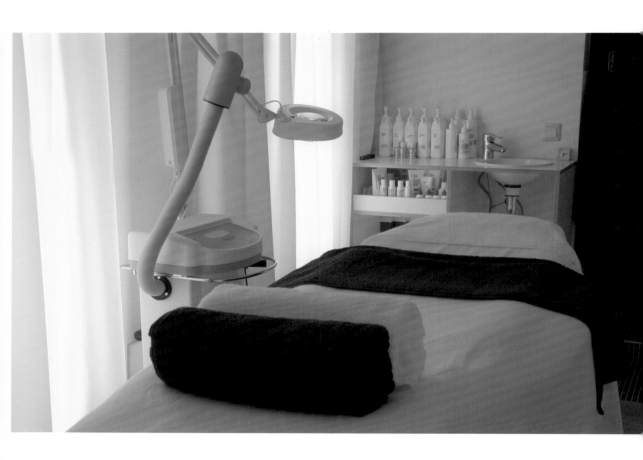

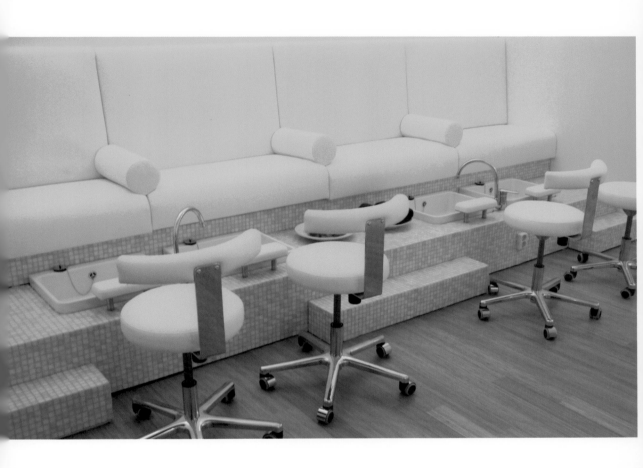

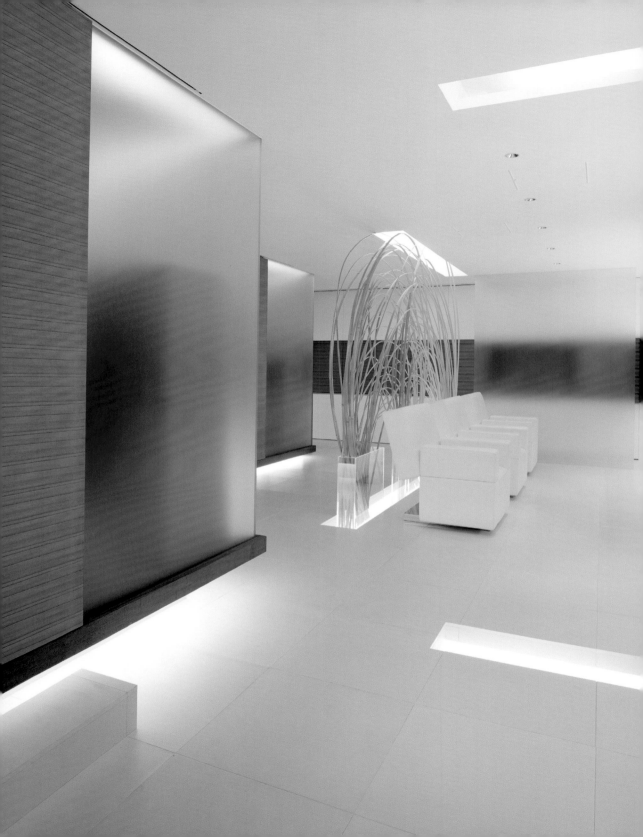

CURIOSITY INC. | **TOKYO**
Mars the Salon
Aoyama, Japan | 2004
Photos: Daici Ano

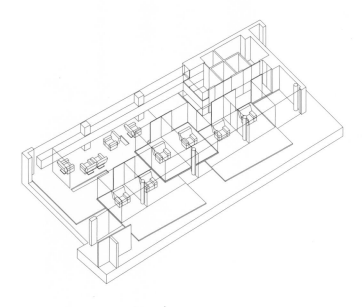

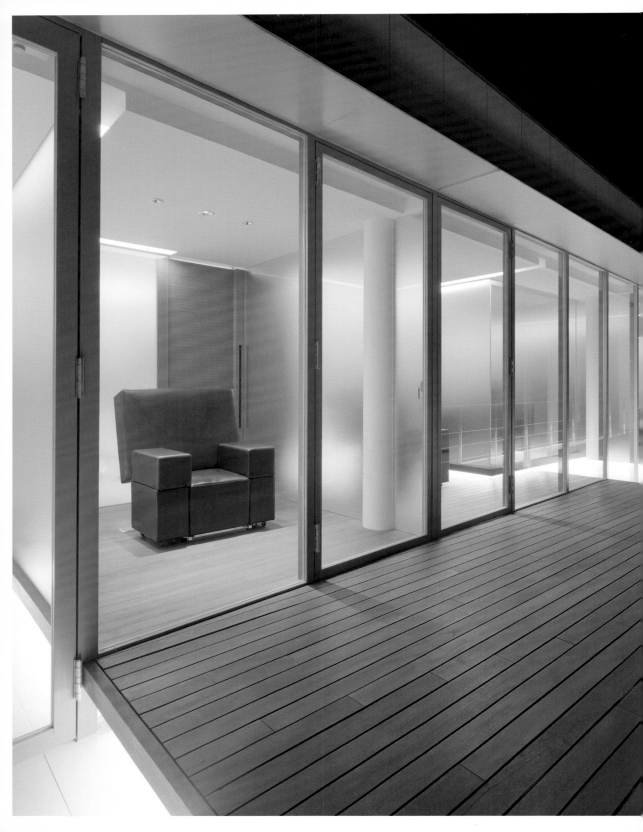

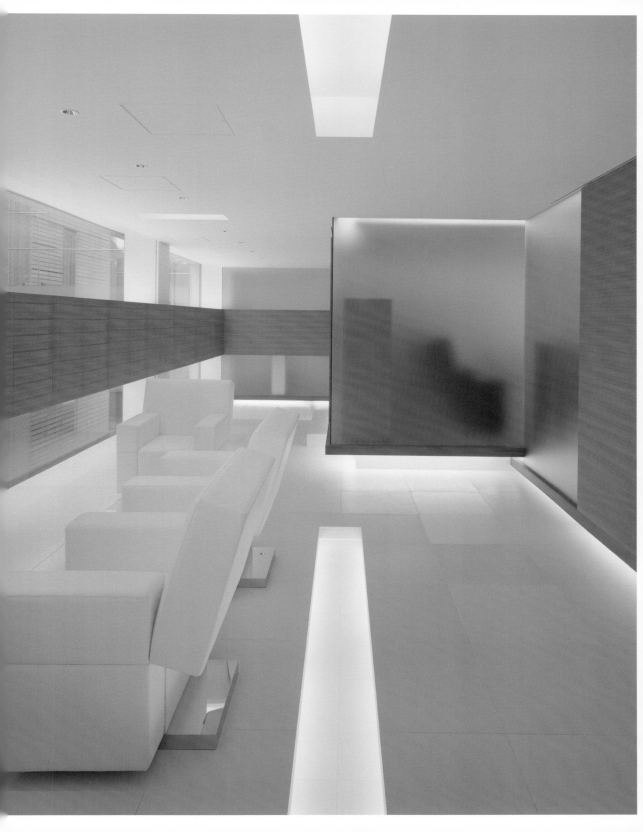

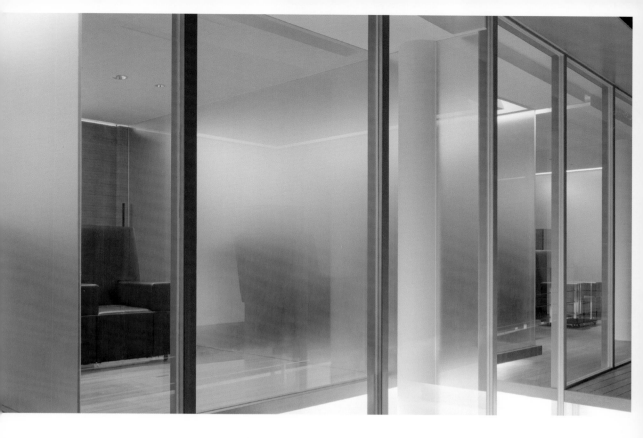

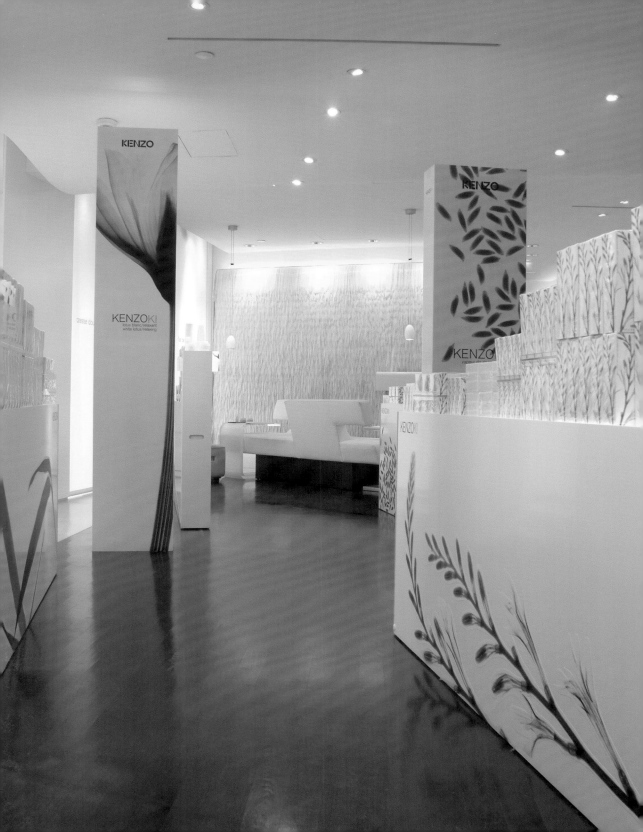

EMMANUELLE DUPLAY | PARIS
LabulleKenzo
Paris, France | 2003
Photos: Markus Bachmann

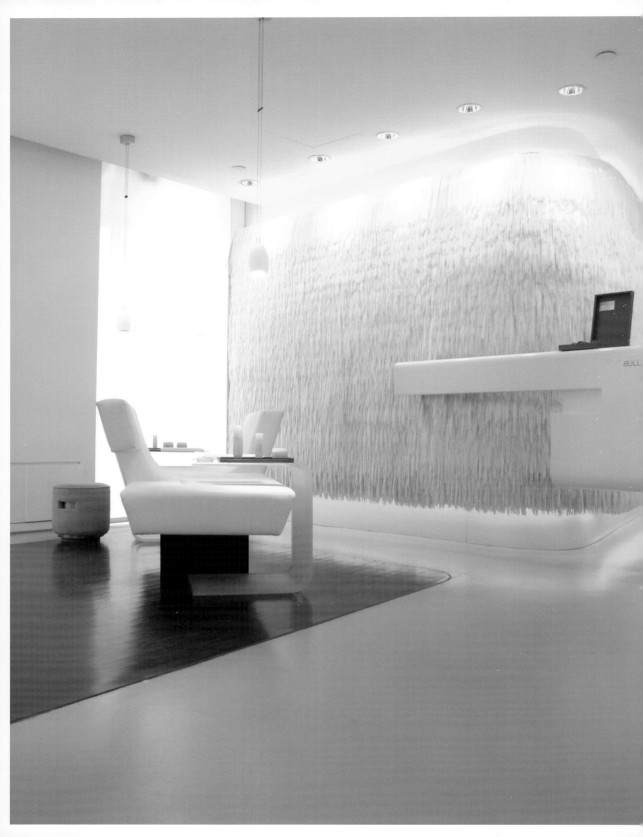

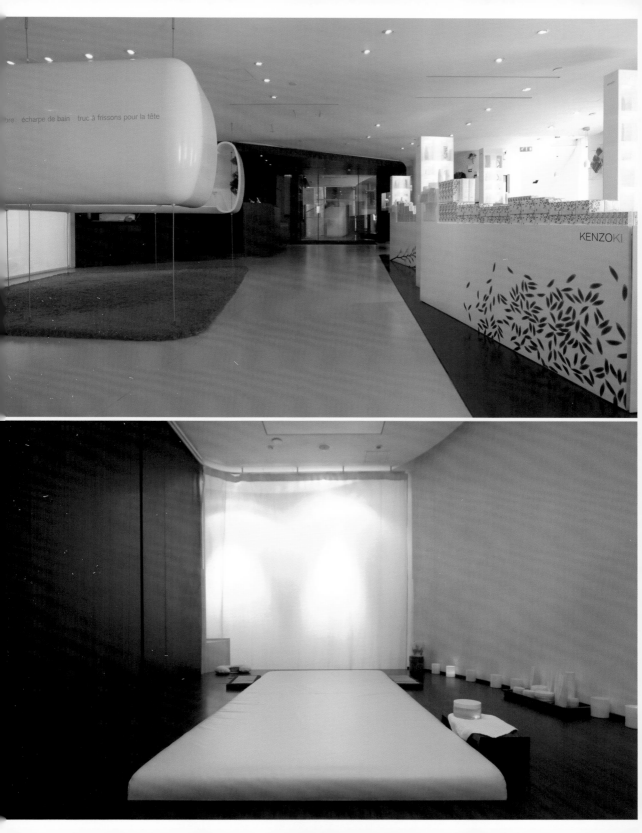

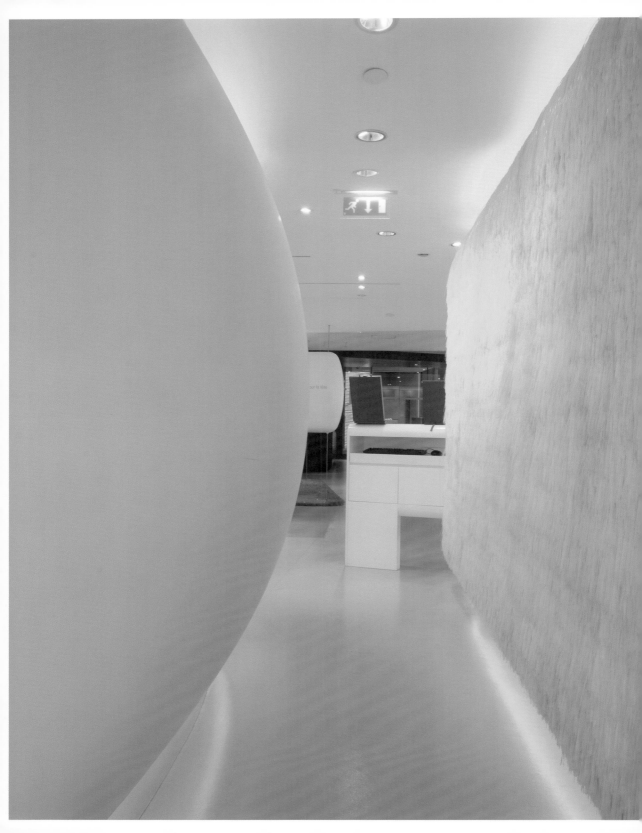

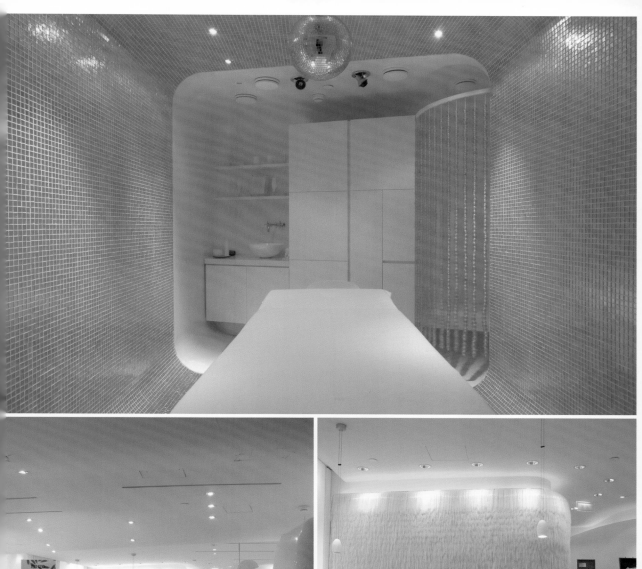
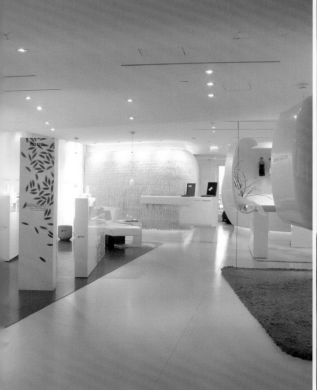
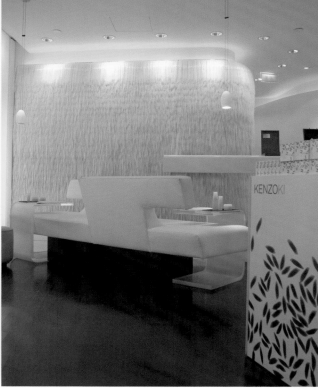

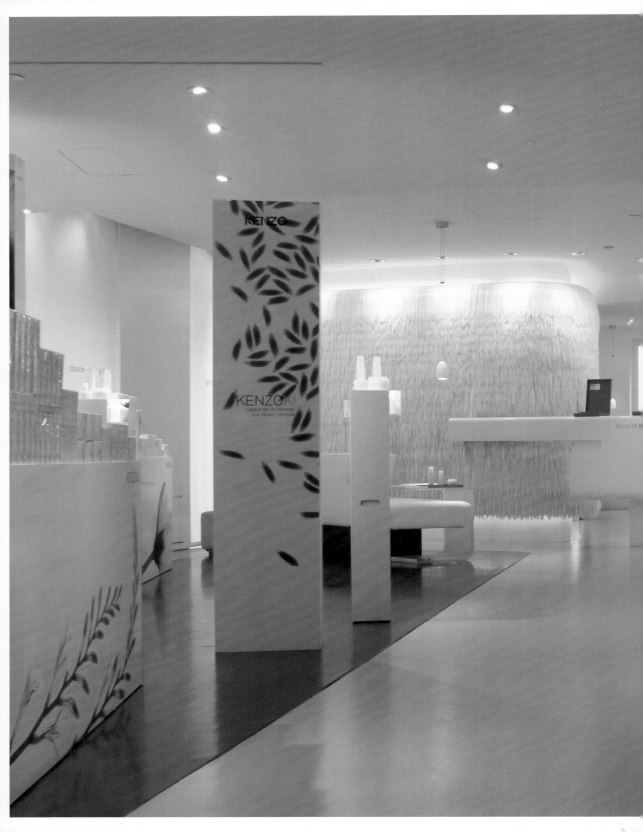

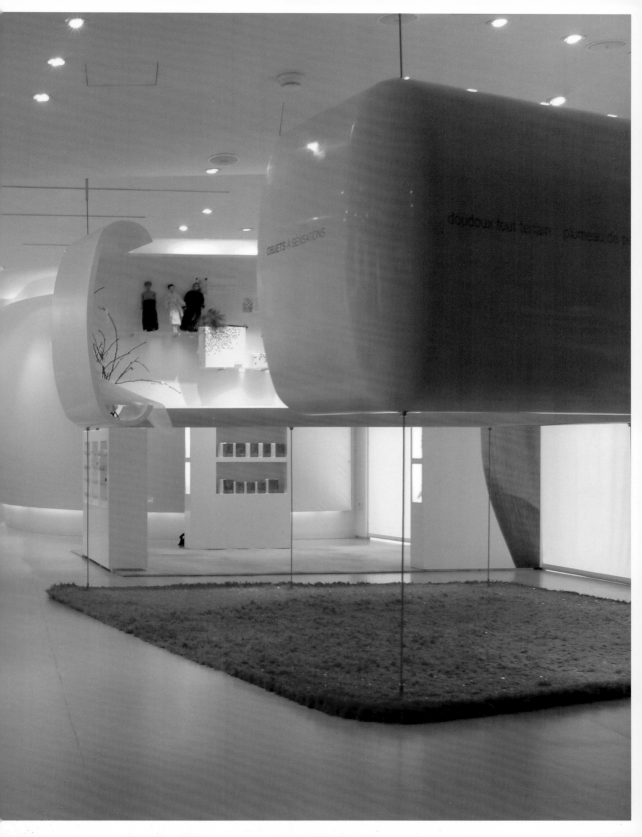

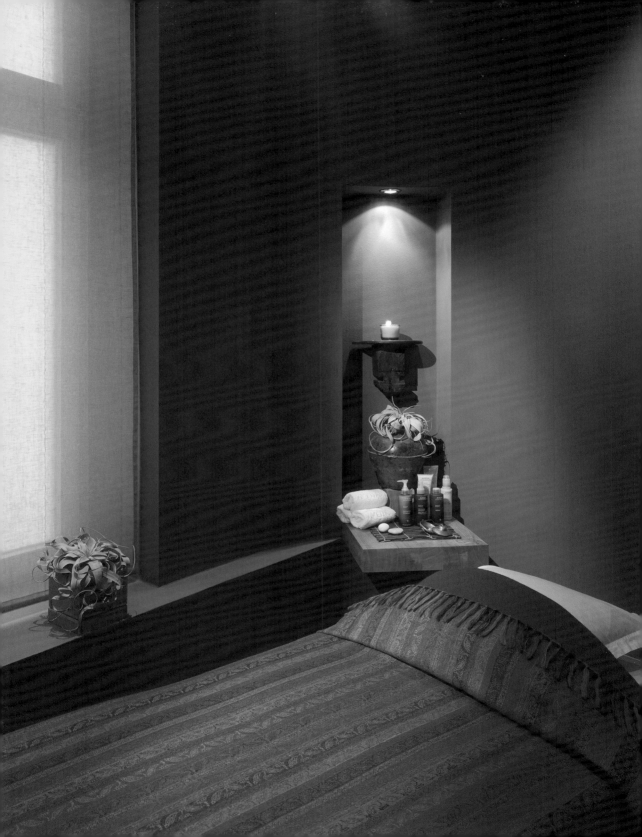

JAMIE FOBERT ARCHITECTS | LONDON
WITH CAROLA SCHÄFERS ARCHITEKTEN | BERLIN
Aveda Institut
Berlin, Germany | 2003
Photos: Courtesy Aveda

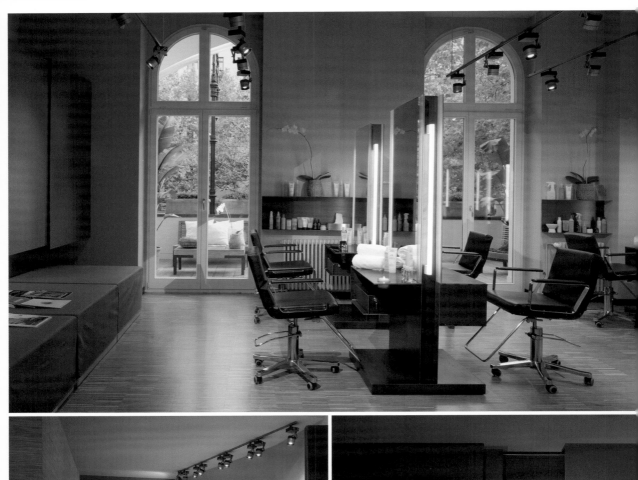

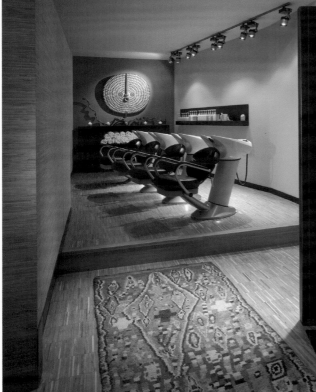

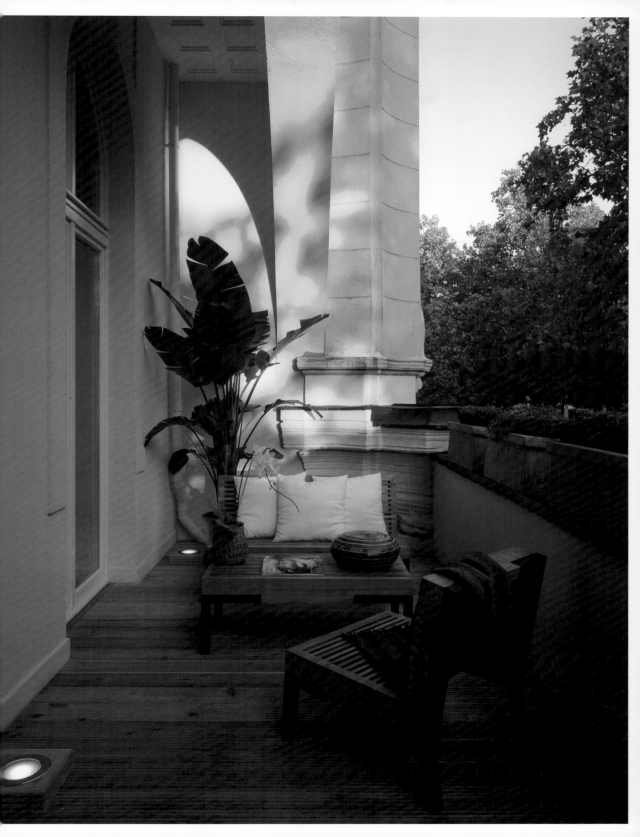

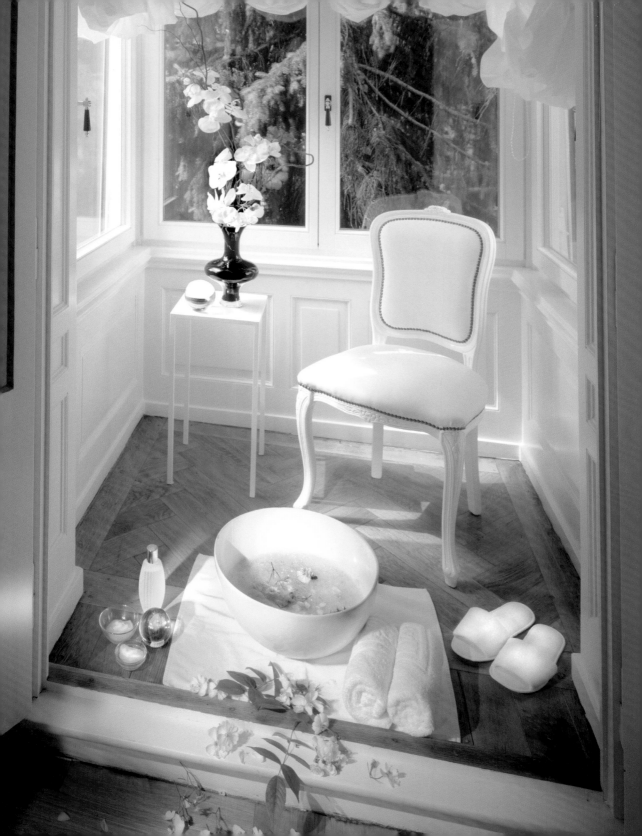

SIMONE GROSS WITH OLIVER SCHEUERMANN | FRANKFURT
Swan's House of Beauty
Frankfurt, Germany | 2003
Photos: Chris Kister

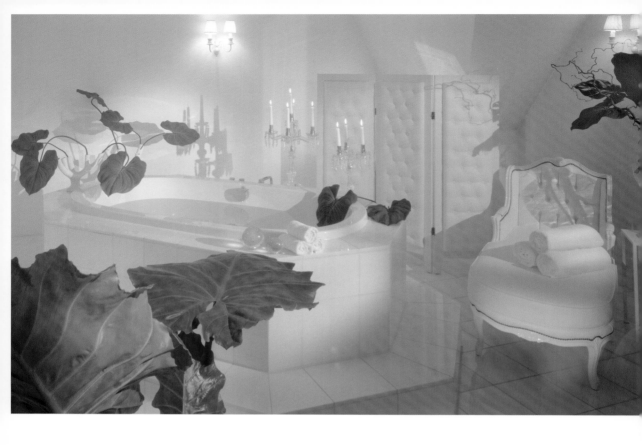

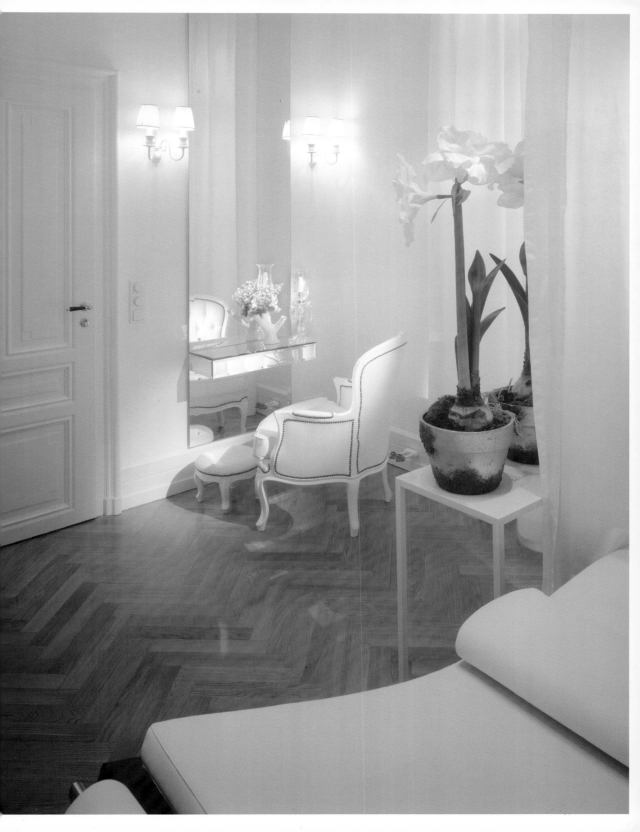

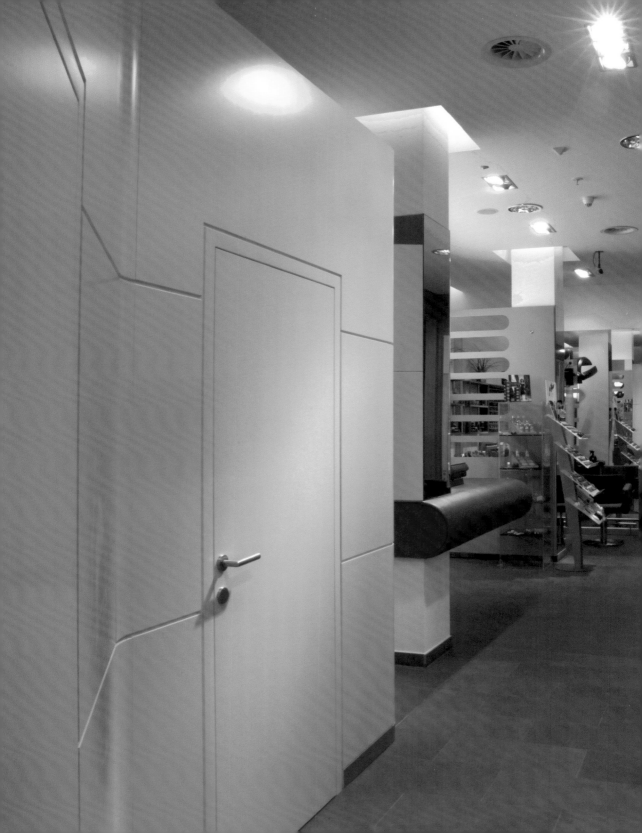

PRODUKTDESIGN HOLZER | VIENNA
Make me up! Professional Beauty Studio
Vienna, Austria | 2005
Photos: Michael Goldgruber

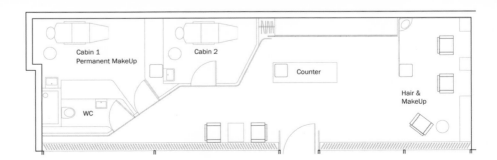

Cabin 1
Permanent MakeUp

Cabin 2

Counter

Hair &
MakeUp

WC

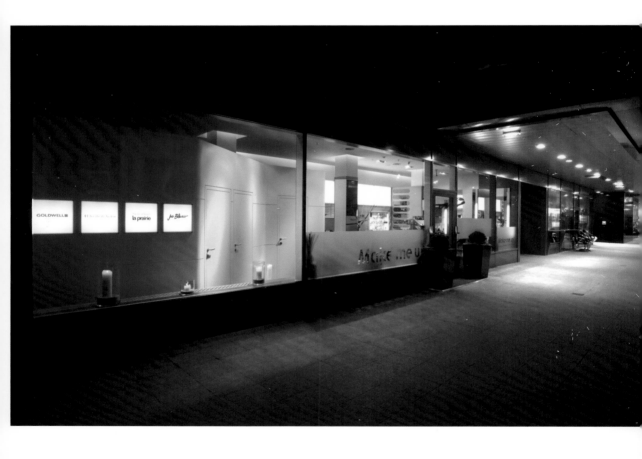

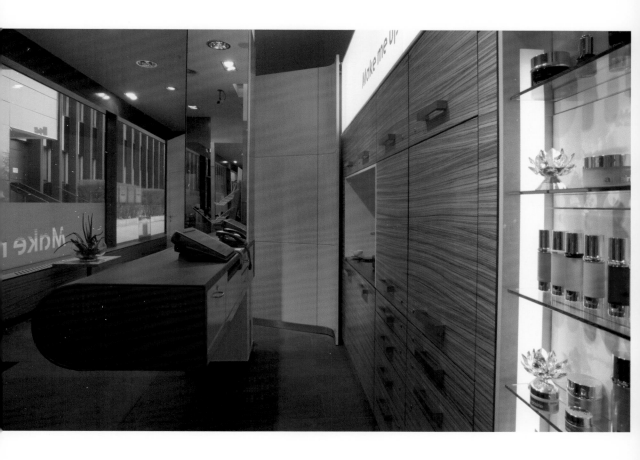

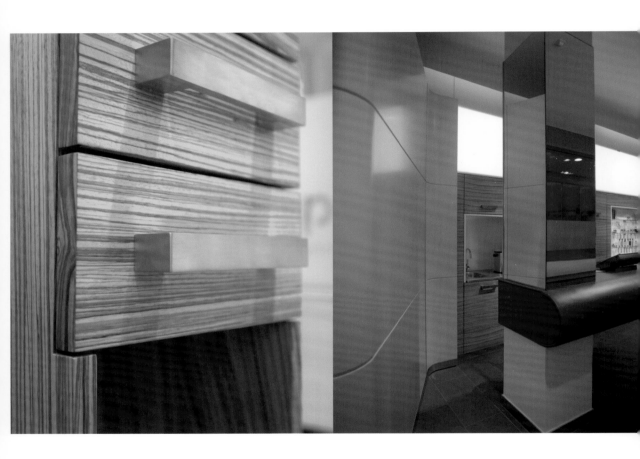

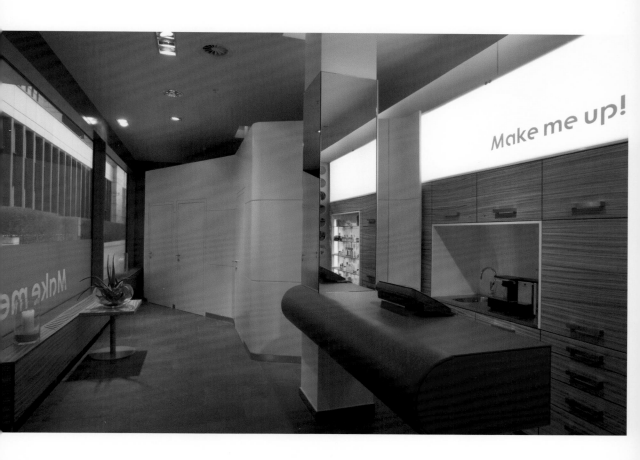

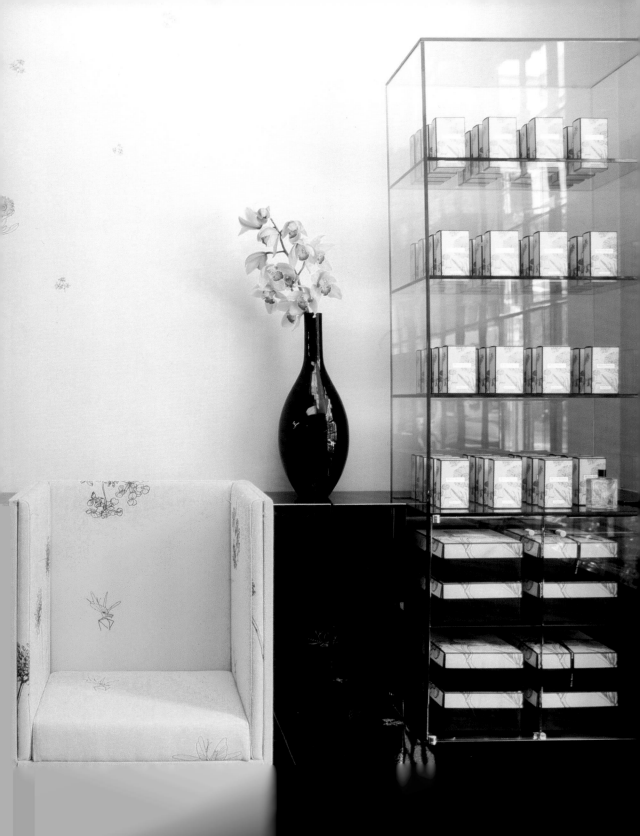

KRD SHONE KITCHEN + AB ROGERS | LONDON
Miller Harris Flagship
London, UK | 2004
Photos: Courtesy Miller Harris

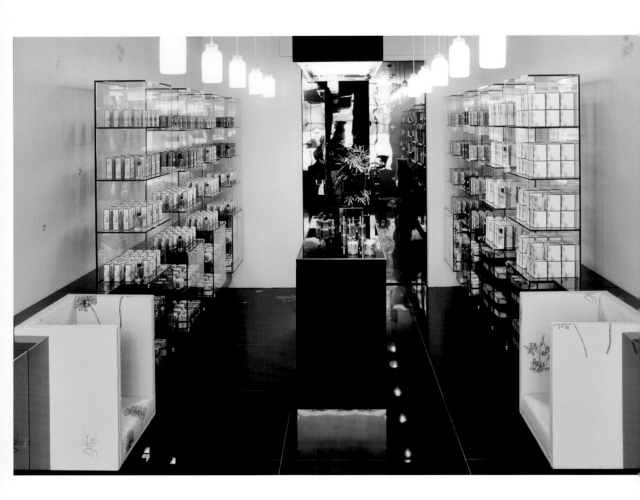

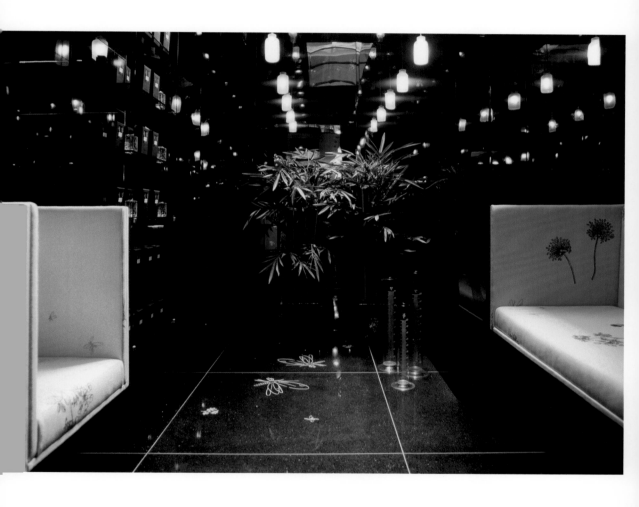

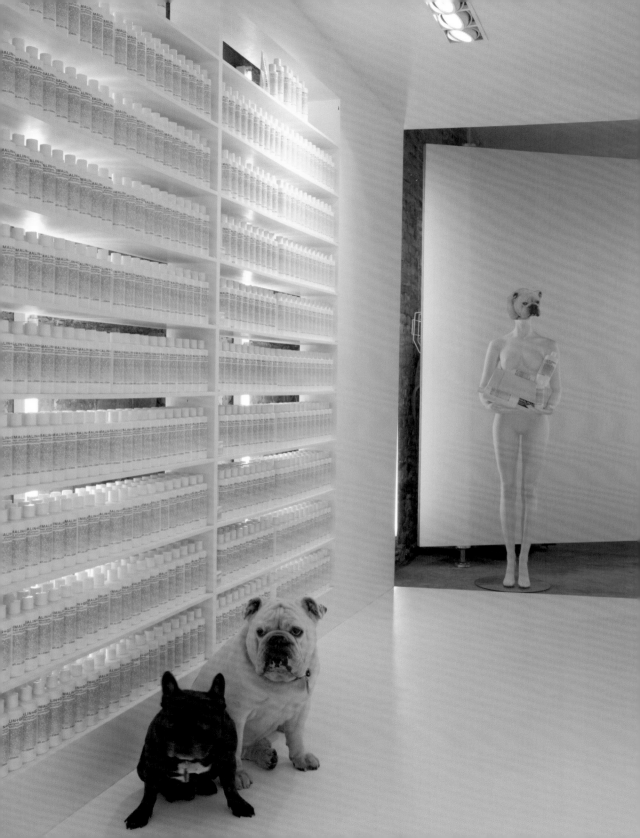

KONYK ARCHITECTURE | NEW YORK
Malin+Goetz
New York, USA | 2004
Photos: Eric Laignel, Roland Bauer, Rise Endo, Suzie Crouch

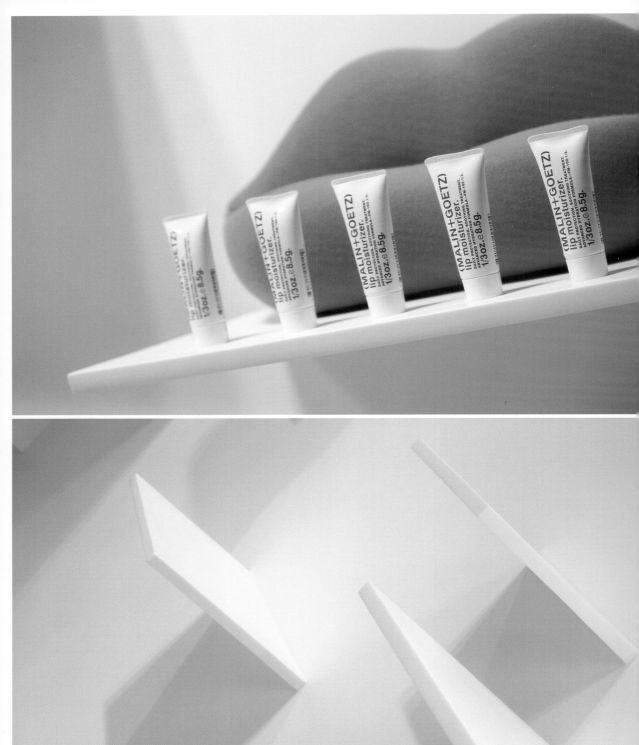

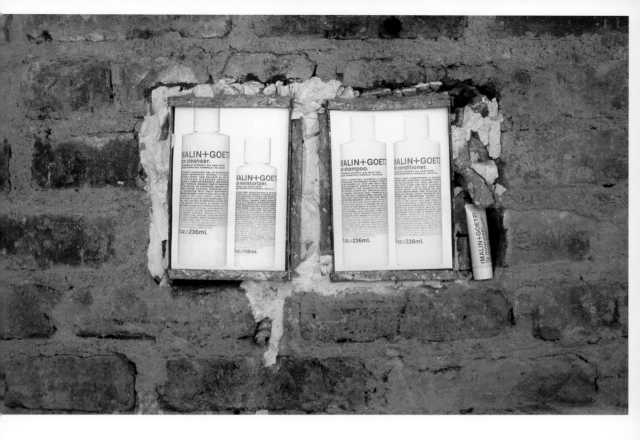

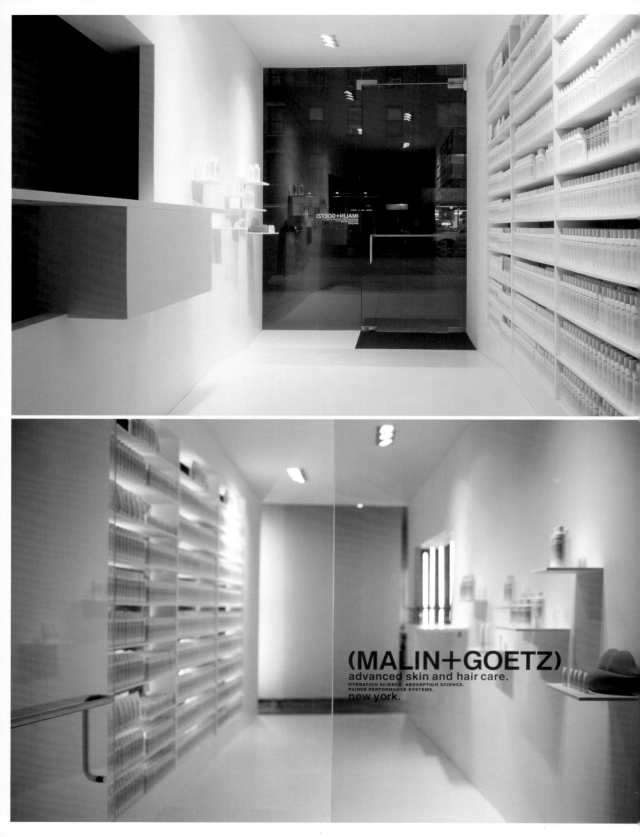

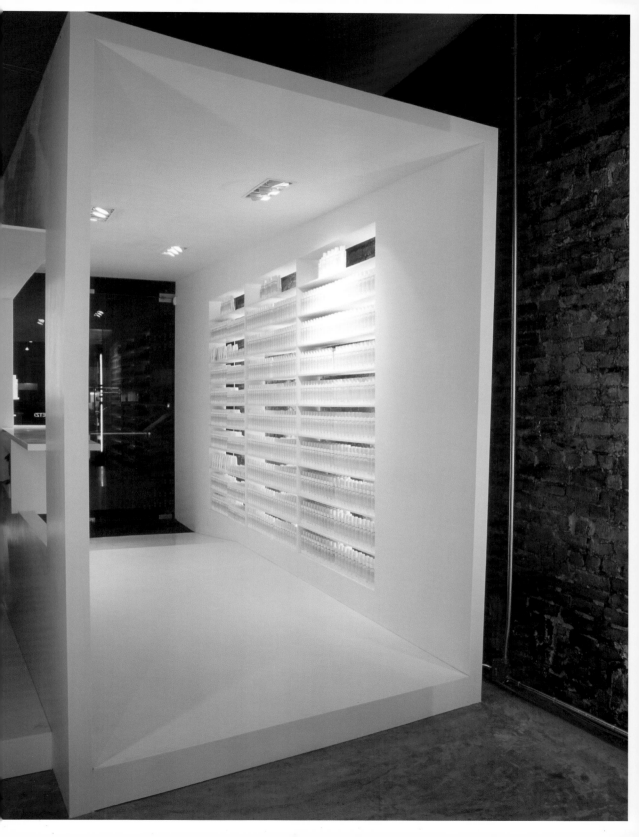

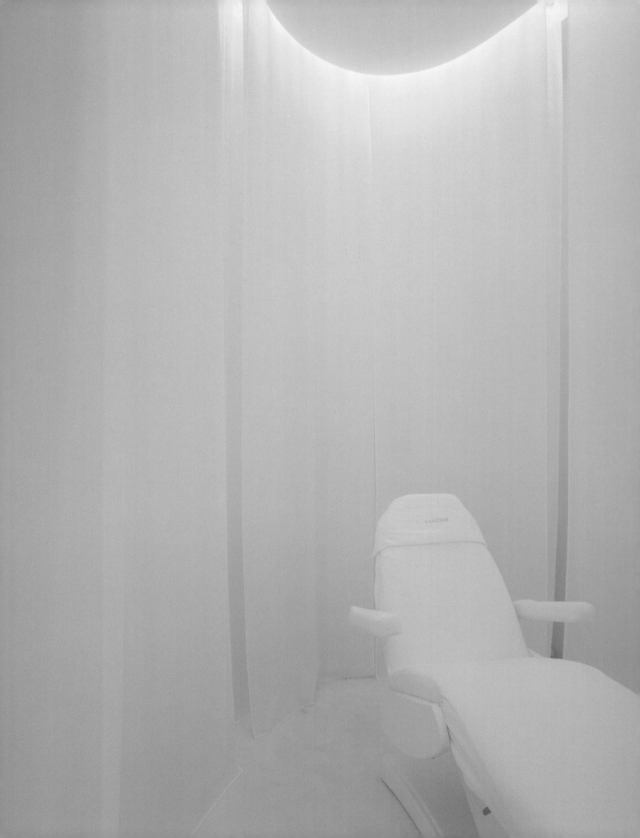

STUDIO MASSAUD | PARIS
Lancôme
Hong Kong, China | 2005
Photos: Virgile Simon

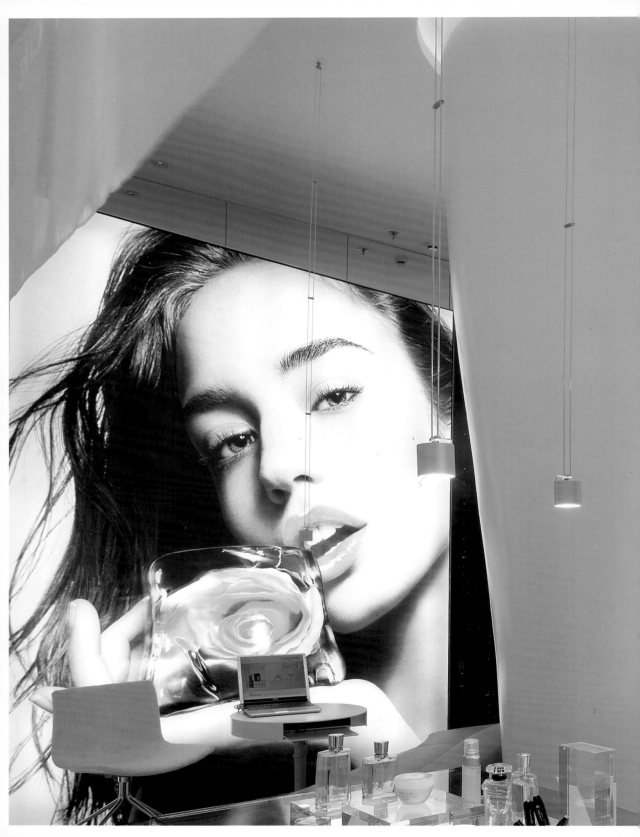

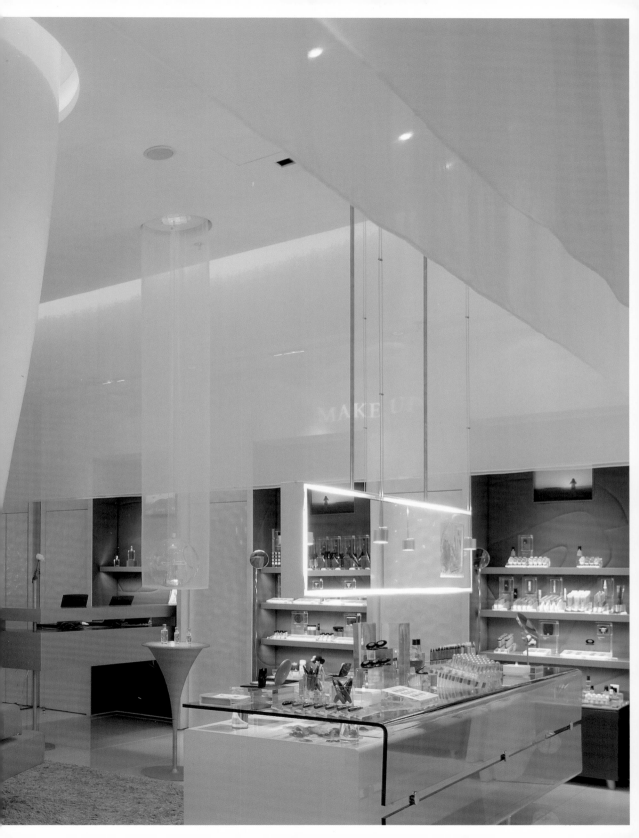

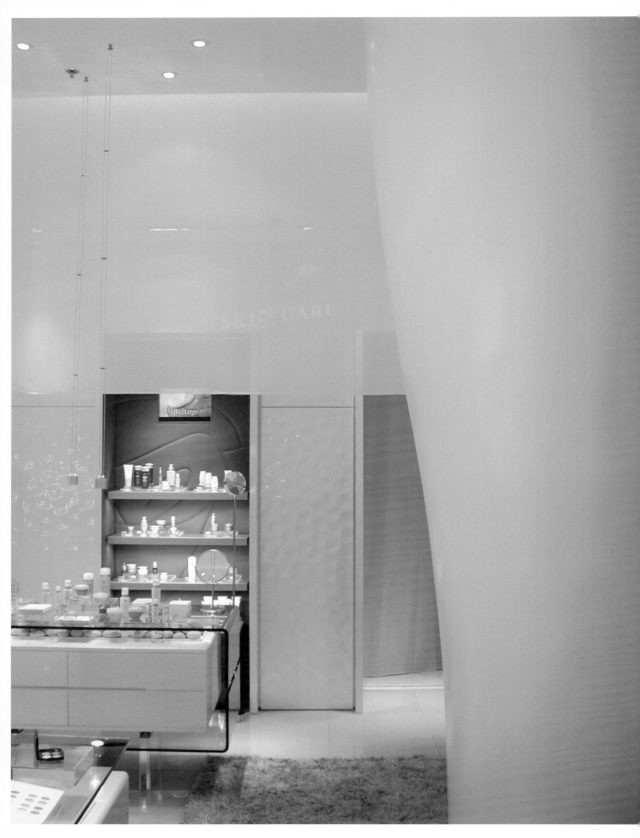

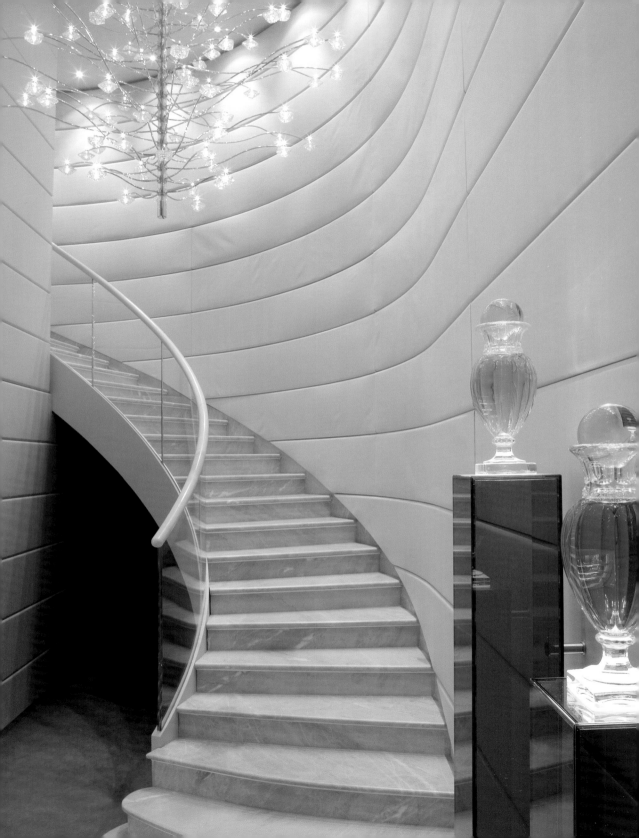

STUDIO MASSAUD | PARIS
Lancôme
Paris, France | 2004
Photos: Antoine Baralhe

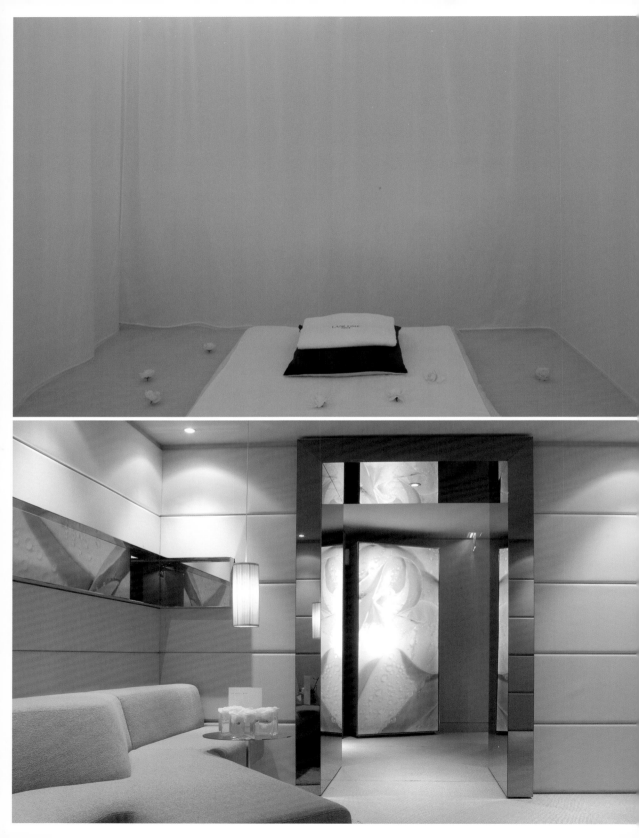

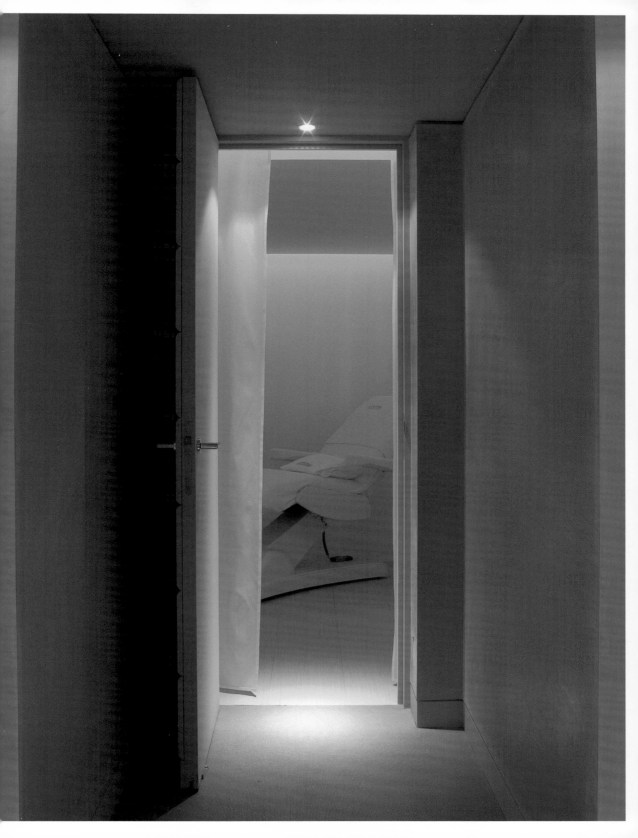

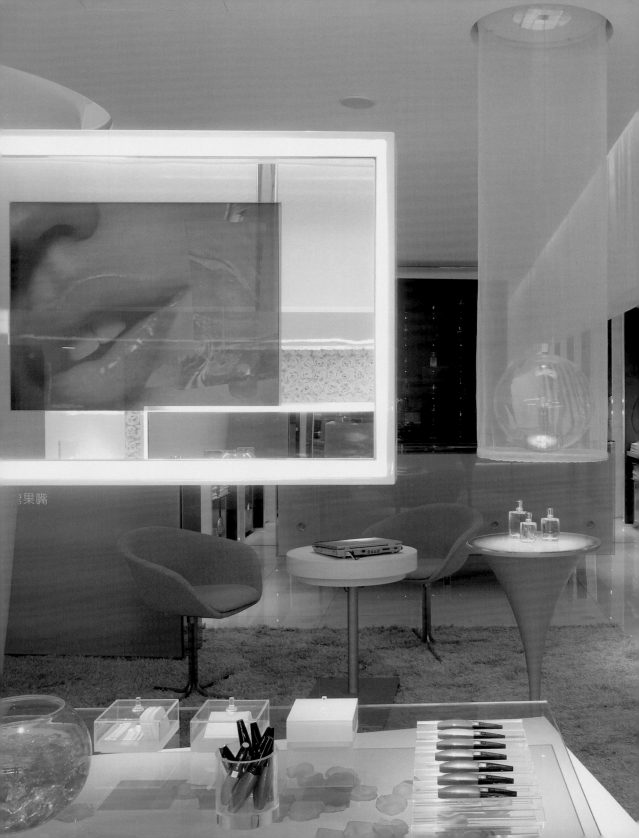

STUDIO MASSAUD | **PARIS**
Lancôme
Shanghai, China | 2005
Photos: Virgile Simon

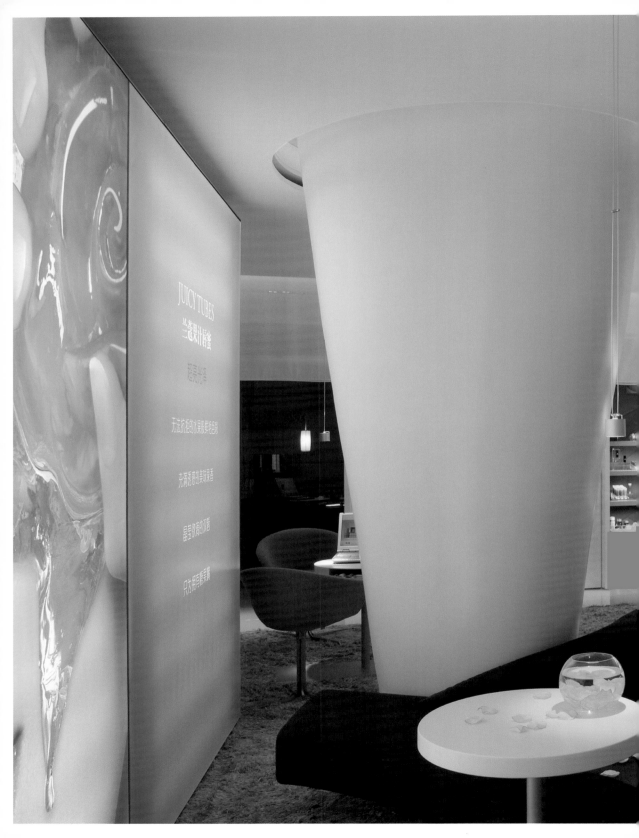

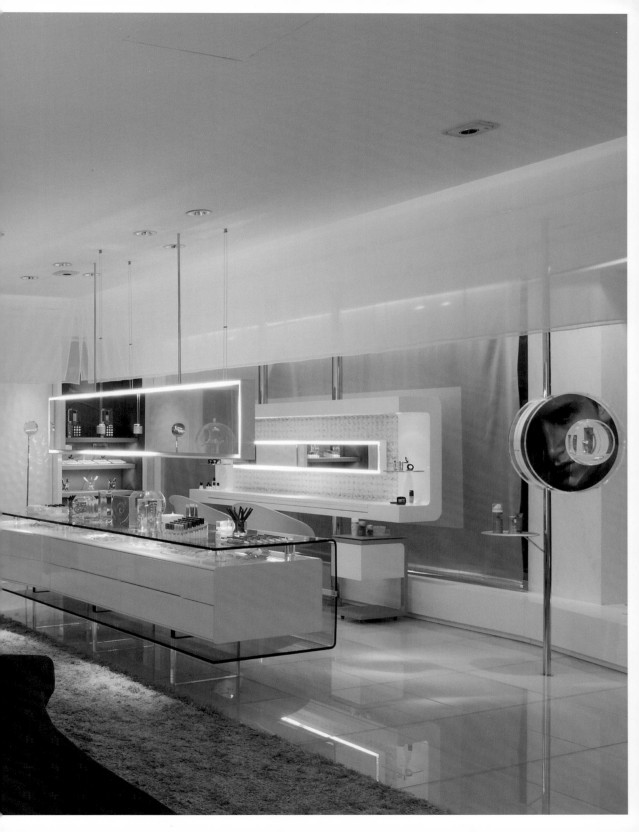

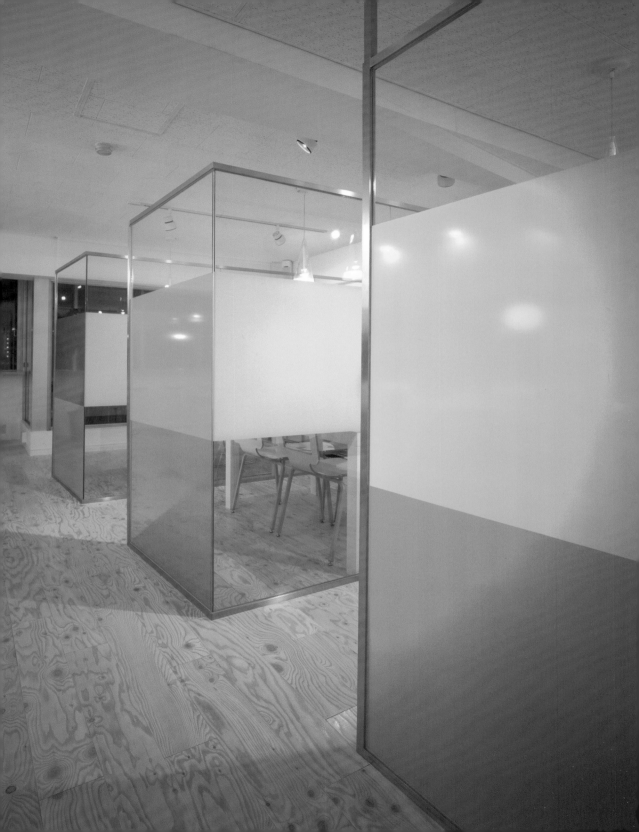

EMMANUELLE MOUREAUX | TOKYO
Be Fine
Tokyo, Japan | 2003
Photos: Hidehiko Nagaishi

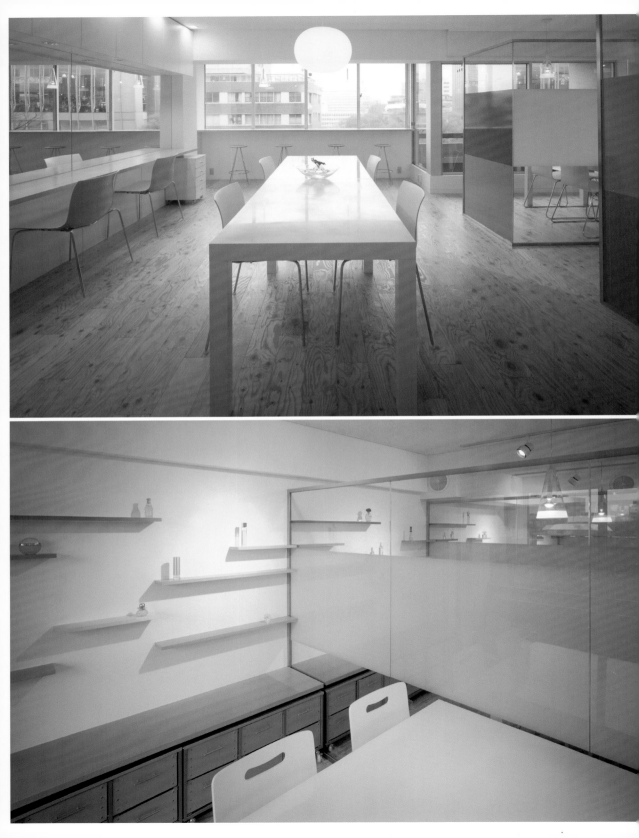

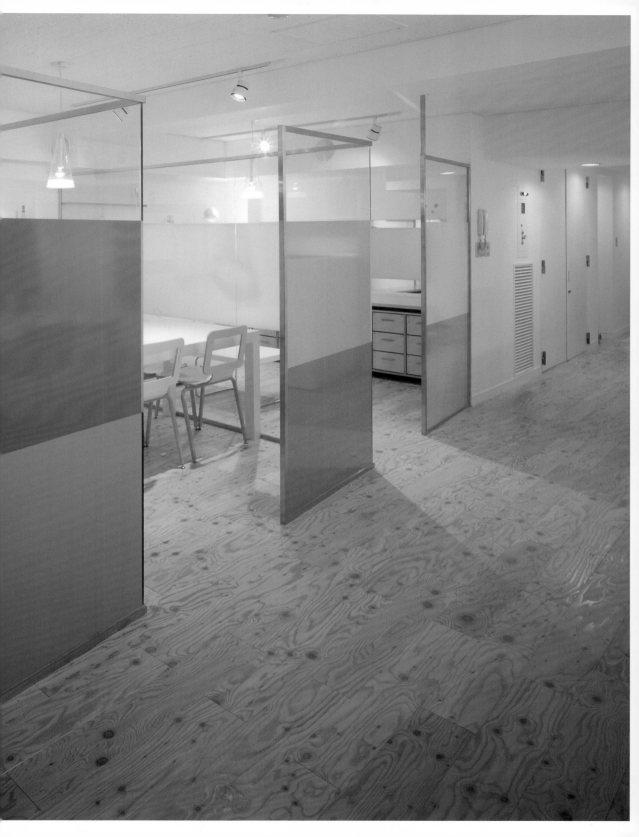

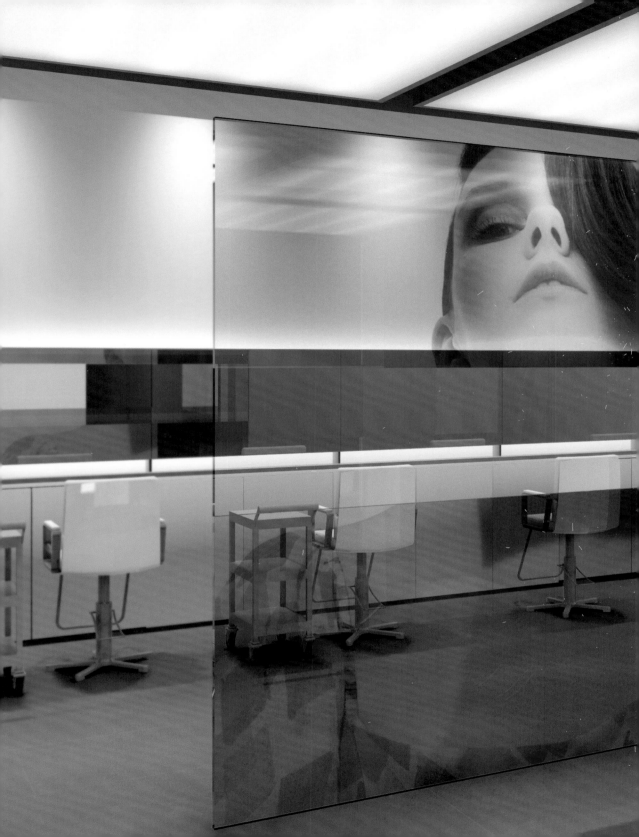

MESSANA O'RORKE ARCHITECTS | NEW YORK
Revlon Lab
New York, USA | 2000
Photos: Courtesy Messana O'Rorke Architects

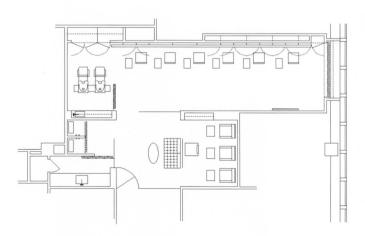

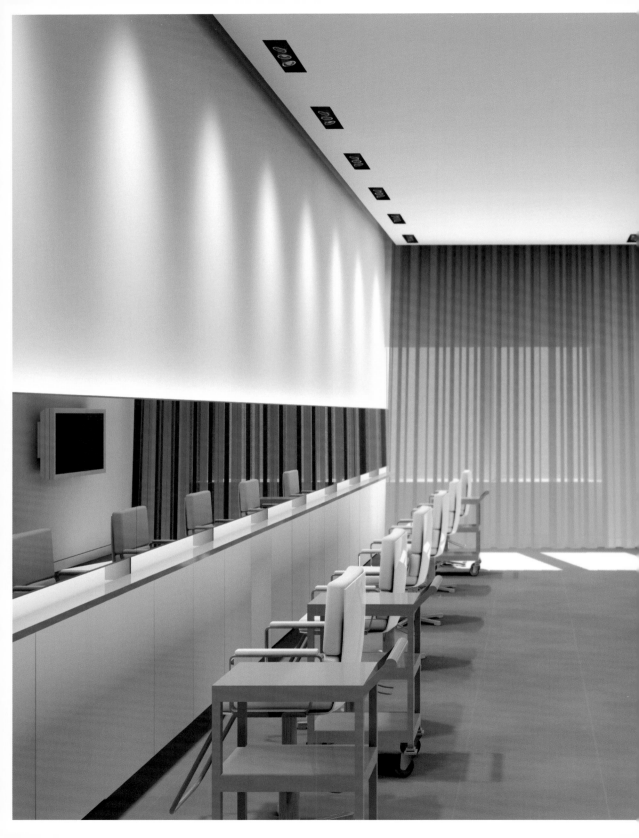

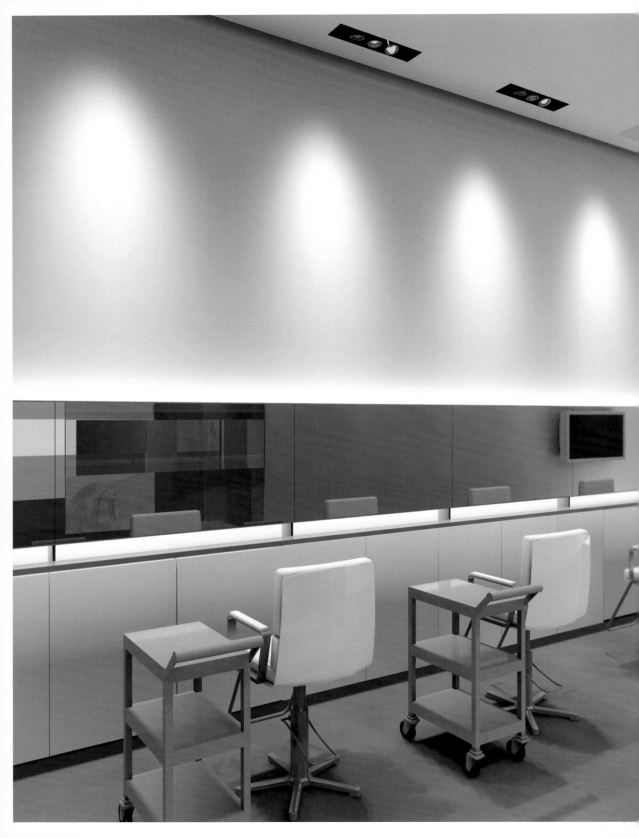

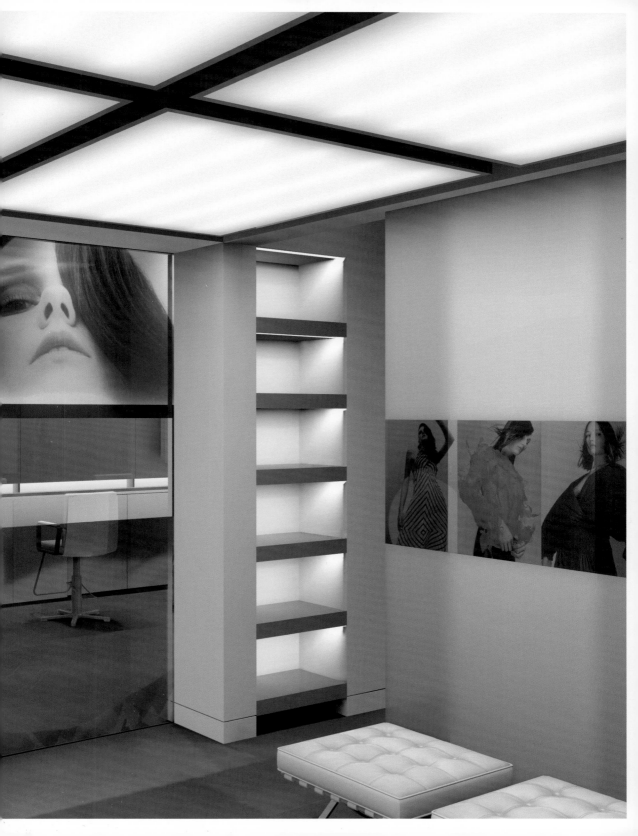

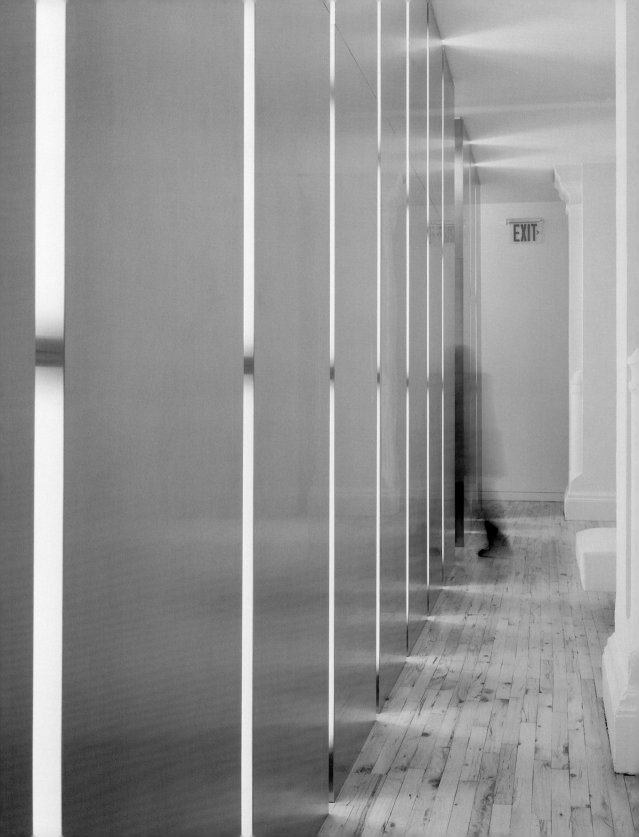

MESSANA O'RORKE ARCHITECTS | NEW YORK
Skin Care Lab
New York, USA | 2001
Photos: Elizabeth Felicella

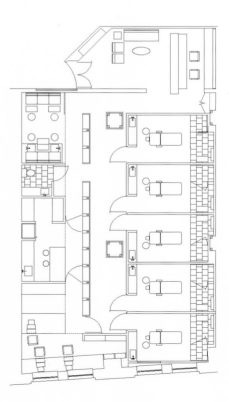

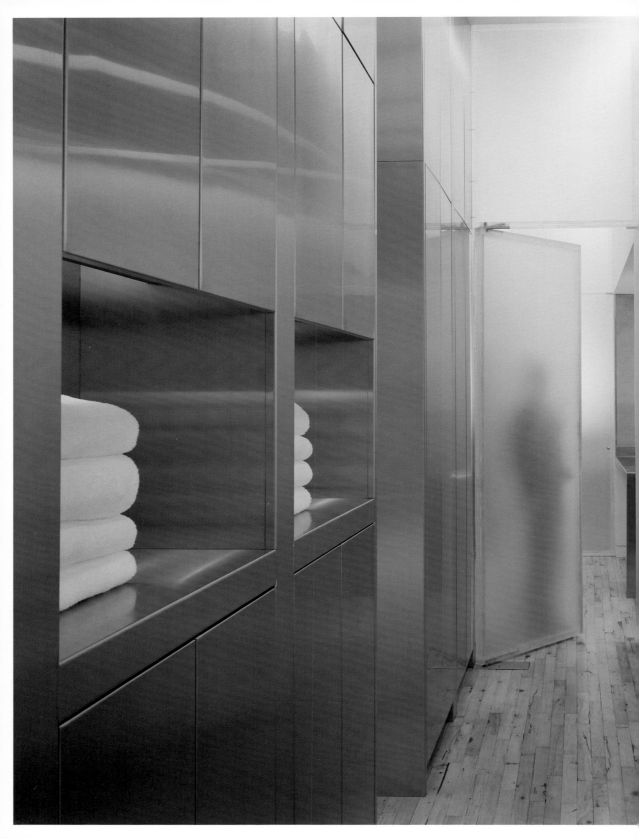

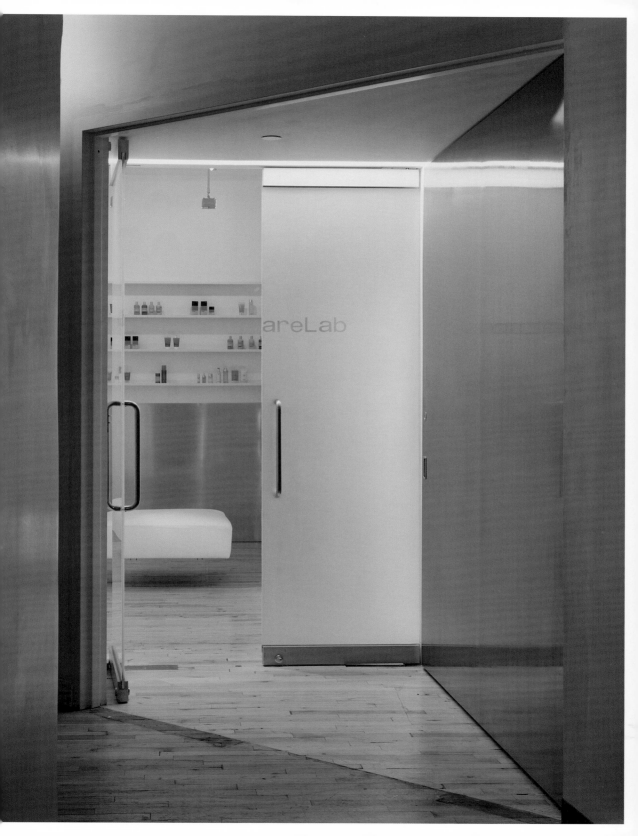

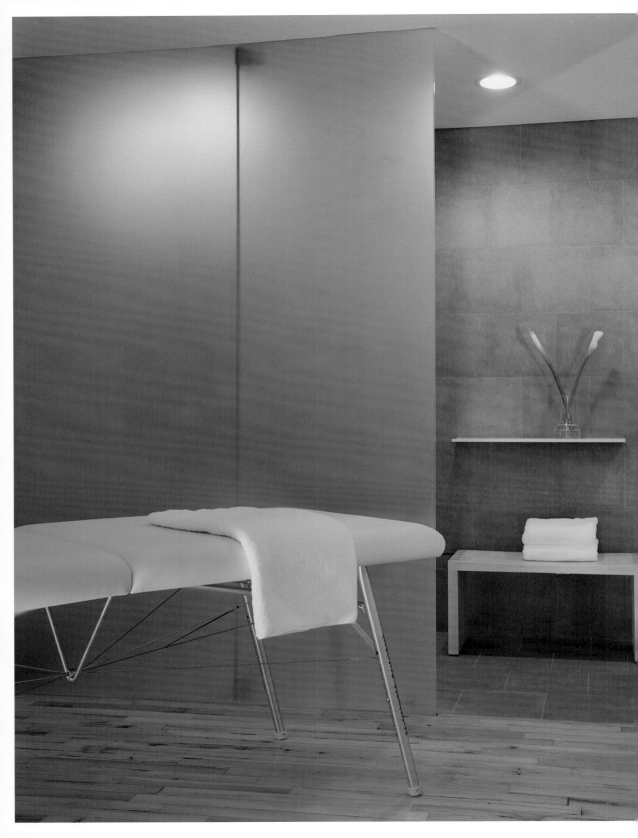

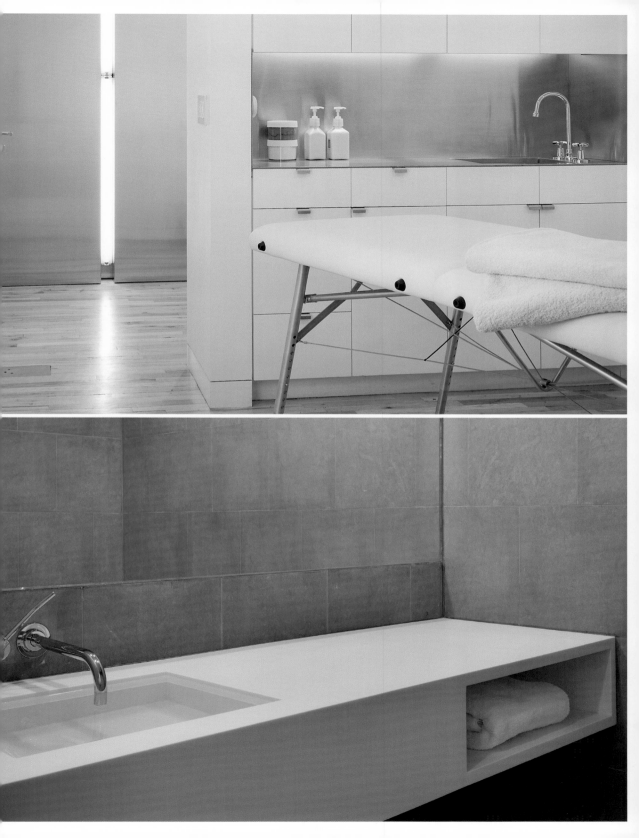

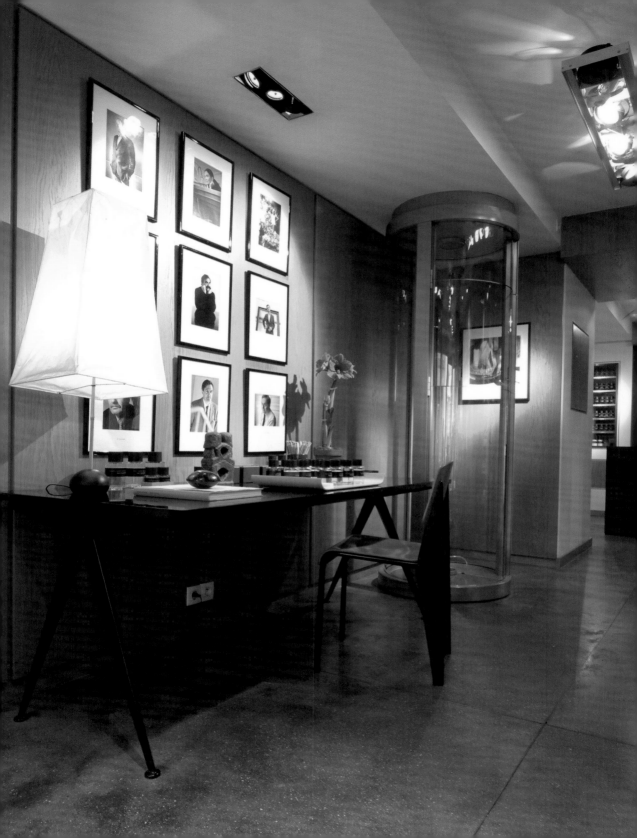

ANDRÉE PUTMAN | PARIS
Frederic Malle Editions de Parfums
Paris, France | 2000
Photos: Markus Bachmann

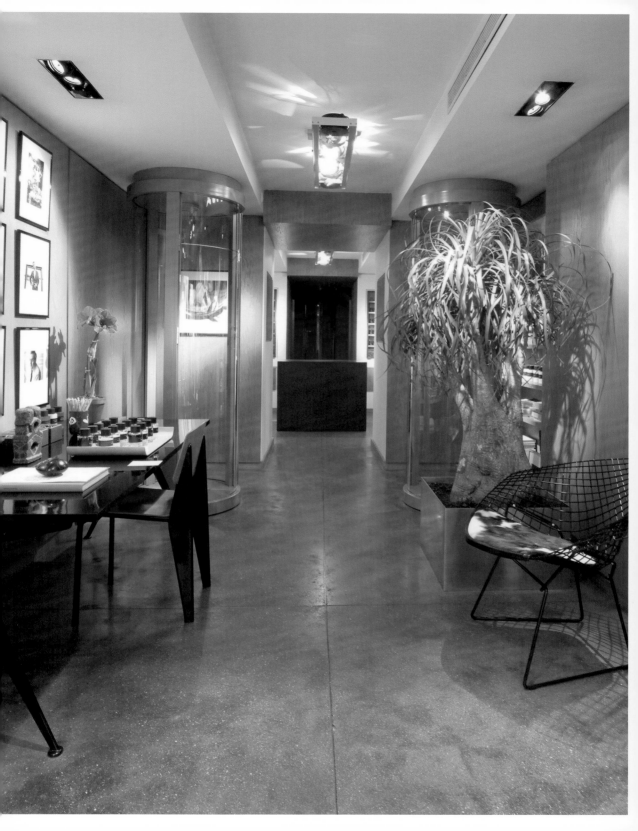

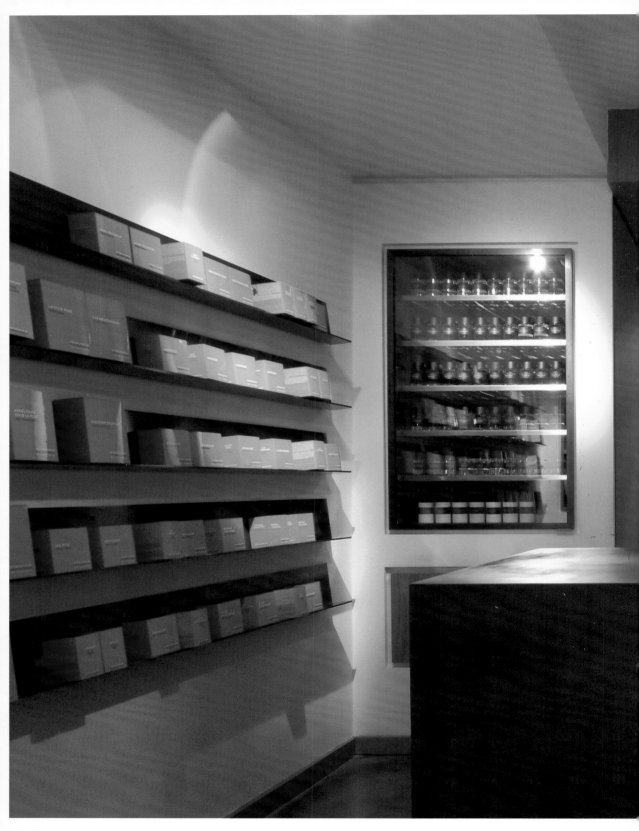

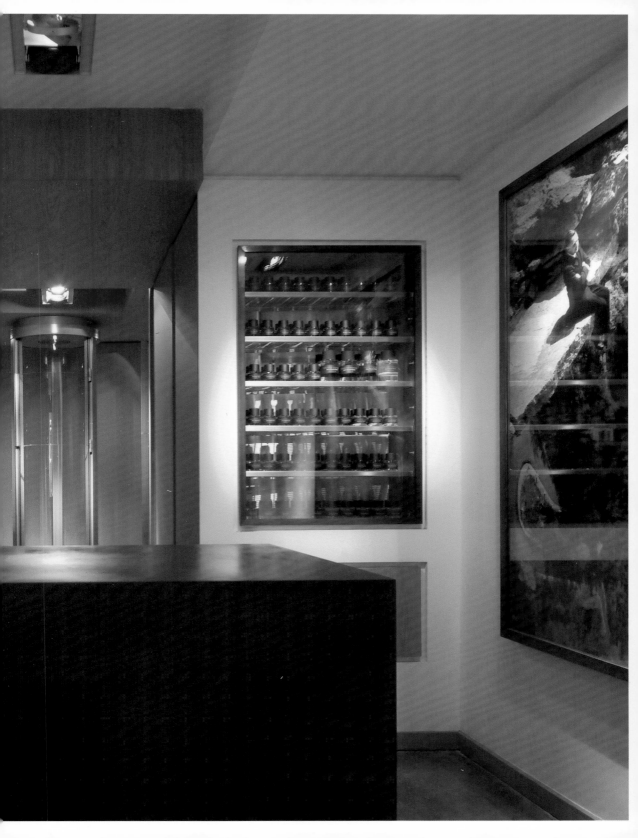

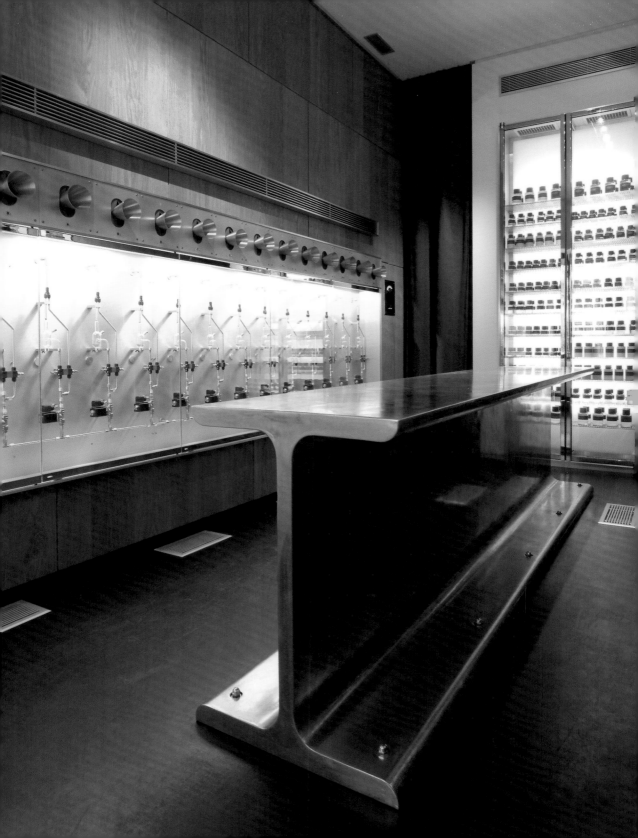

PATRICK NAGGAR | PARIS
Frederic Malle Editions de Parfums
Paris, France | 2001
Photos: Markus Bachmann

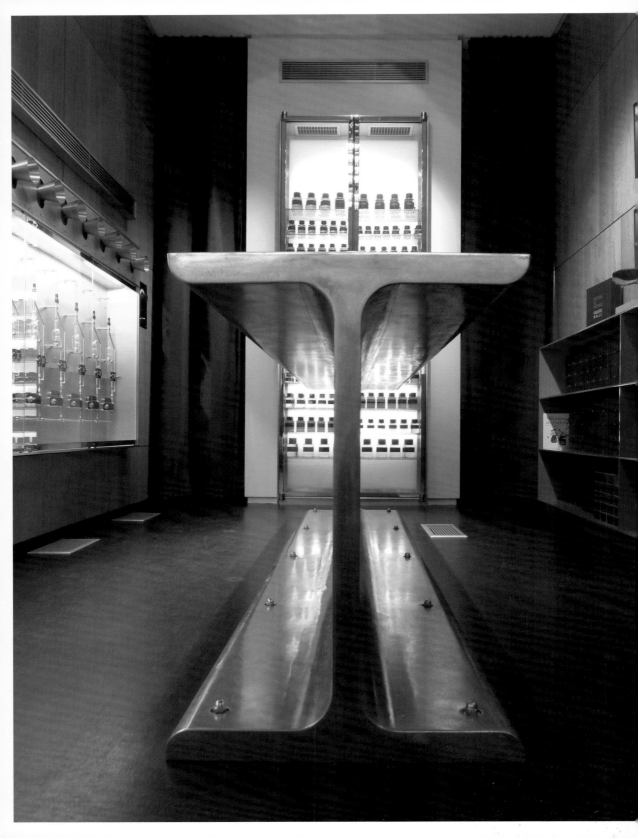

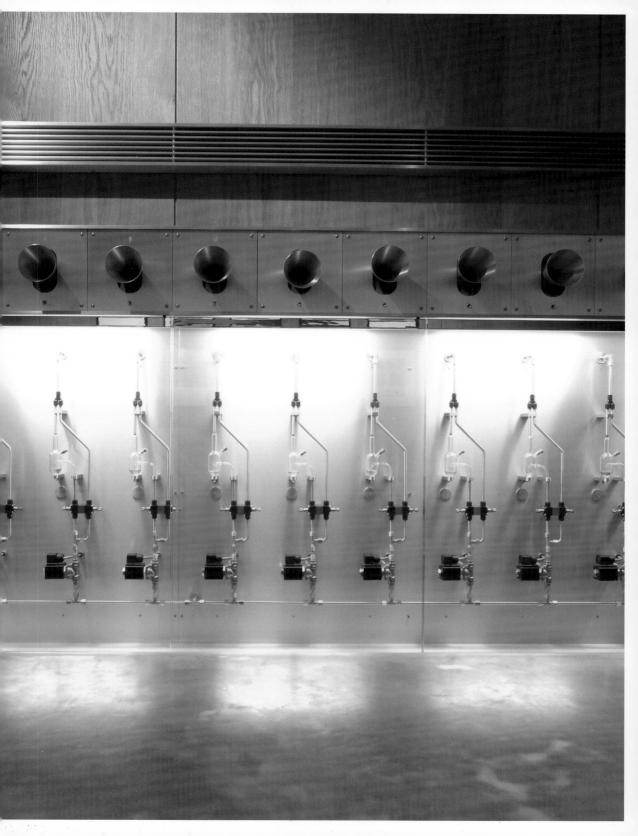

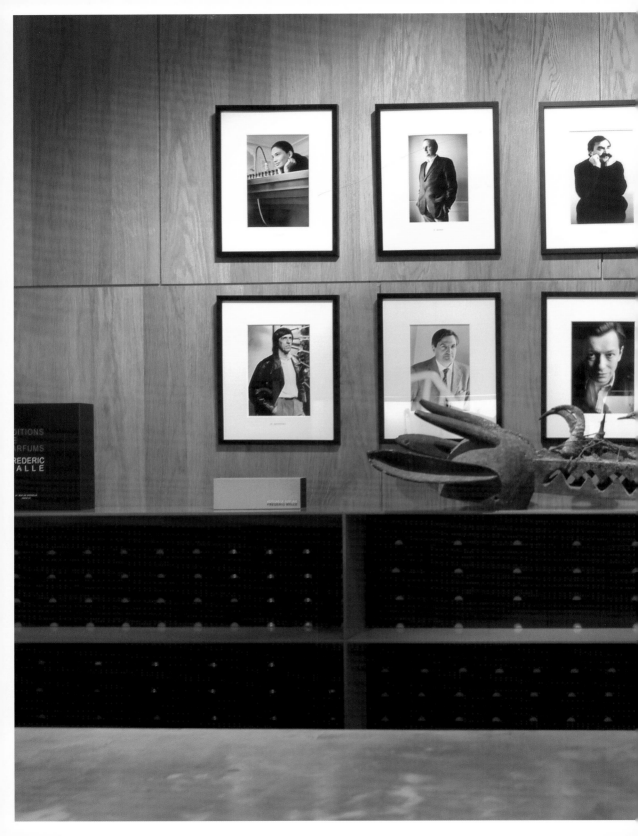

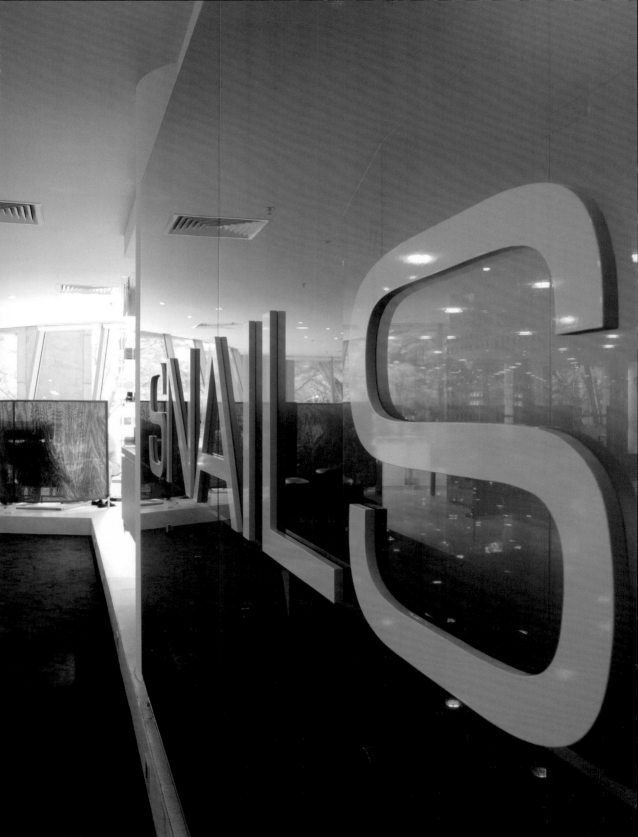

WALLFLOWER ARCHITECTURE & DESIGN | SINGAPORE
Snails
Singapore, Asia | 2003
Photos: CI&A Photography

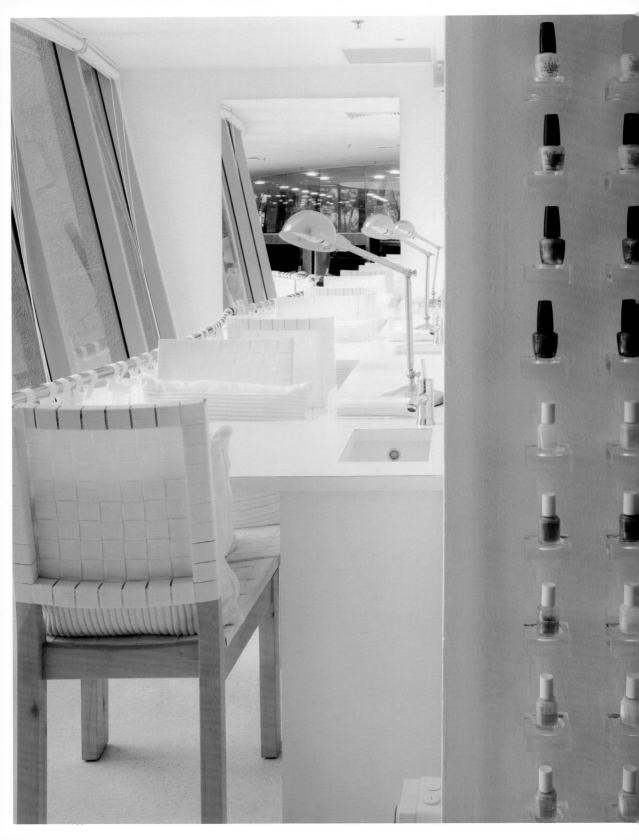

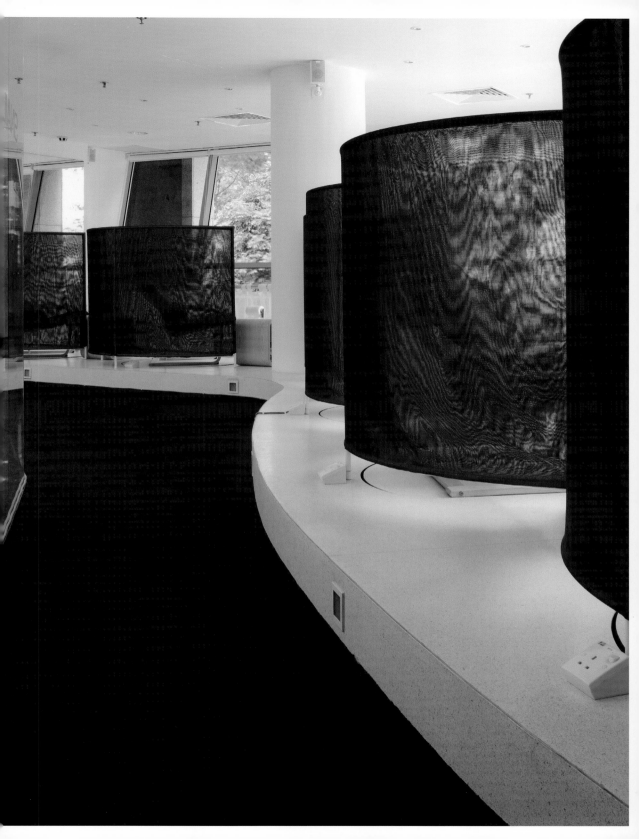

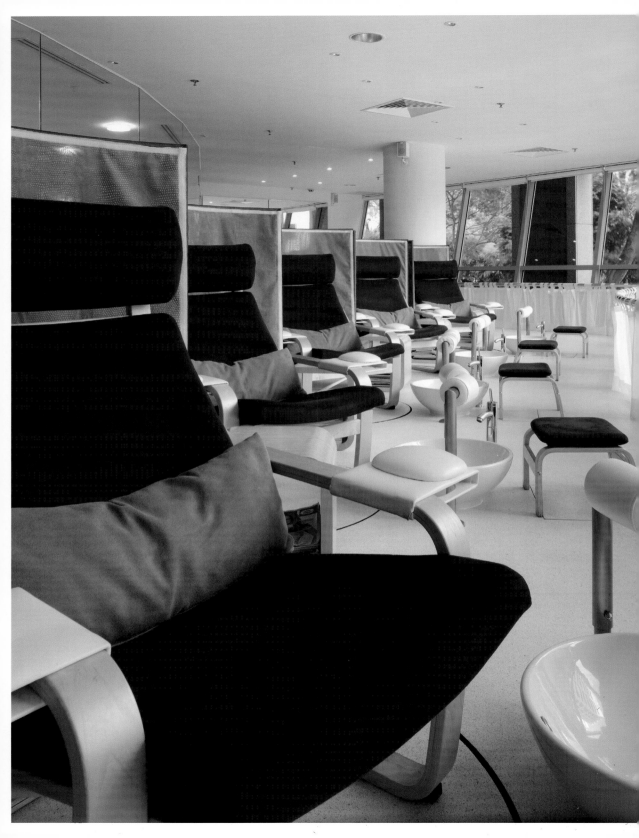

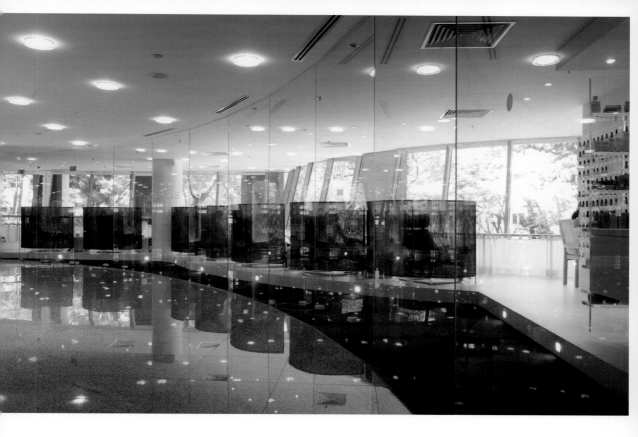

HAIRDRESSER

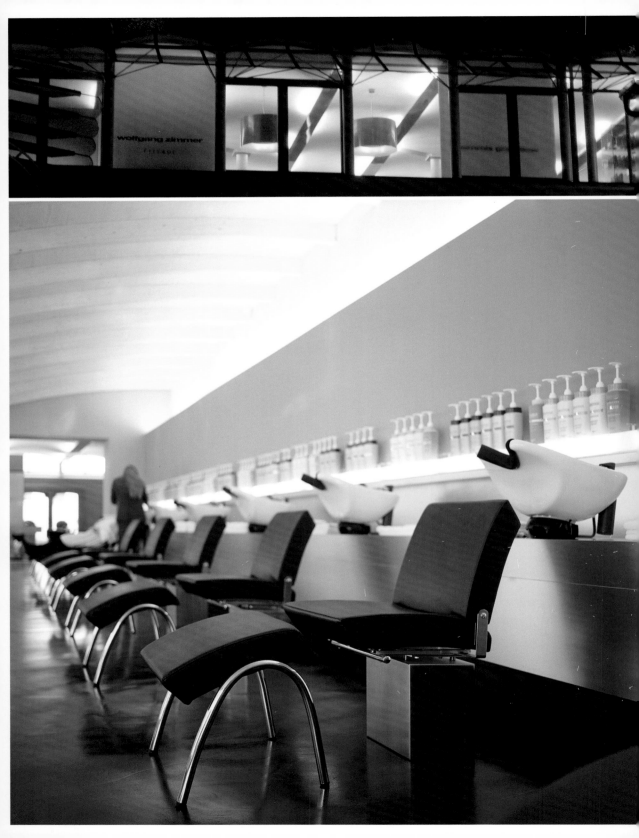

BFS DESIGN | BERLIN
Wolfgang Zimmer Friseur
Berlin, Germany | 2003
Photos: Katharina Gossow, Annette Kisling

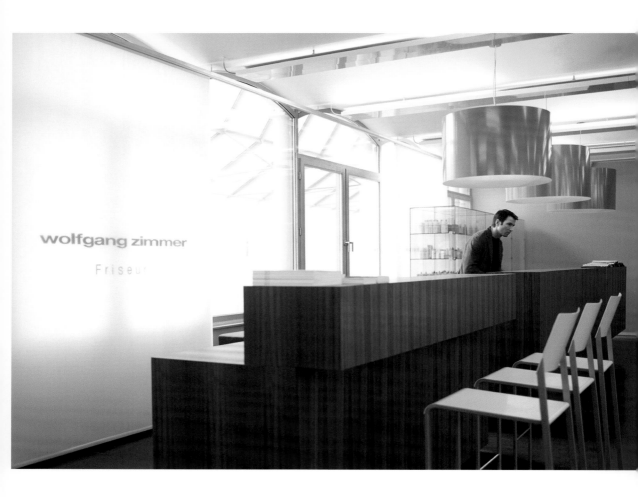

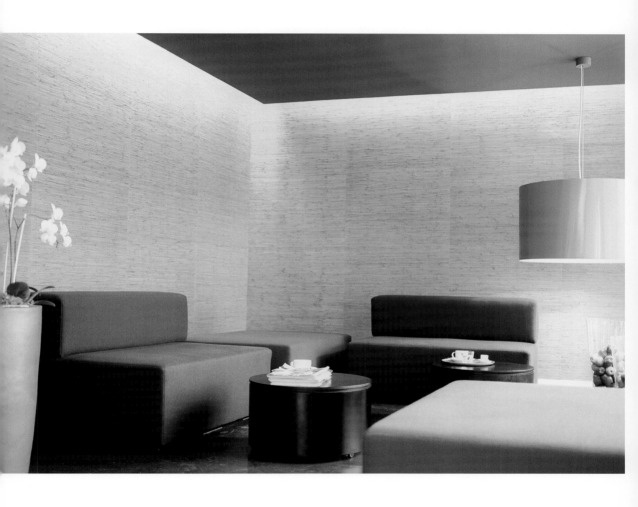

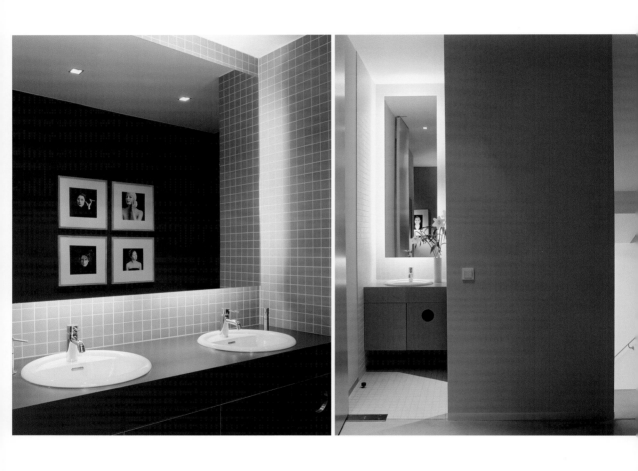

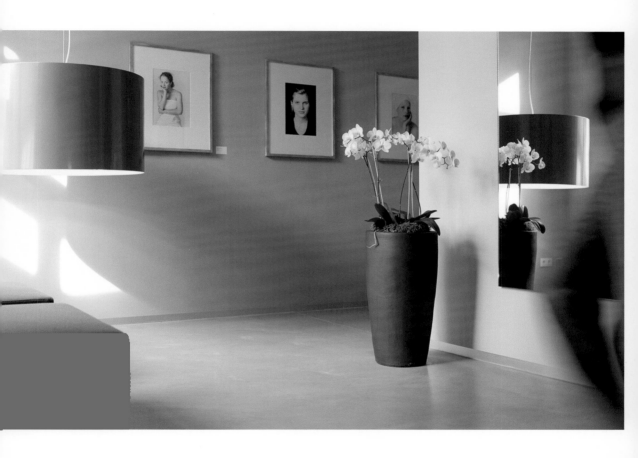

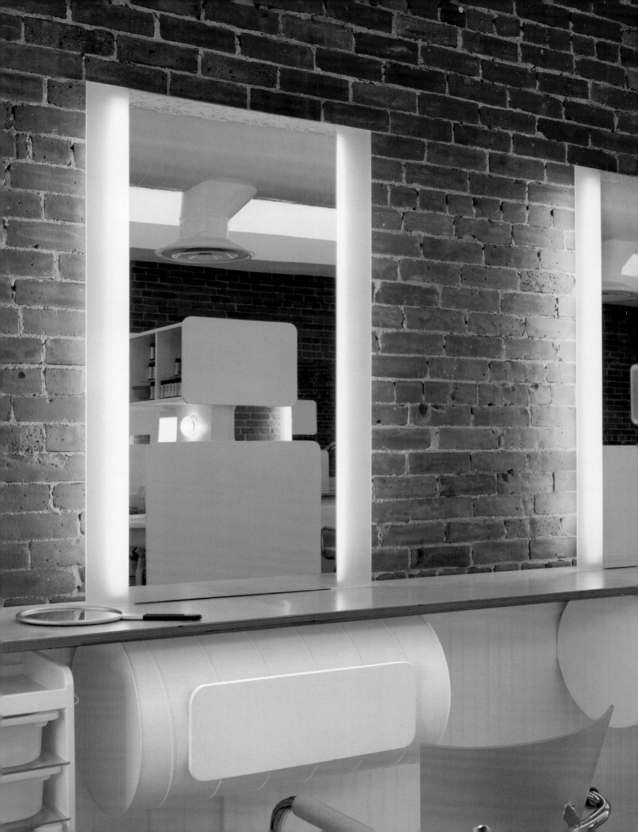

LOUISE BRAVERMAN ARCHITECT | NEW YORK
Joe's Salon + Spa
Connecticut, USA | 2003
Photos: Michael Moran

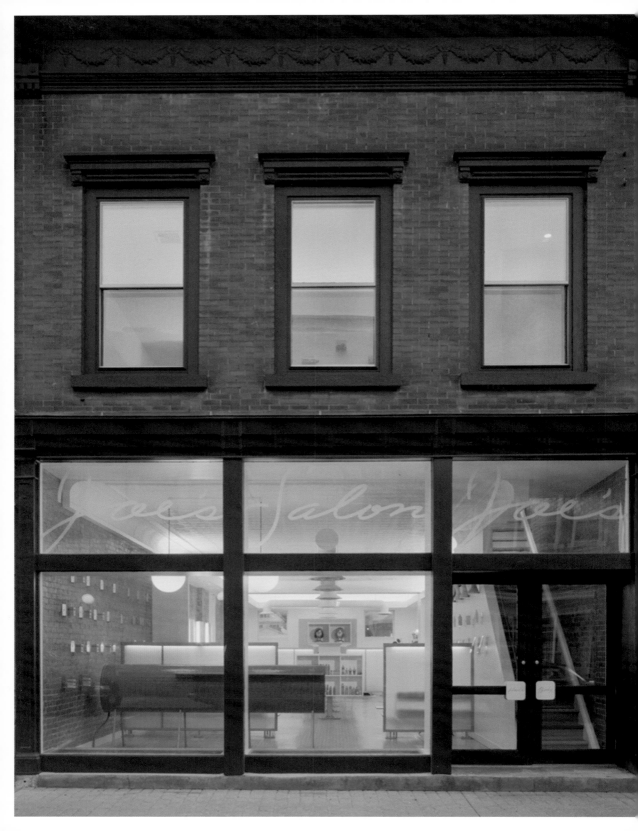

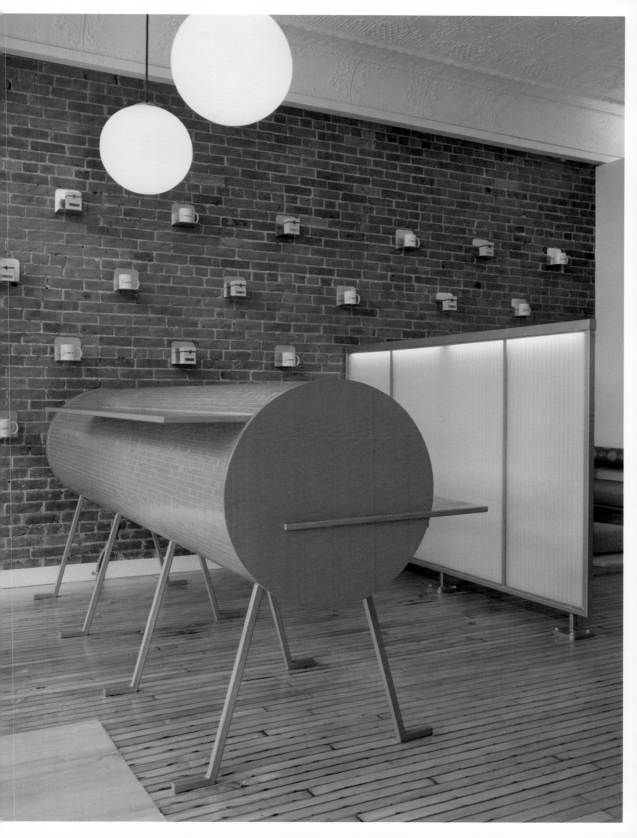

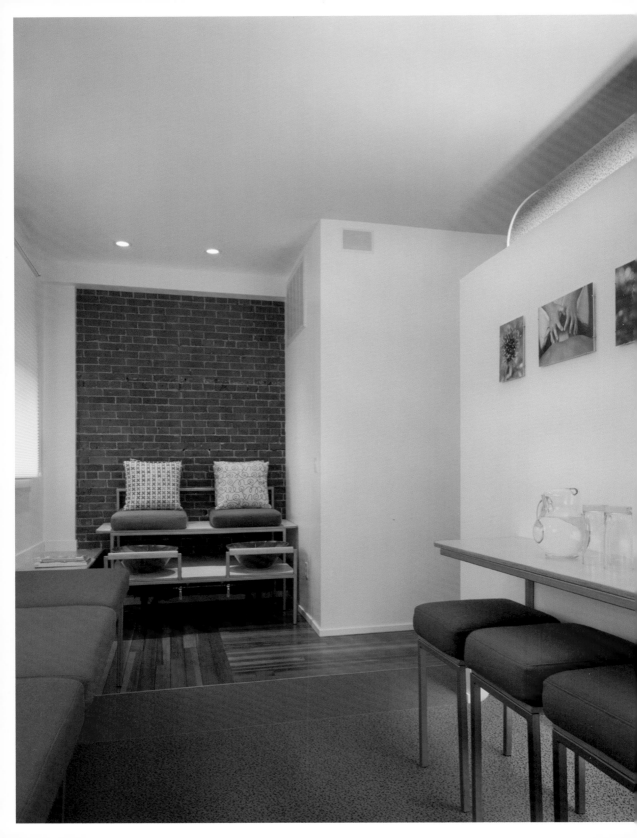

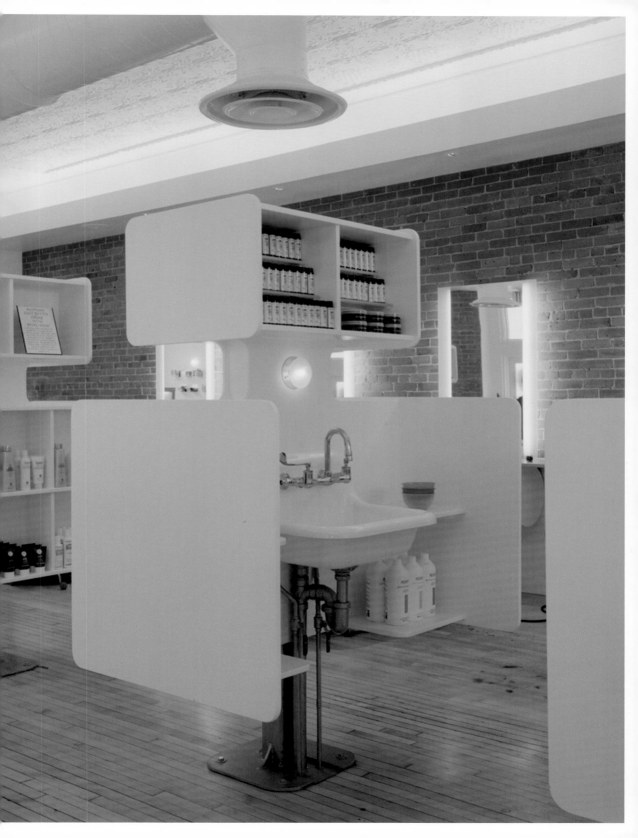

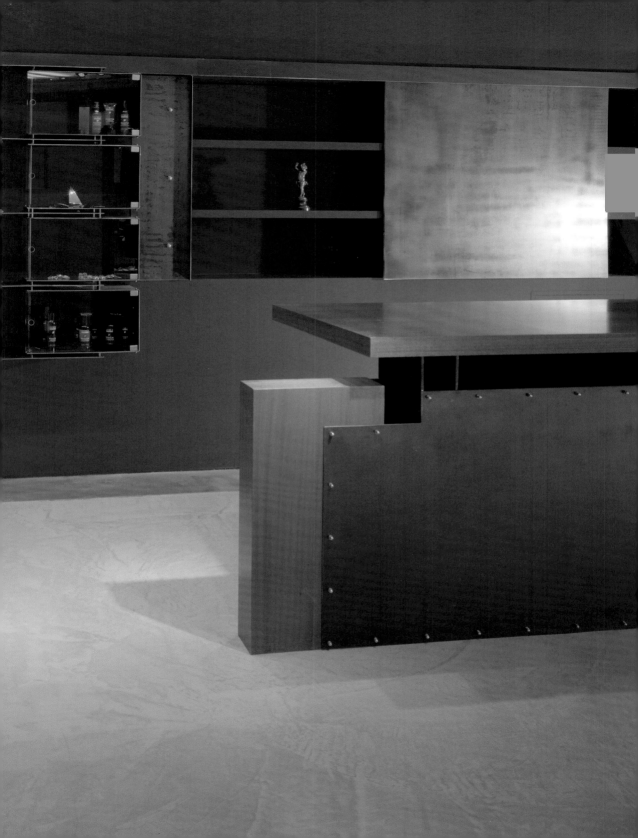

DINSE FEEST ZURL ARCHITEKTEN I HAMBURG
Coiffeur Udo Walz im Kempinski Plaza
Berlin, Germany I 2004
Photos: Klaus Frahm

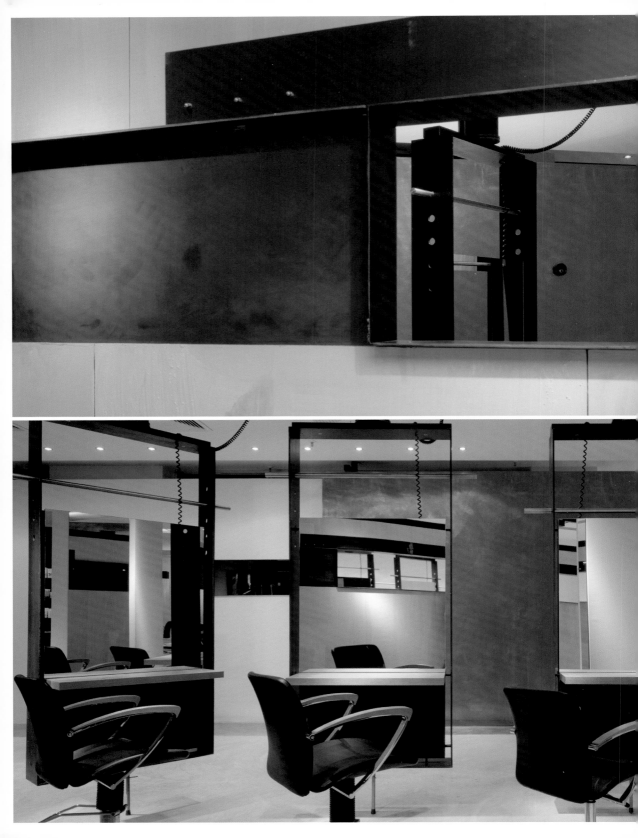

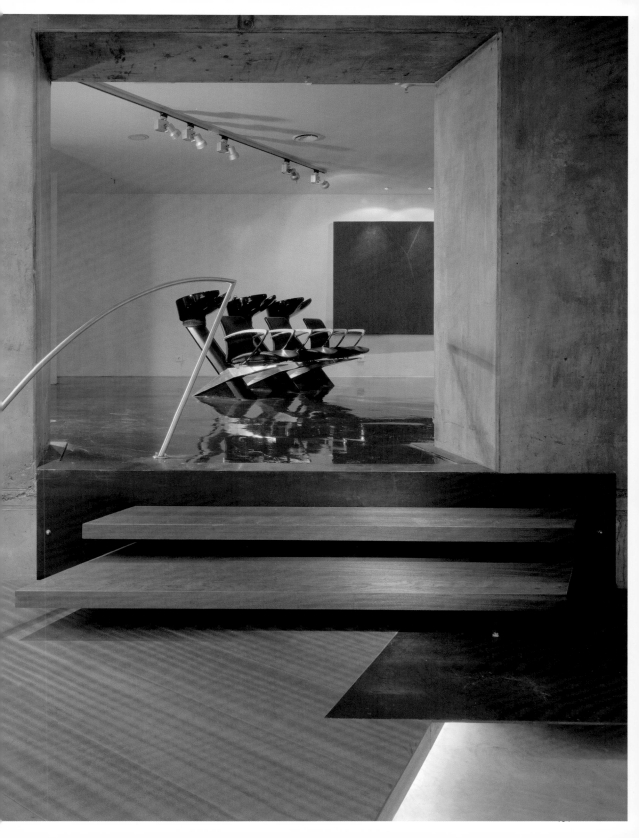

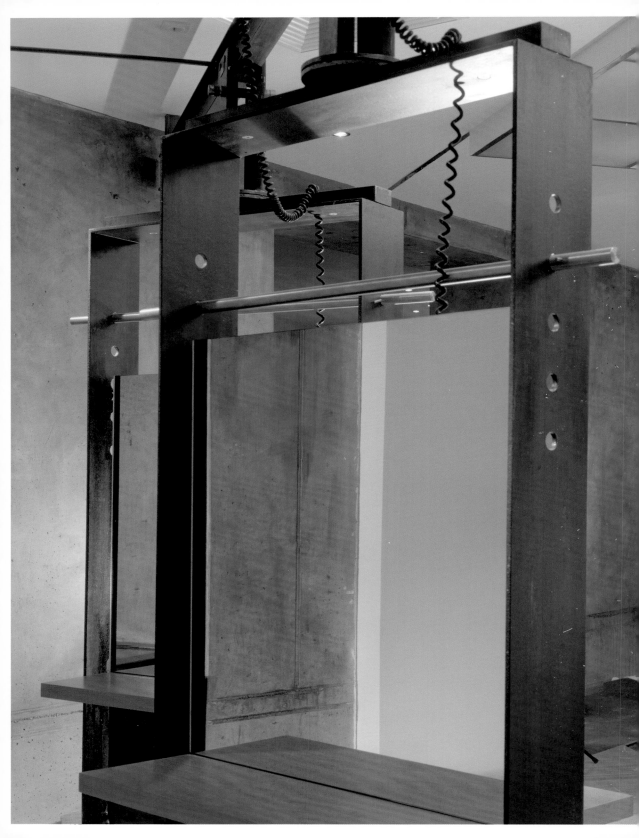

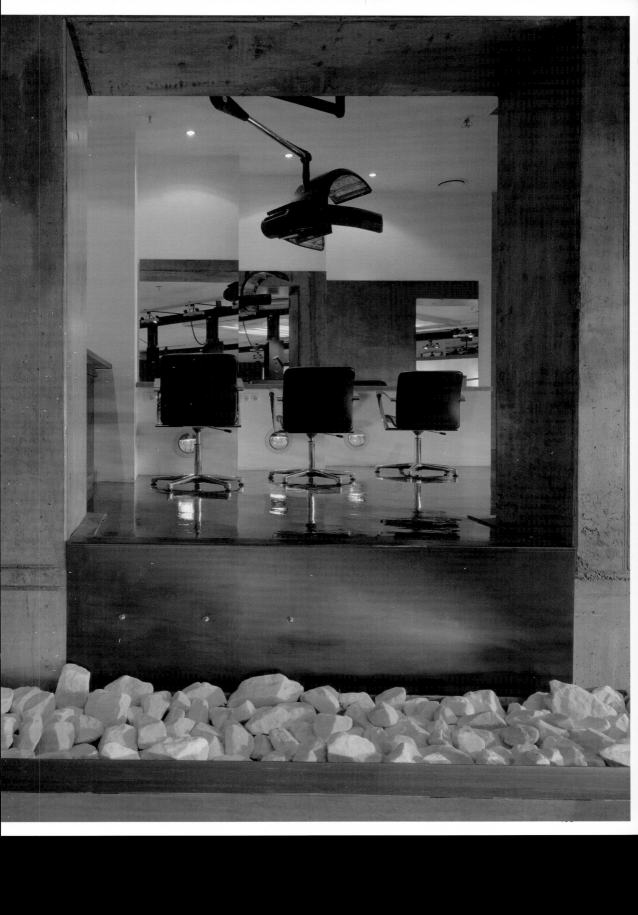

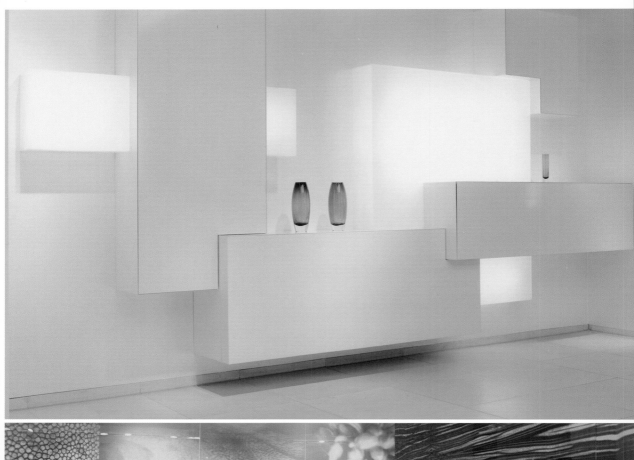

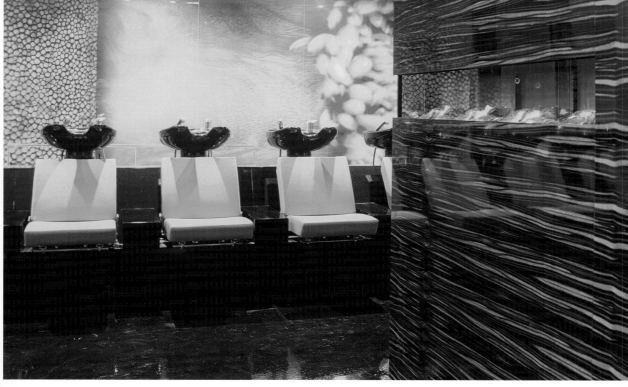

DOLLE + GROSS ARCHITEKTEN WITH JANE AINSCOUGH | HAMBURG
Marlies Möller
Hamburg, Germany | 2002
Photos: Janne Peters

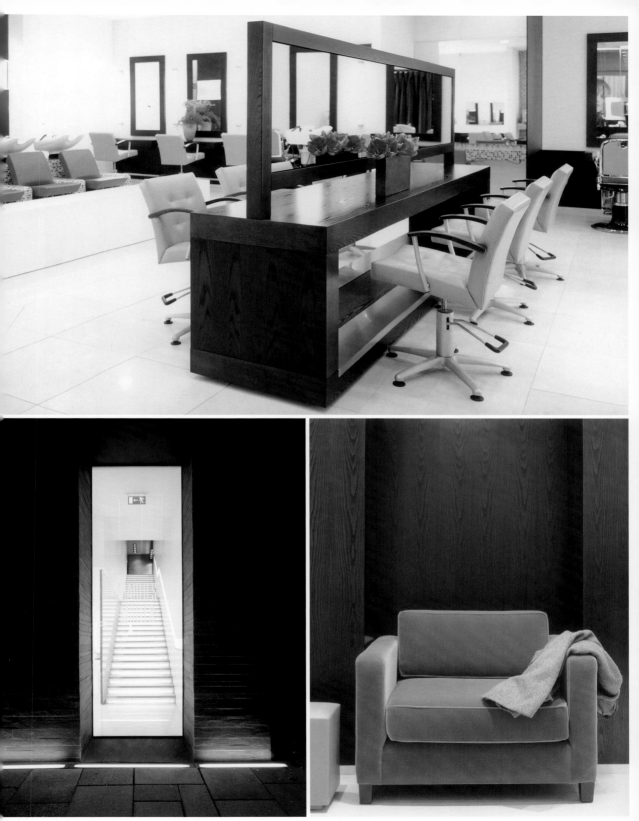

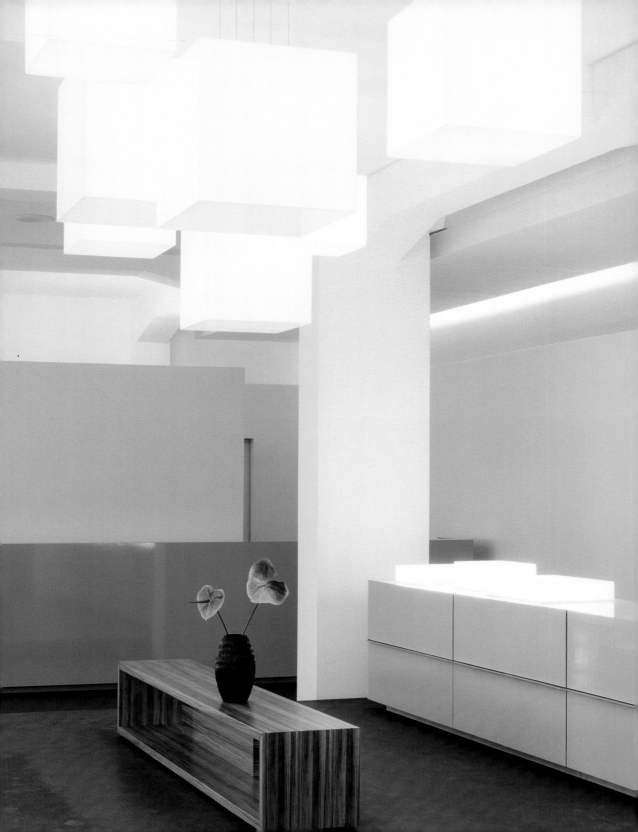

EINS:33 BÜRO MÜLLER BATEK | MUNICH
WITH MORI:PROJECTS CLAUDIA WALD | BÖBLINGEN
Sauter Beautypool
Stuttgart, Germany | 2000
Photos: Fritz Busam, Heiko Simayer, Frank Taormino

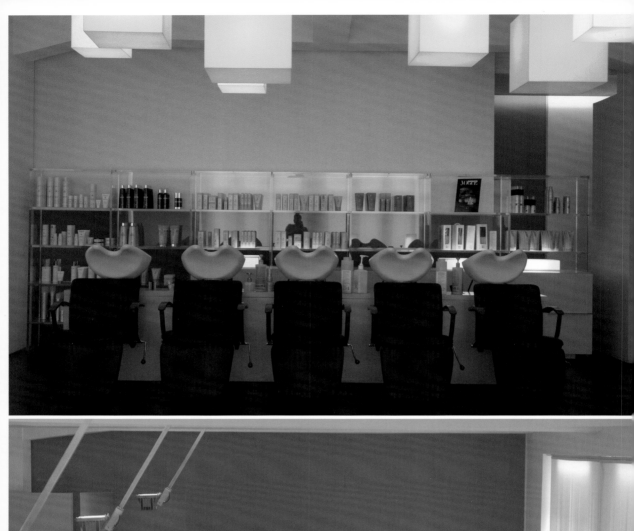

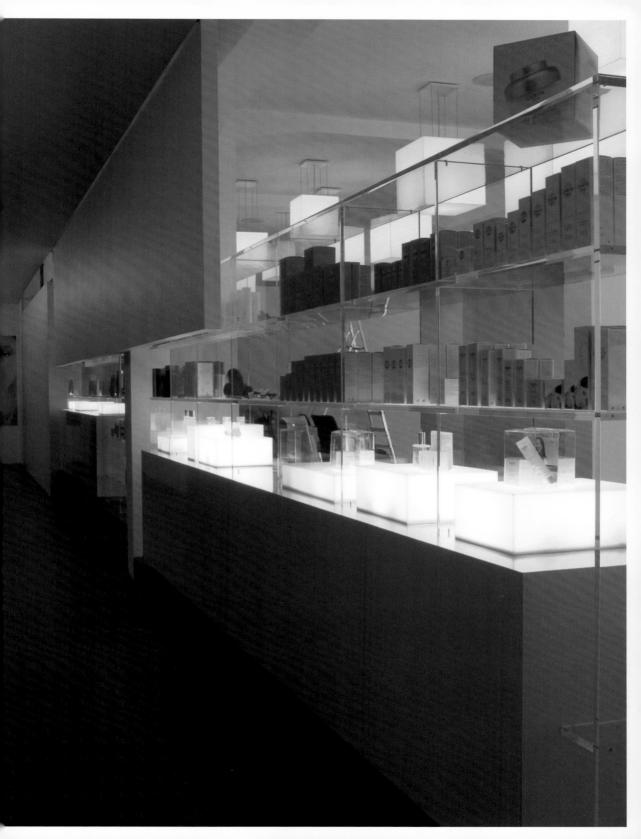

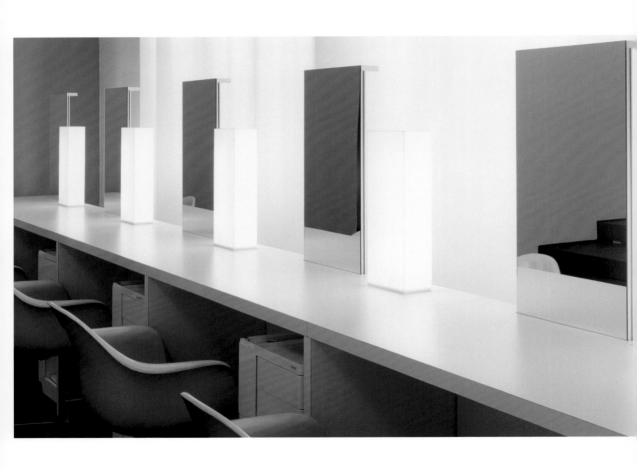

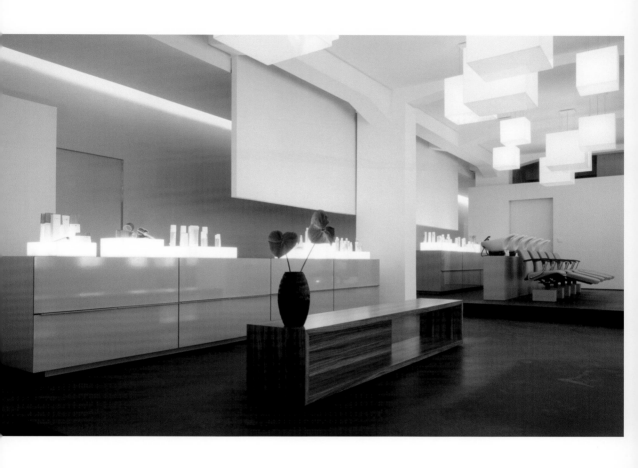

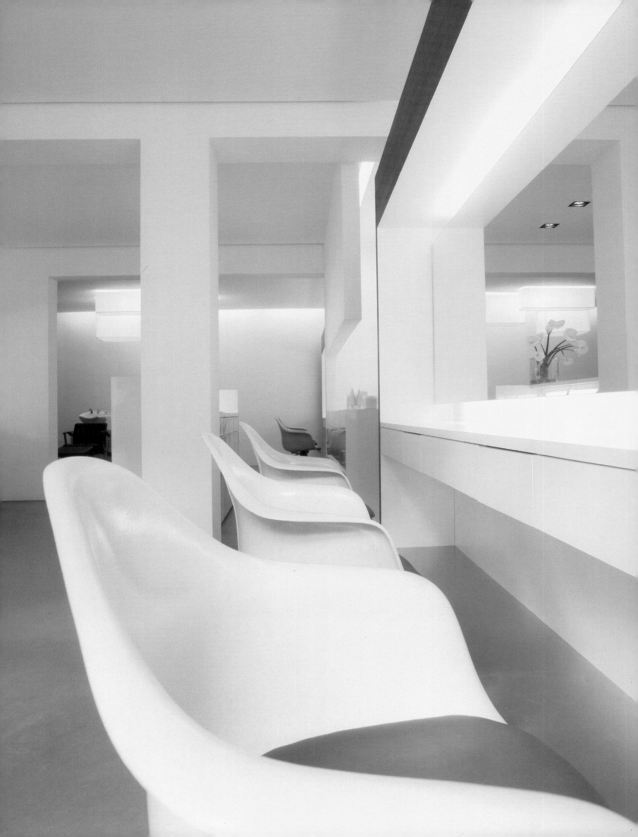

EINS:33 BÜRO MÜLLER BATEK | MUNICH
LA COUPE
Stuttgart, Germany | 2001
Photos: Francis Koenig

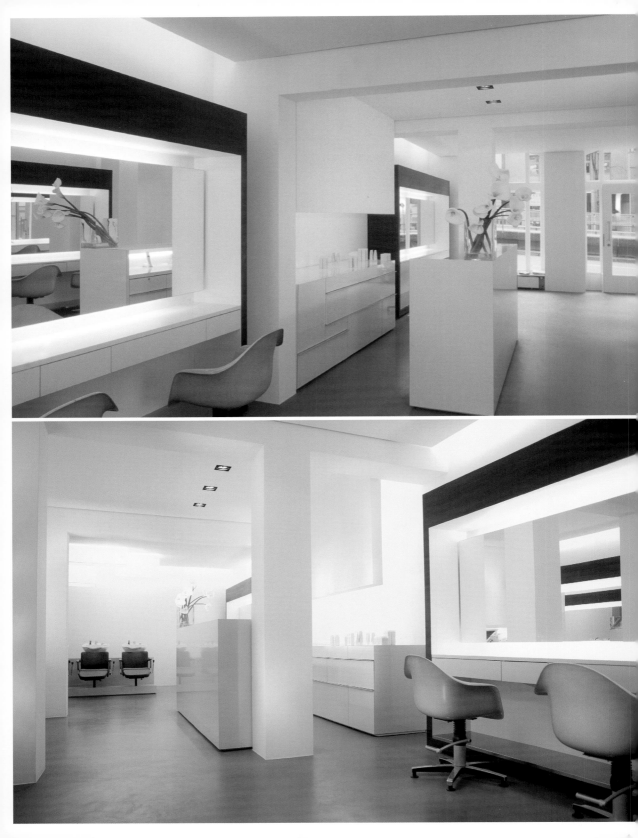

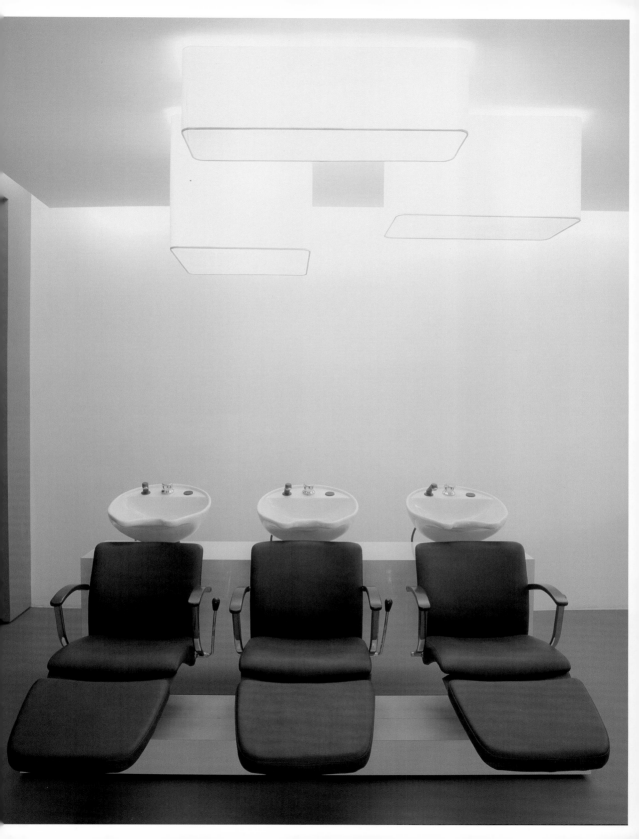

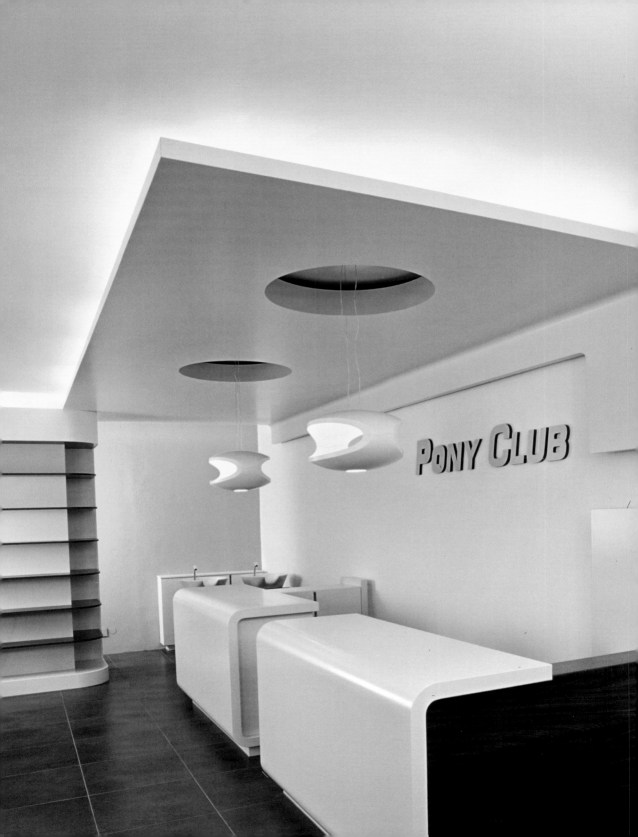

**FORMSTELLE CLAUDIA WIEDEMANN, JÖRG KÜRSCHNER
WITH PHILIPP KRAMPITZ | MUNICH**
Pony Club 1 Hairdressers
Munich, Germany | 2003
Photos: Christoph Gramann

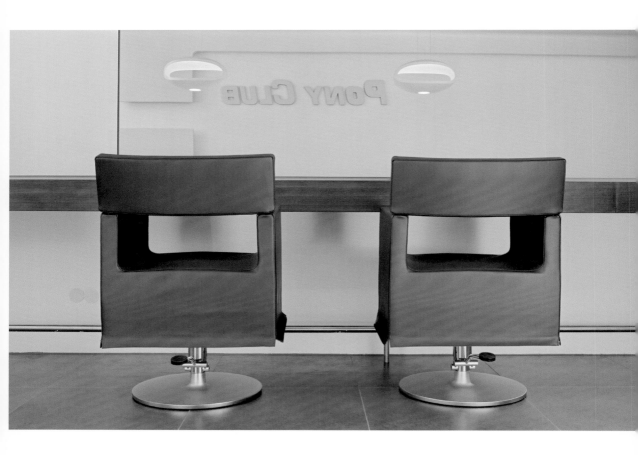

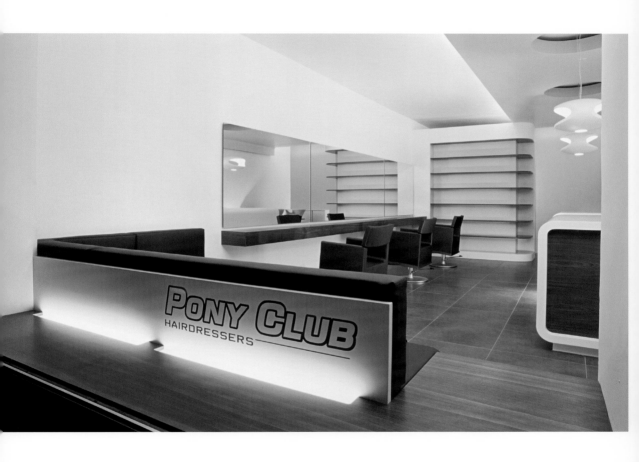

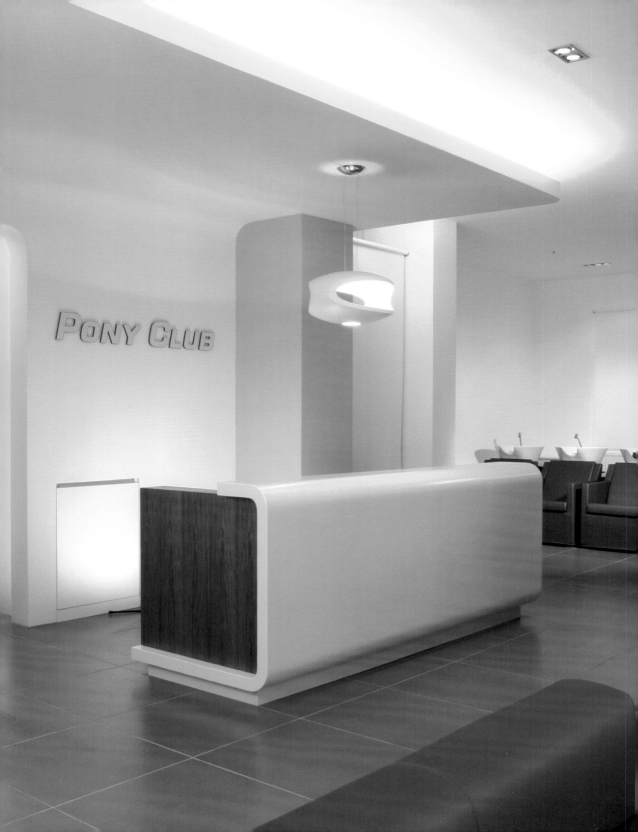

**FORMSTELLE CLAUDIA WIEDEMANN, JÖRG KÜRSCHNER
WITH PHILIPP KRAMPITZ | MUNICH**
Pony Club 2 Hairdressers
Munich, Germany | 2004
Photos: Christoph Gramann

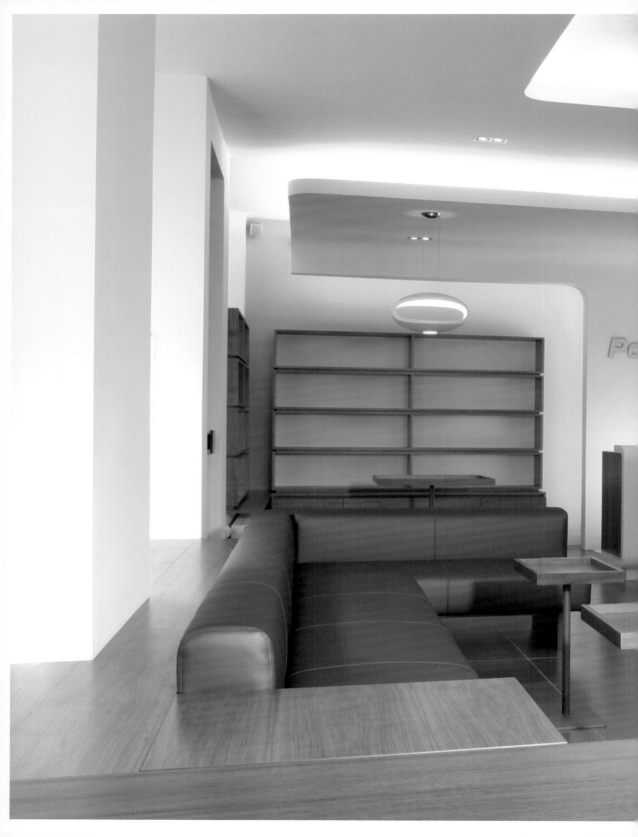

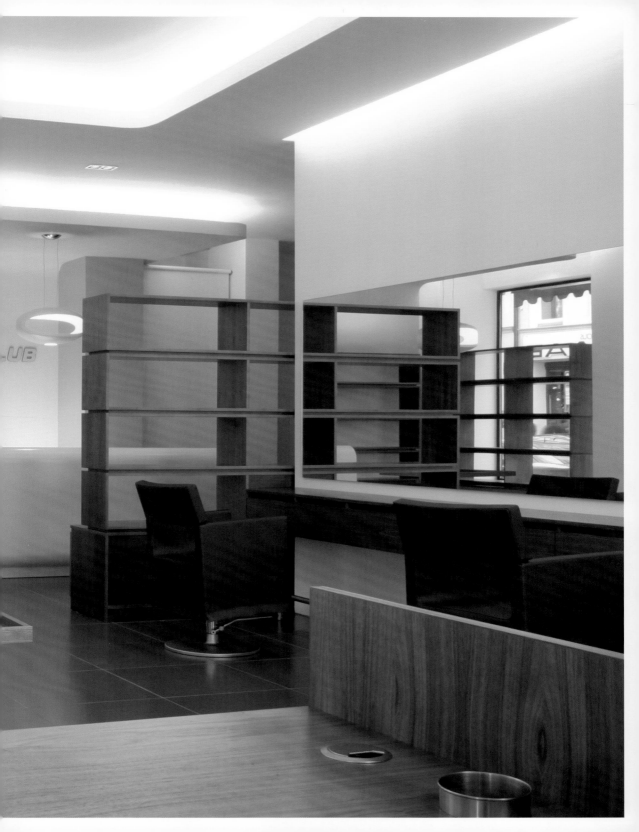

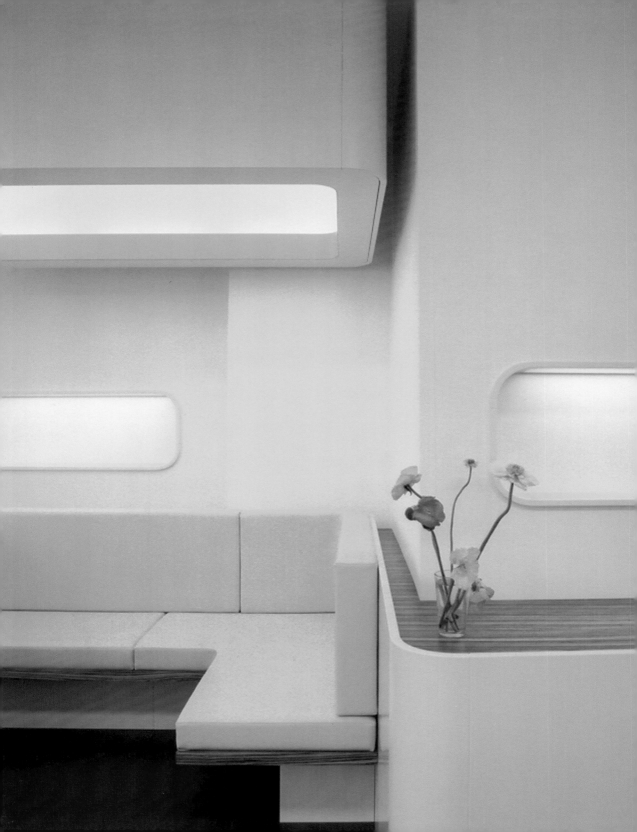

**FORMSTELLE CLAUDIA WIEDEMANN, JÖRG KÜRSCHNER
WITH PHILIPP KRAMPITZ | MUNICH**
Schnittraum
Munich, Germany | 2002
Photos: Christian Haupt

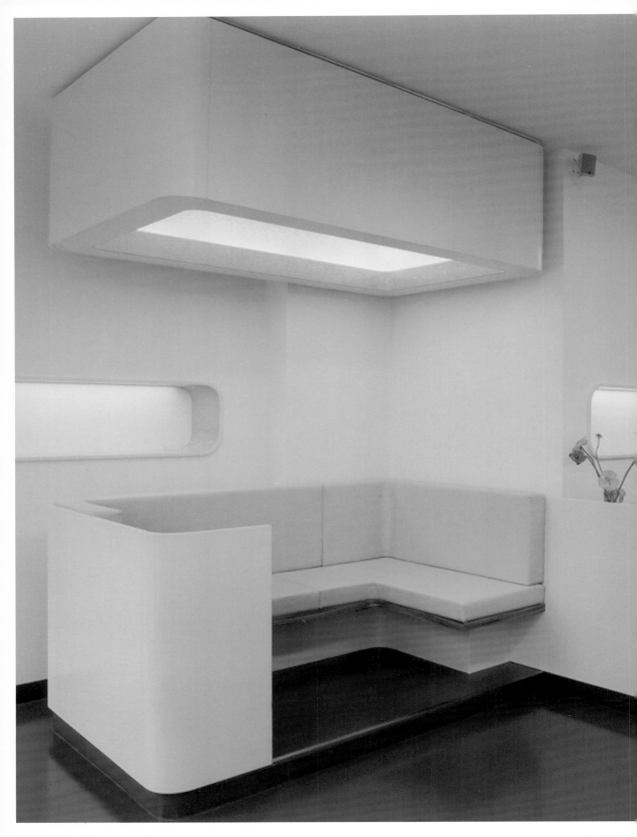

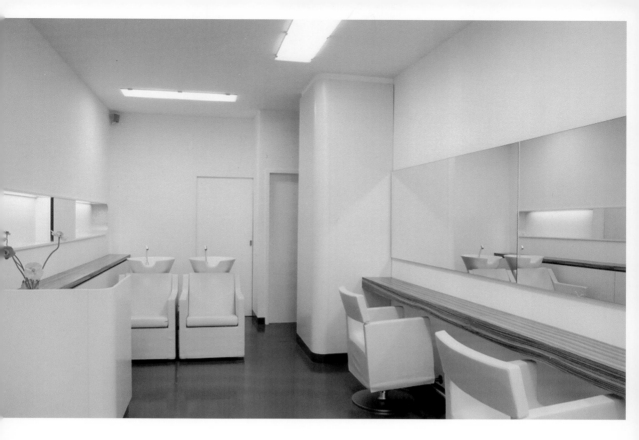

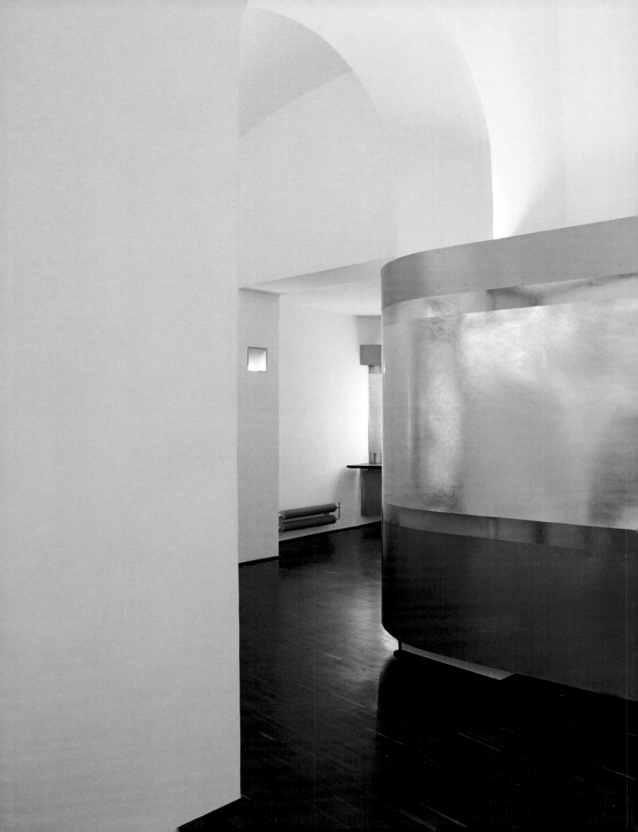

GAUPENRAUB+/– | VIENNA
Friseursalon Markus Herold
Vienna, Austria | 2000
Photos: Patricia Weisskirchner

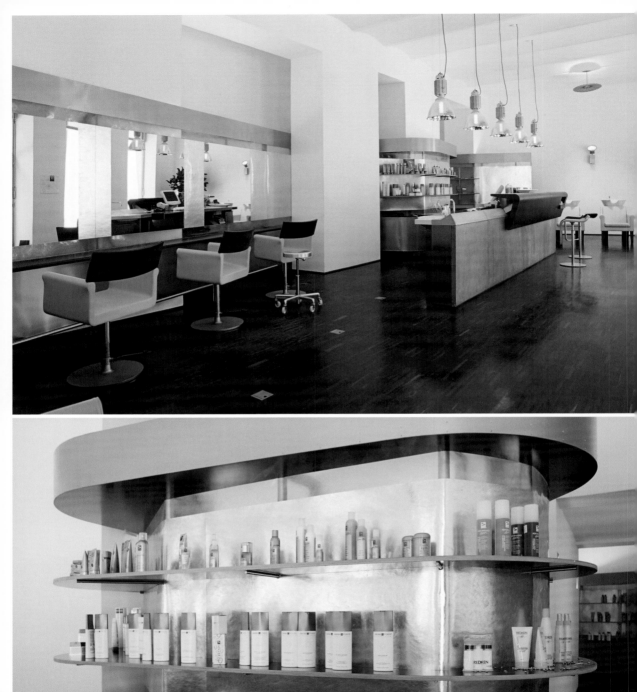

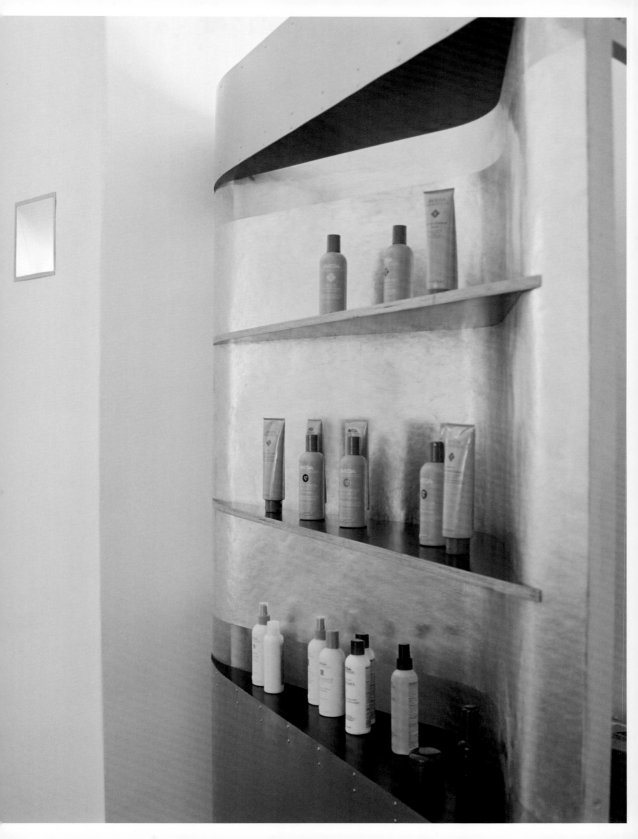

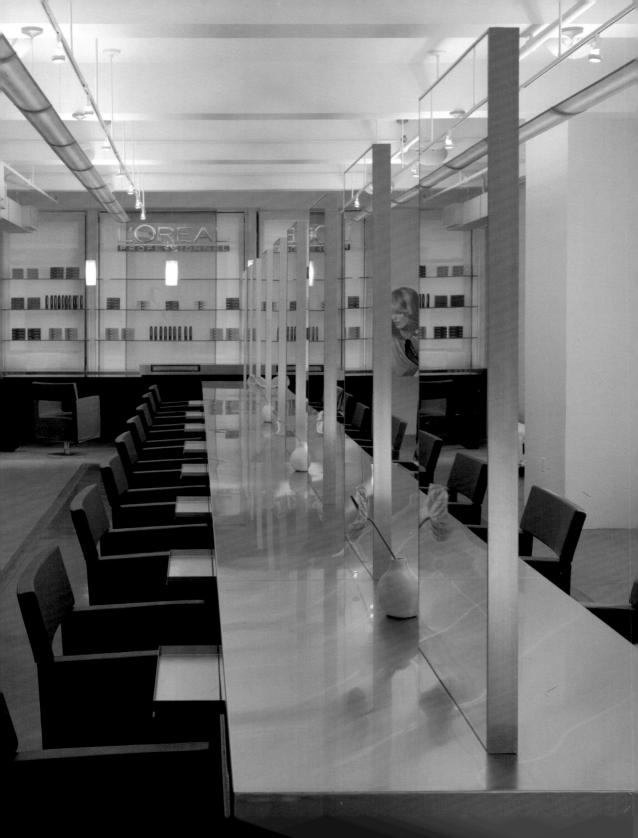

ROBERT D. HENRY ARCHITECTS | NEW YORK
Butterfly Studio
New York, USA | 2004
Photos: Paul Warchol, Robert D. Henry

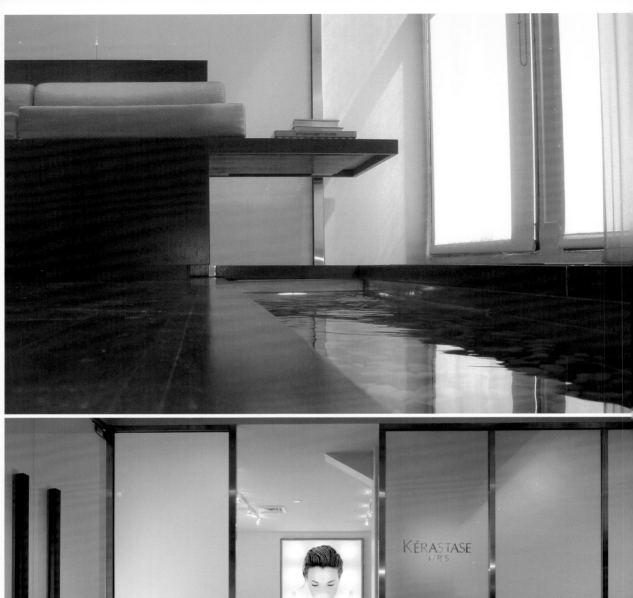
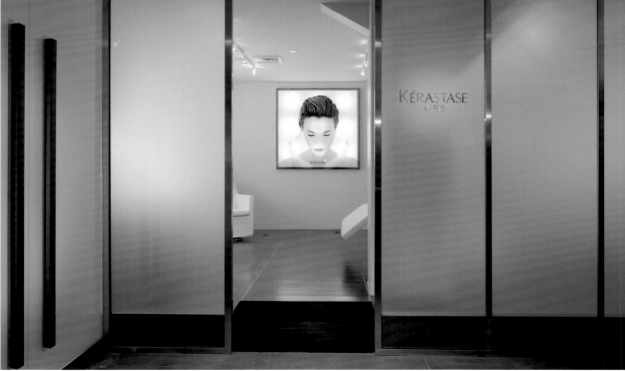

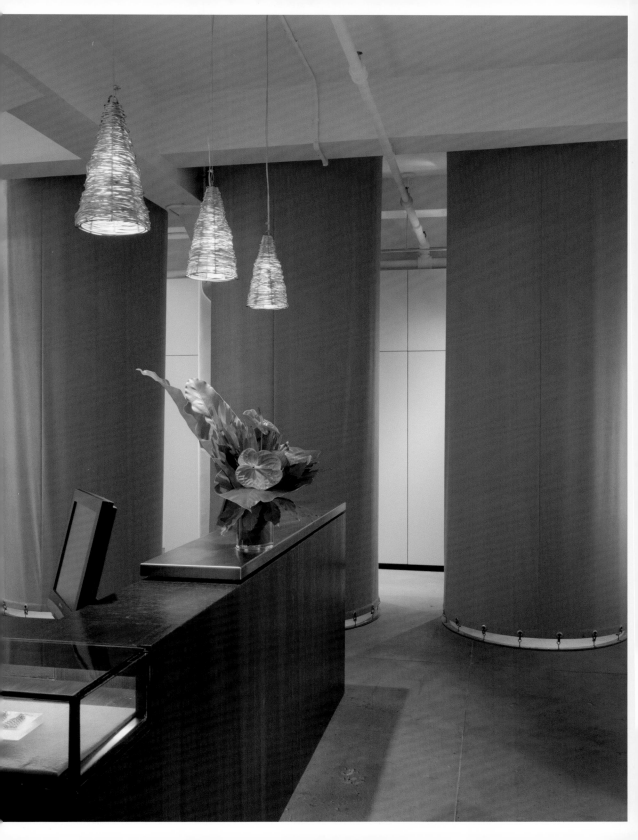

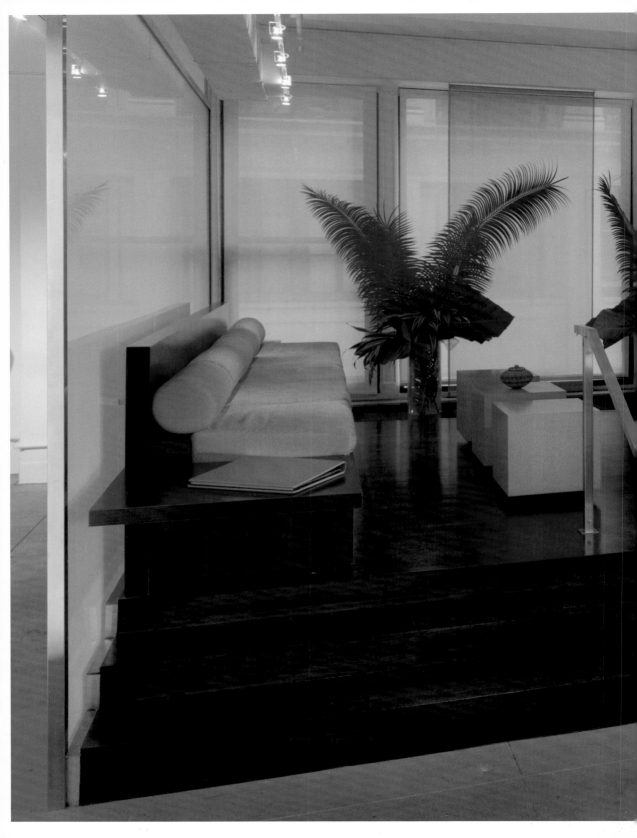

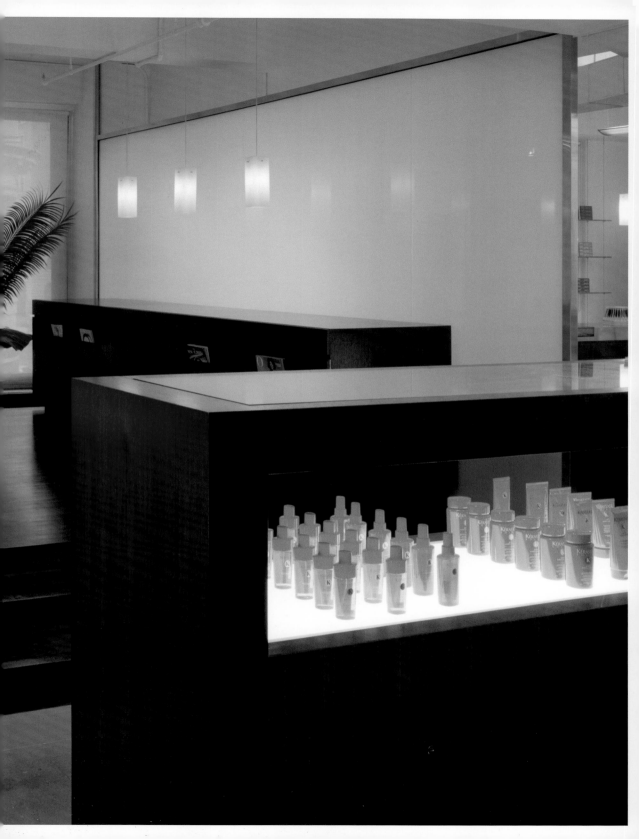

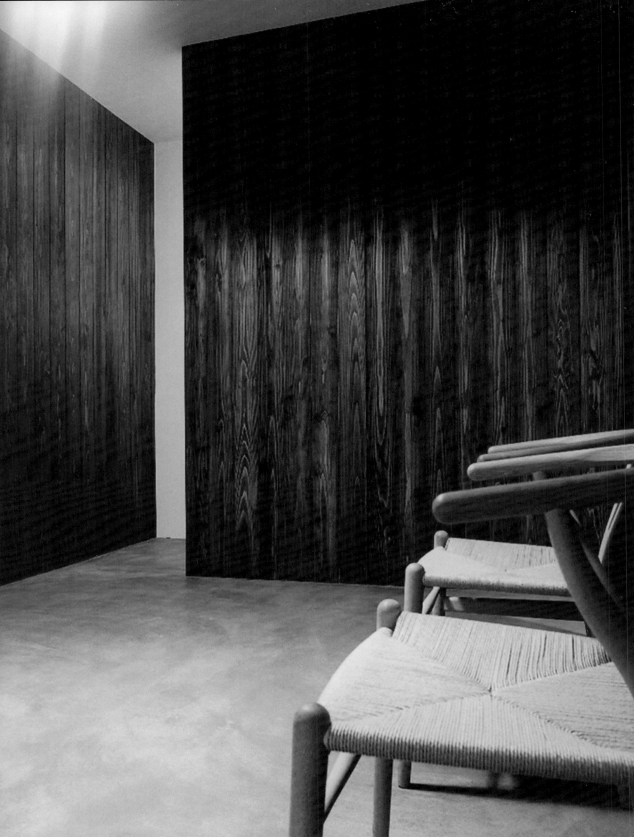

TERUHIRO YANAGIHARA/ISOLATION UNIT I OSAKA
Higurashi
Kagawa, Japan I 2004
Photos: Kei Nakajima

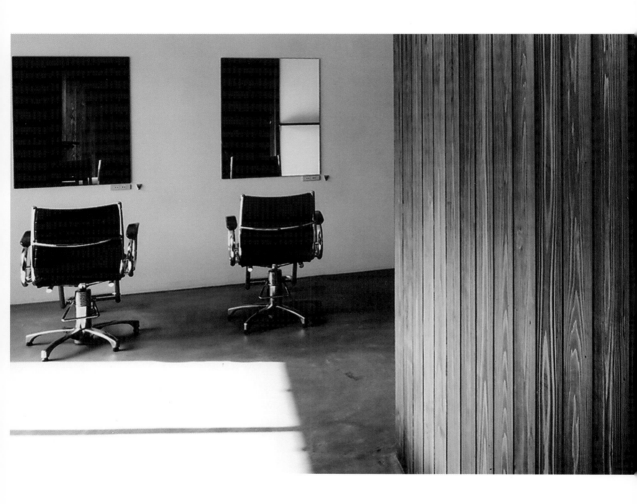

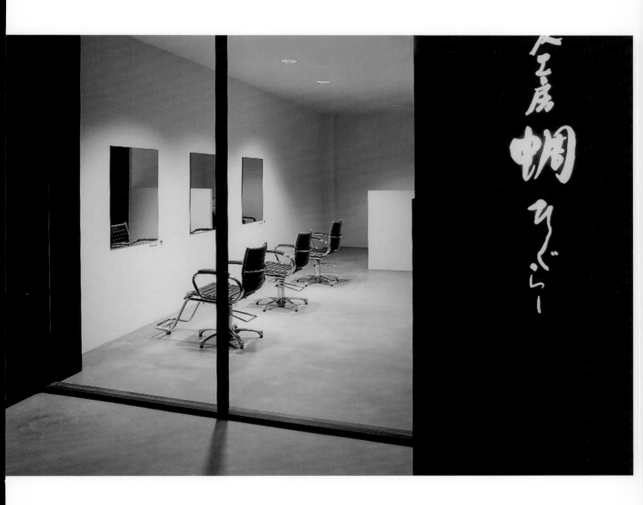

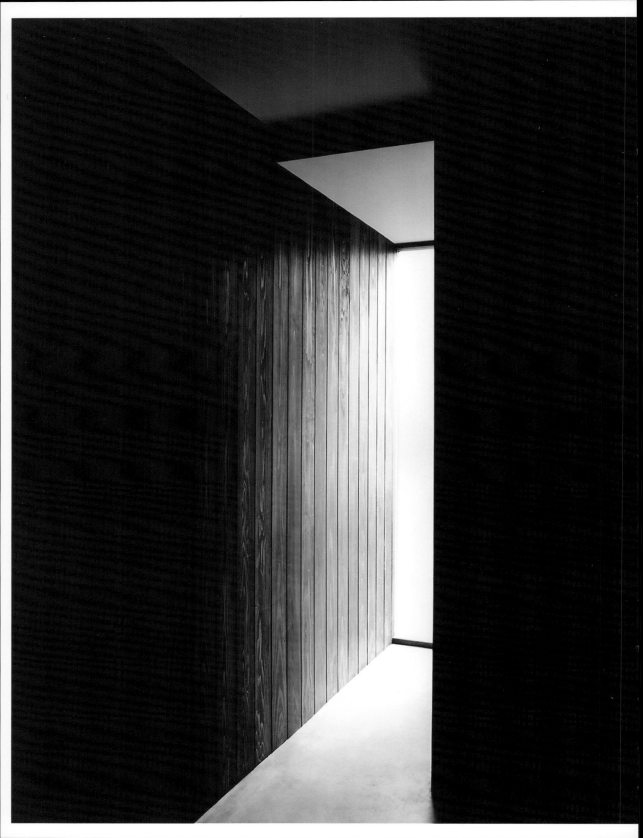

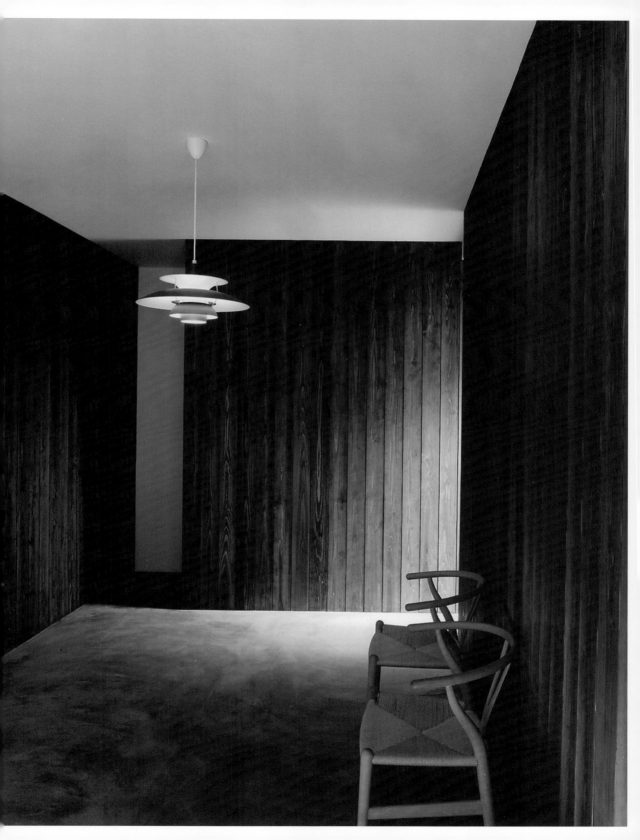

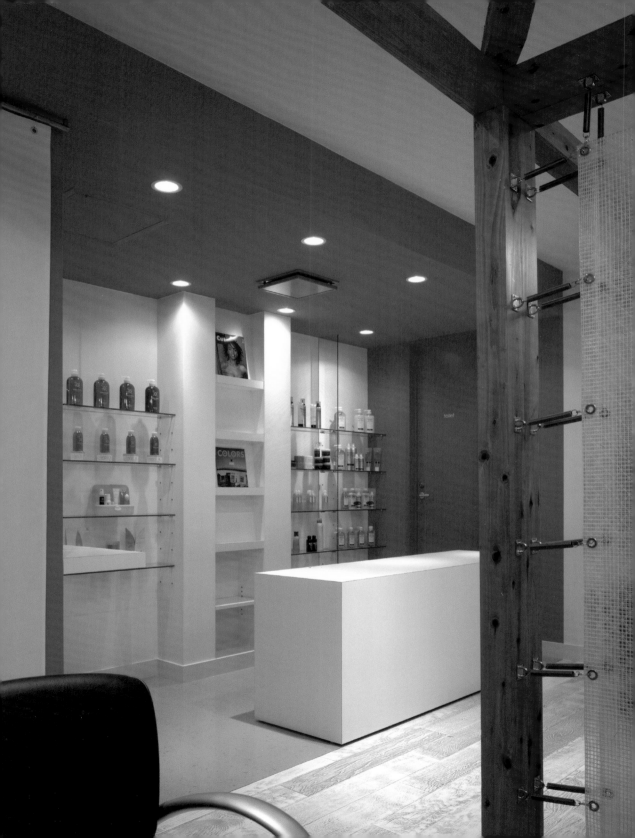

AKEMI KATSUNO, TAKASHI YAGI – LOVE THE LIFE | TOKYO
Aquira Hair Designs
Kanagawa, Japan | 1999
Photos: Shinichi Sato

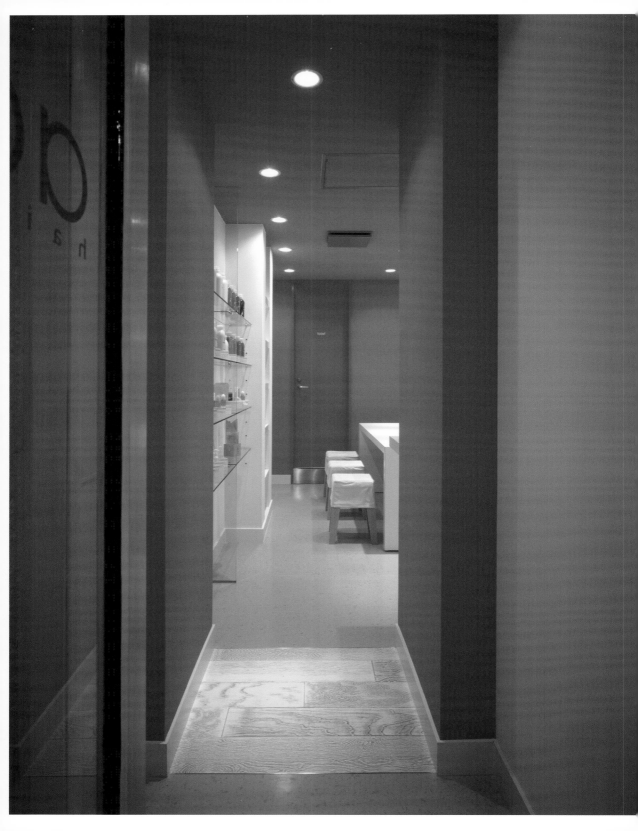

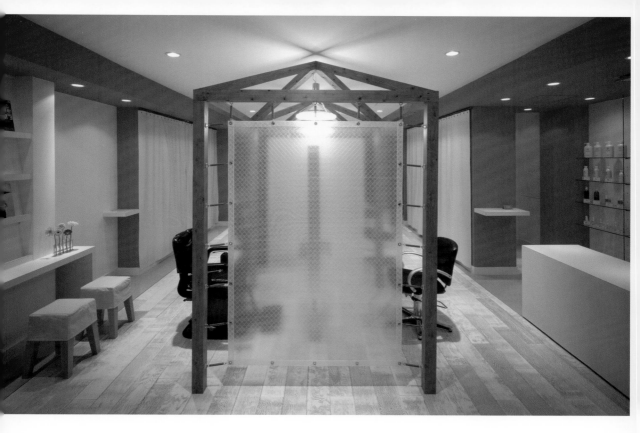

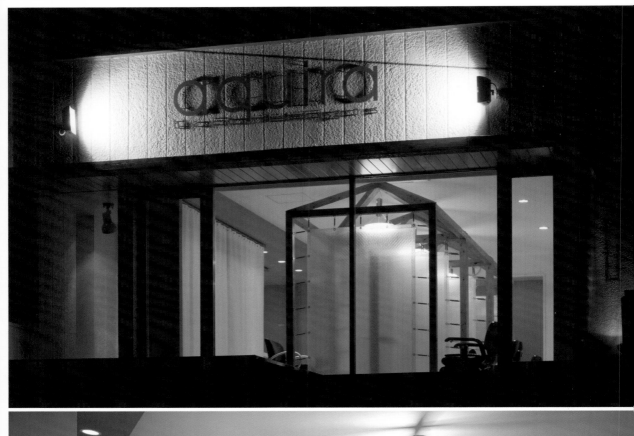
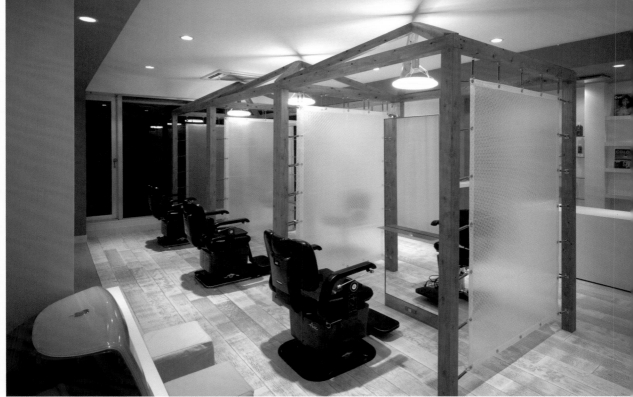

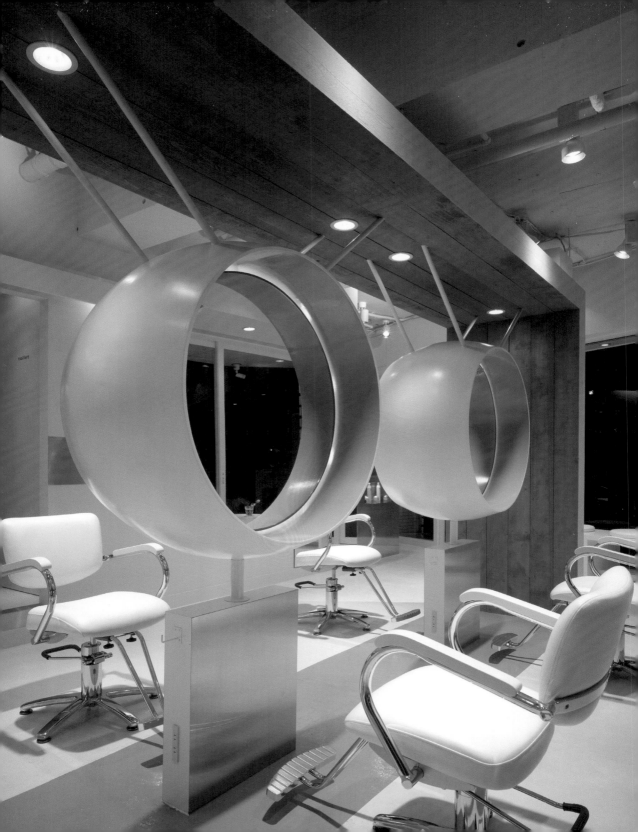

AKEMI KATSUNO, TAKASHI YAGI – LOVE THE LIFE | TOKYO
Fit Hair Design Studio
Kanagawa, Japan | 2003
Photos: Shinichi Sato

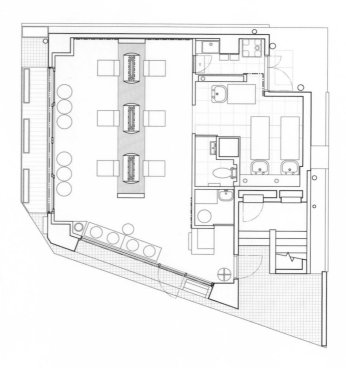

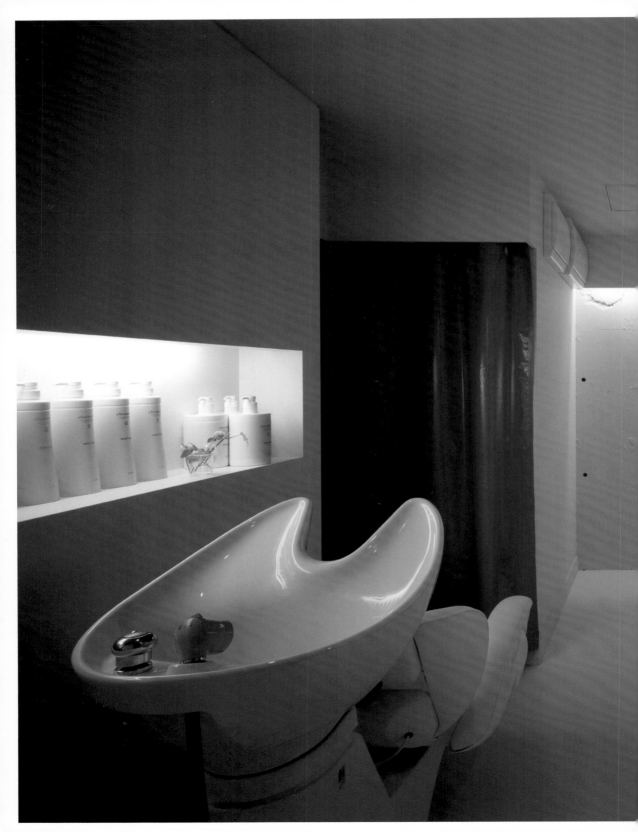

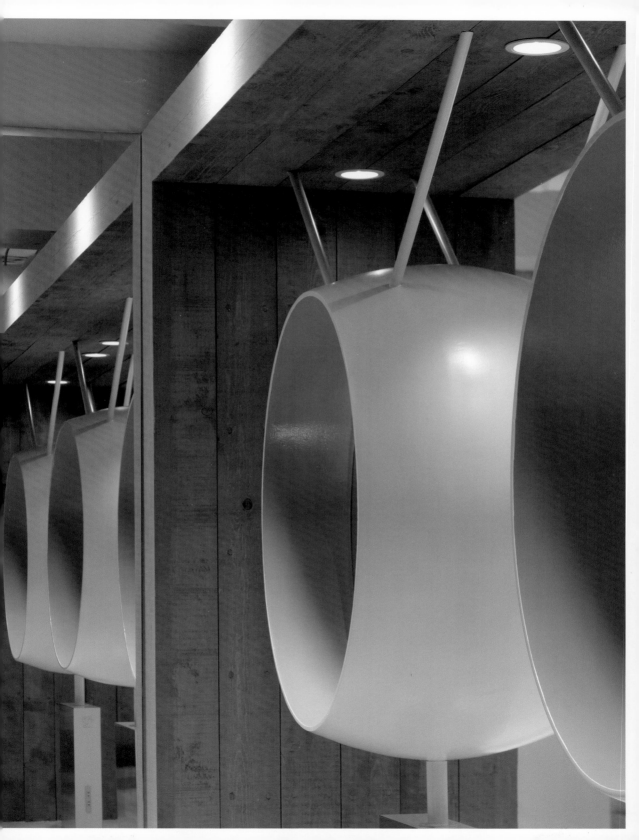

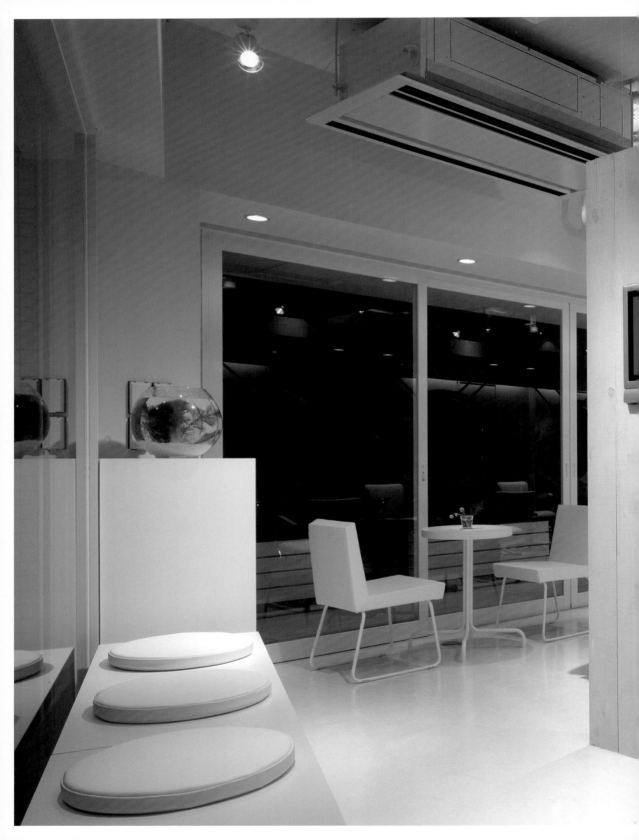

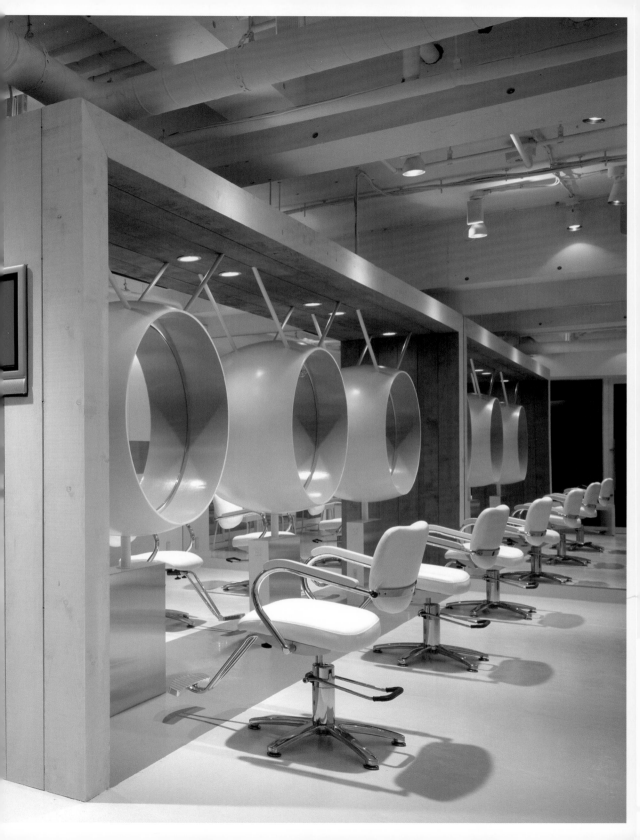

DIANA MILLER WITH USCHI KOENIG | MUNICH
Noemi & Friends
Munich, Germany | 2004
Photos: Tom Roch, Sandra Seckinger

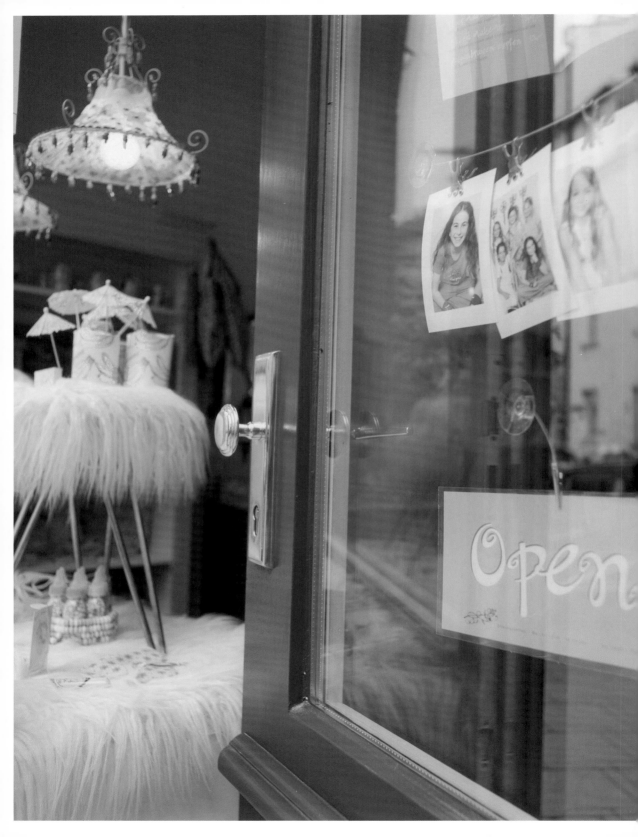

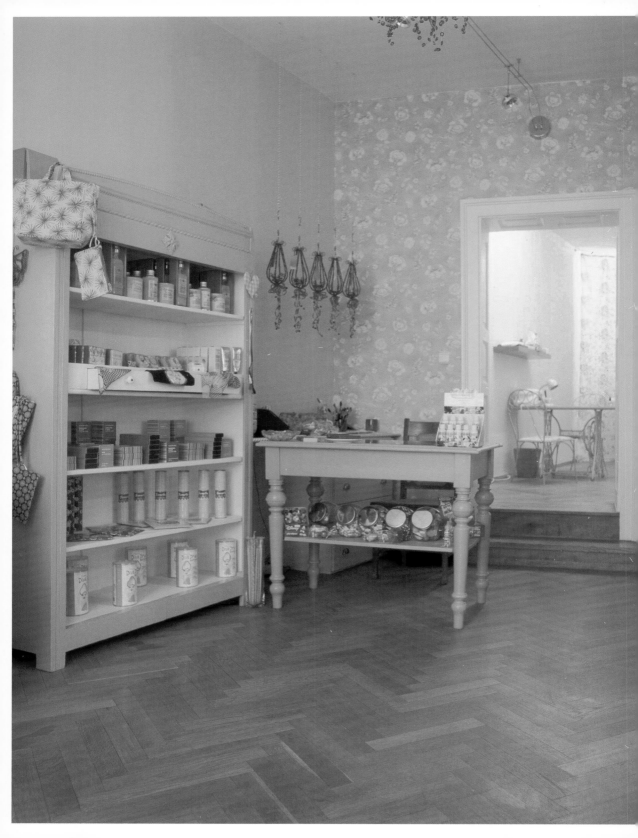

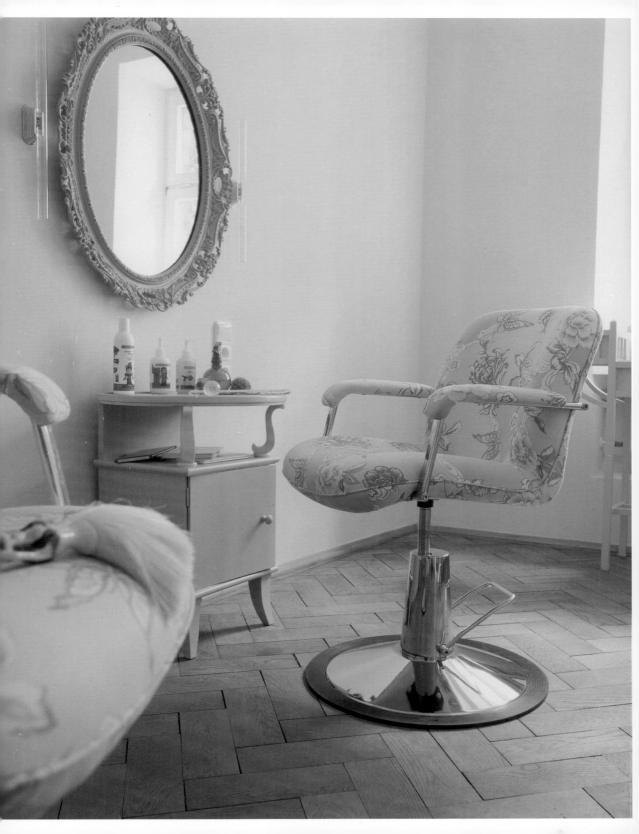

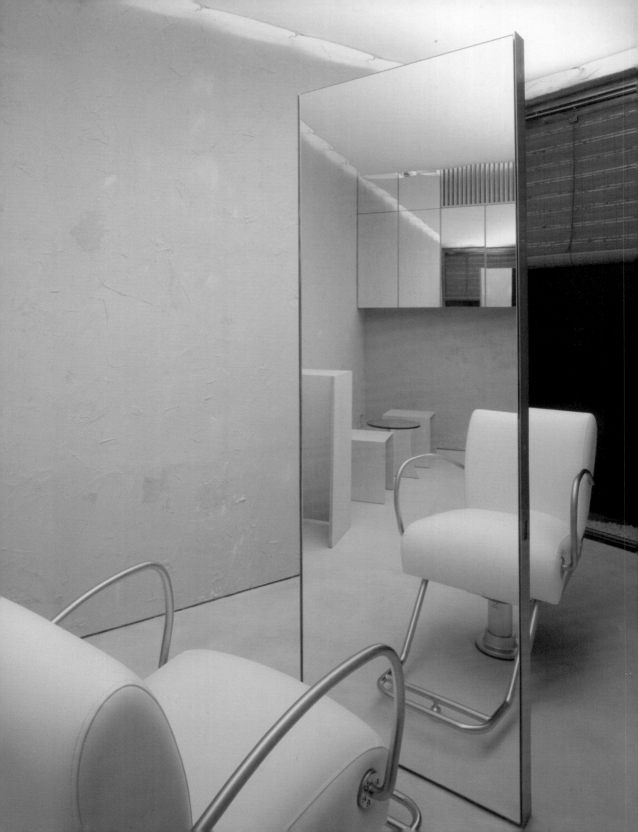

MUSEGRAM & ASSOCIATION INC. | TOKYO
Hair We-3
Kanagawa-ken, Japan | 2003
Photos: Kozo Takayama

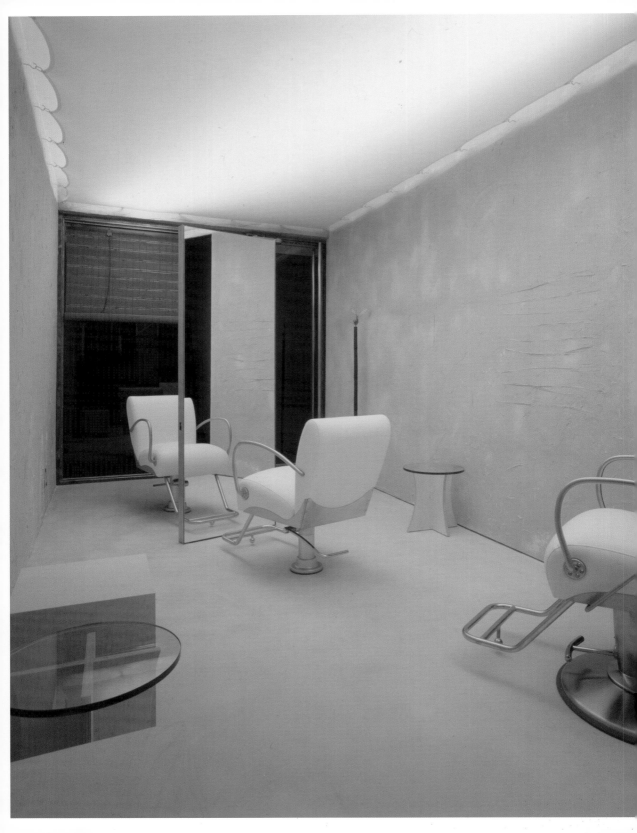

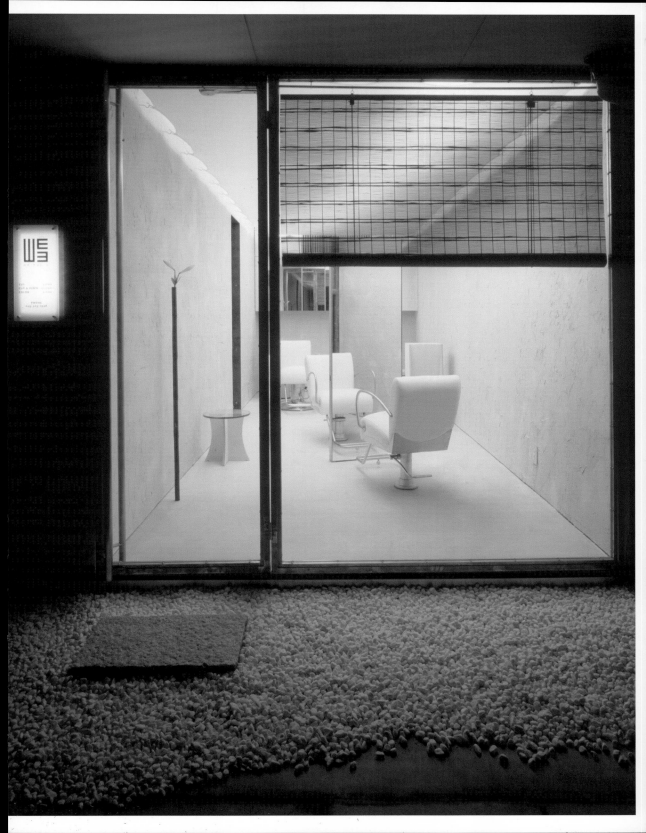

WOLFGANG NEUGEBAUER | HAMBURG
4u Haare Cosmetic Styling
Hamburg, Germany | 2004
Photos: Peter Rüssmann

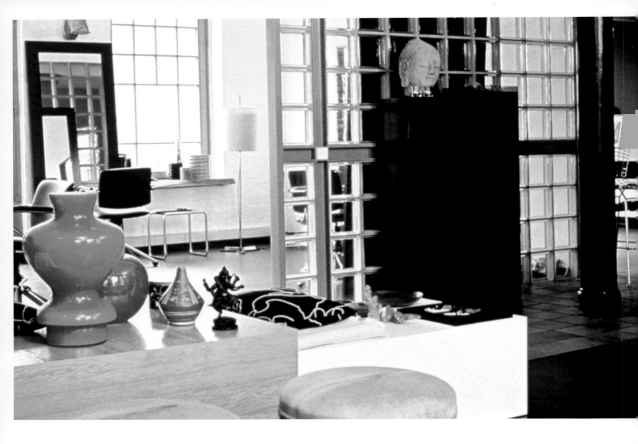

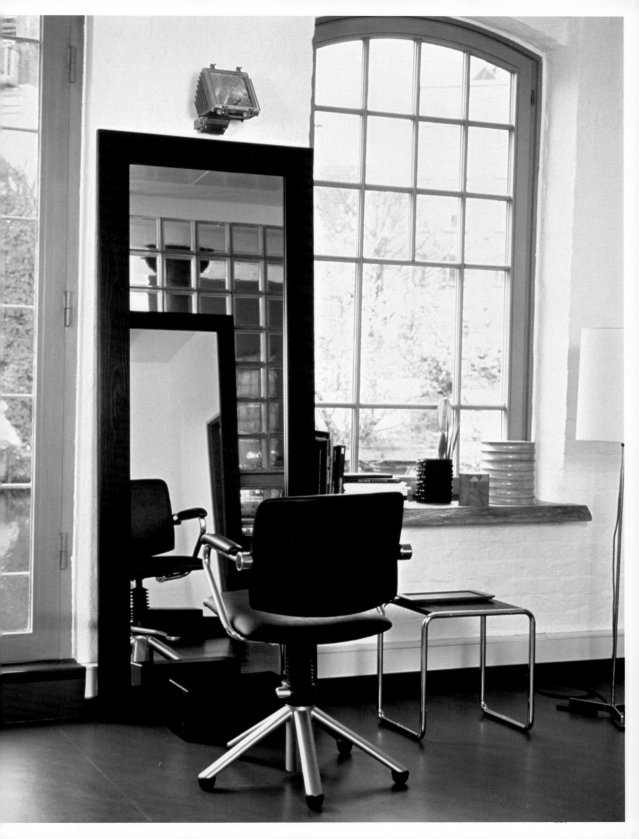

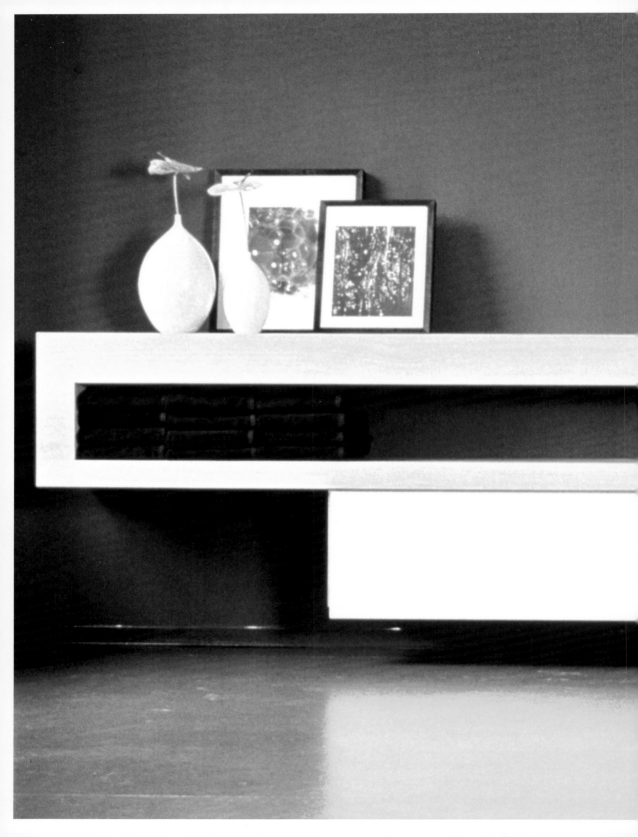

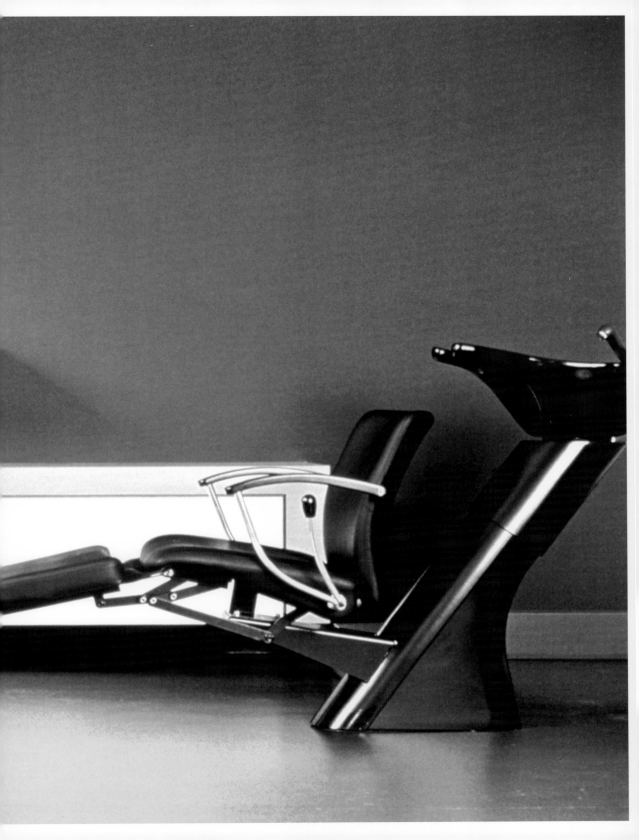

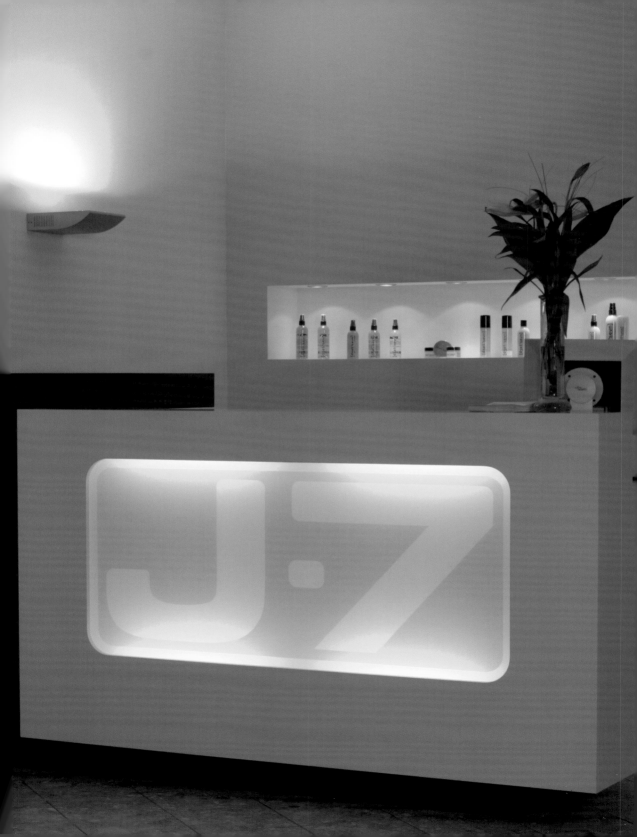

OLYMP WITH AXEL KUPPLER | STUTTGART
J-7 hair lounge
Stuttgart, Germany | 2005
Photos: Vlado Golub

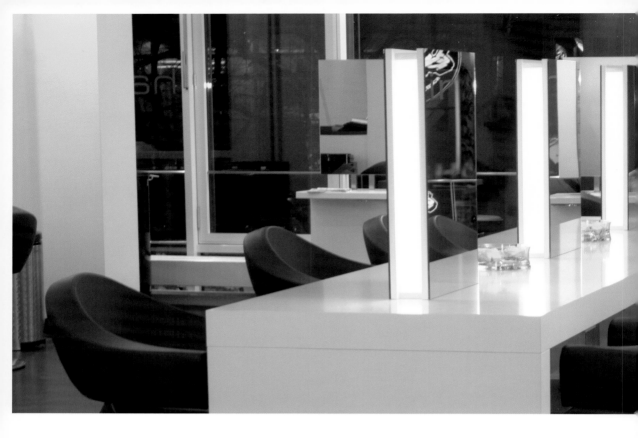

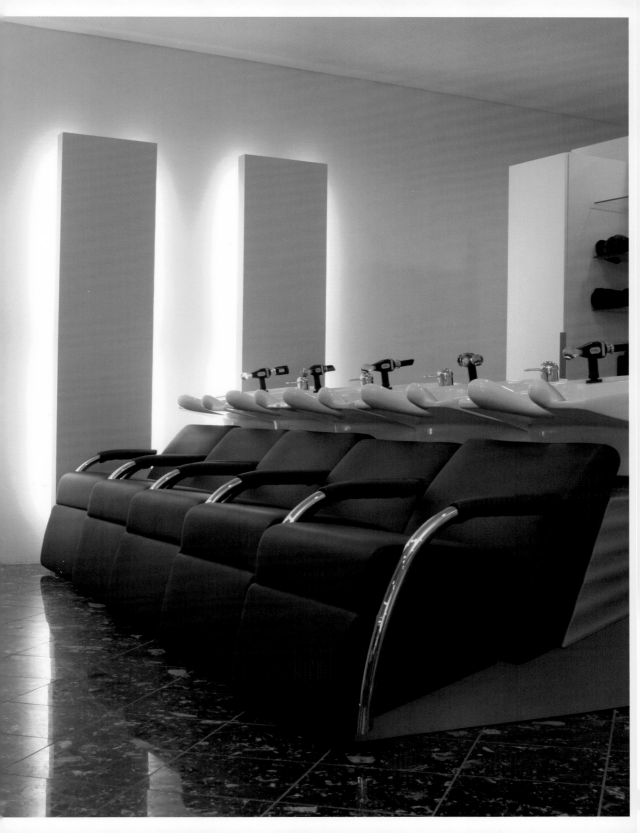

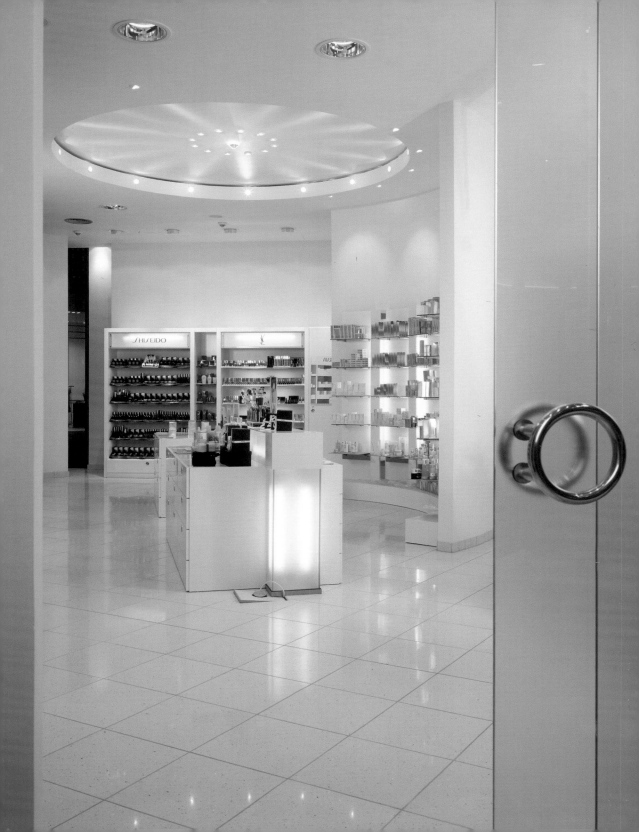

OLYMP | STUTTGART
Roman Kroupa Hairsalon
Bremen, Germany | 2003
Photos: Matthias Maas

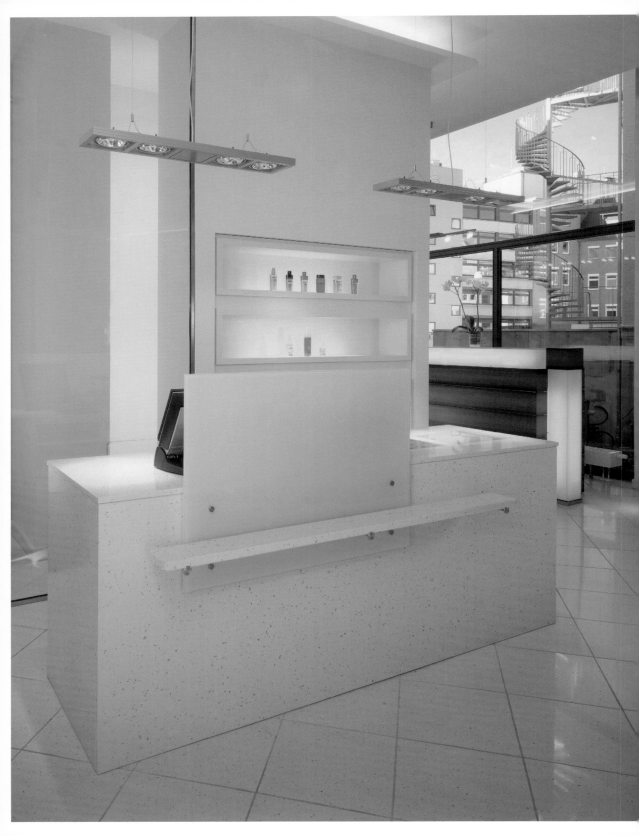

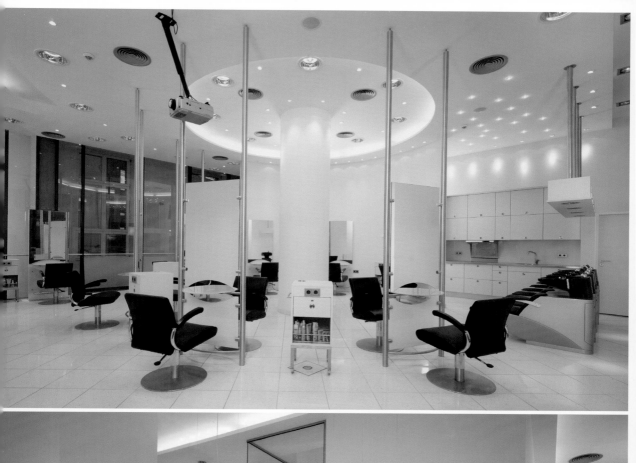
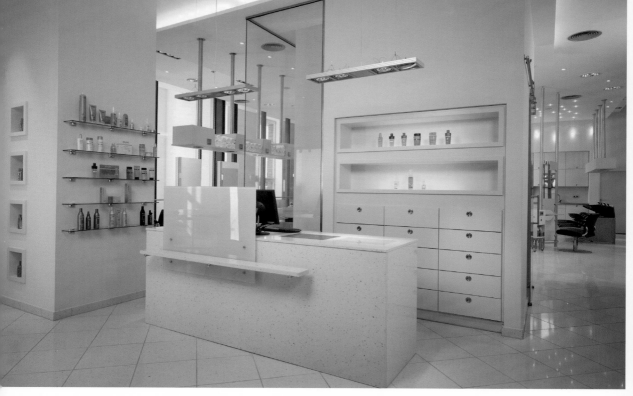

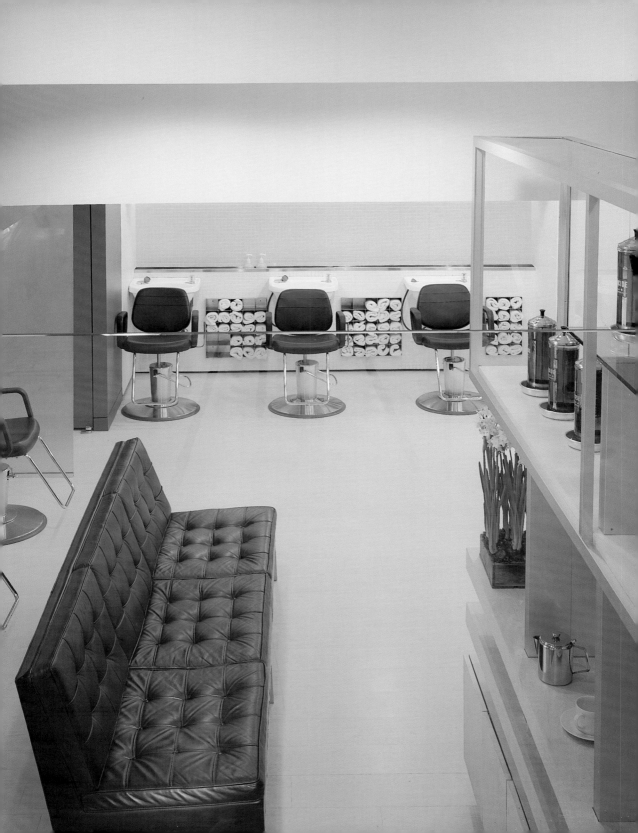

MESSANA O'RORKE ARCHITECTS | NEW YORK
Arrojo Cutler Salon
New York, USA | 1998
Photos: Elizabeth Felicella

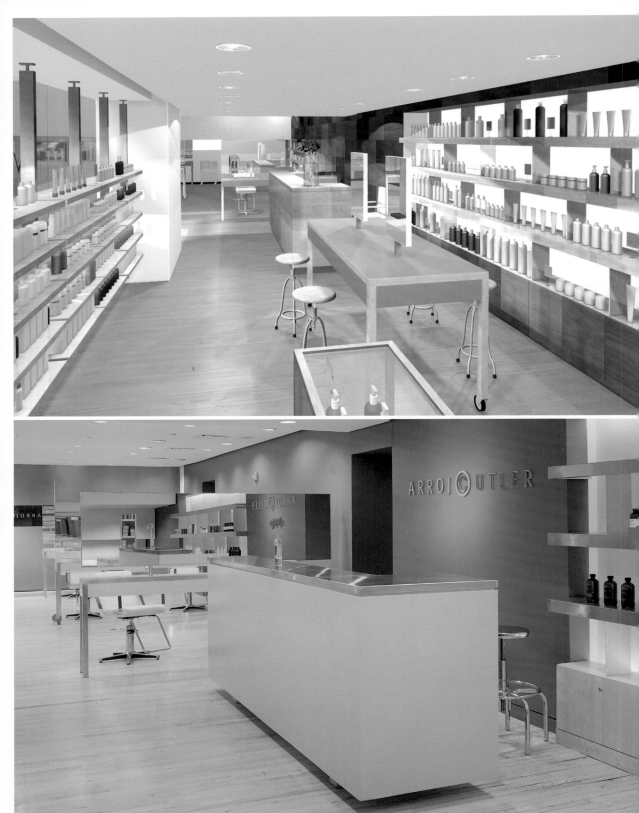

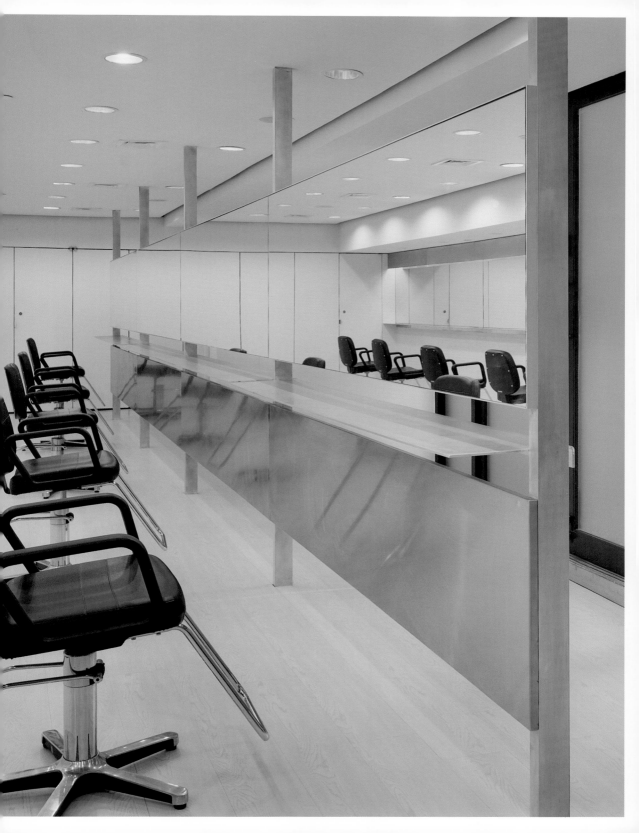

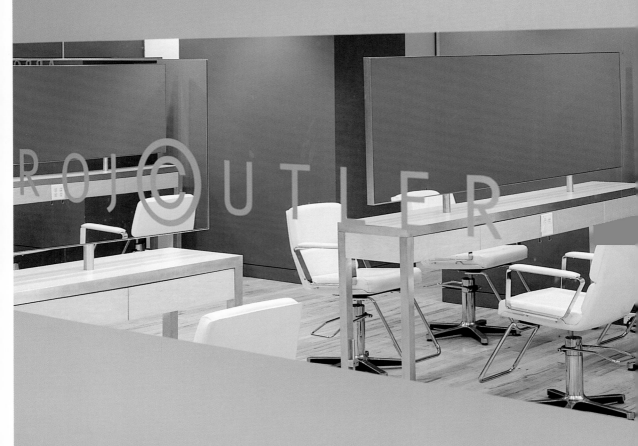

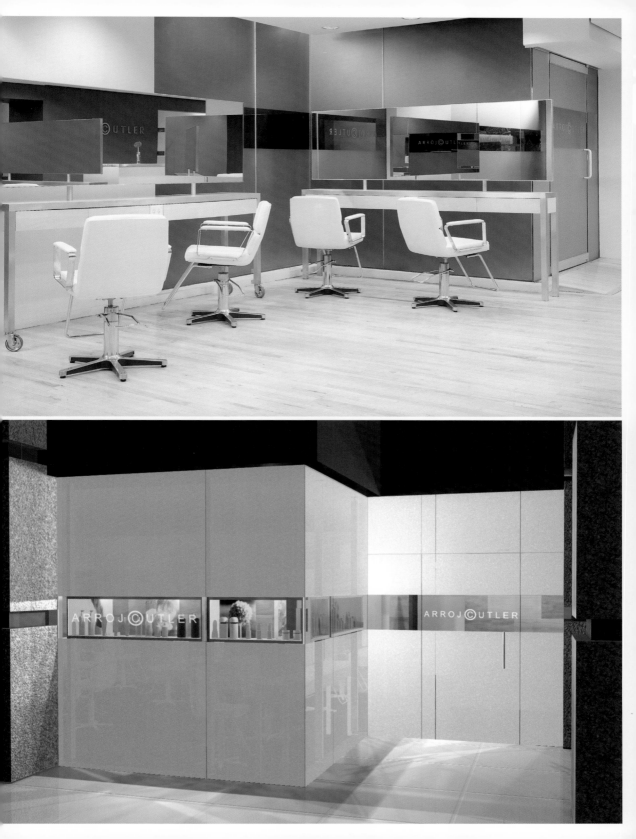

RASSMANN ARCHITEKTEN | BERLIN
shift Frisöre
Berlin, Germany | 2003
Photos: Ingo Robin, Wolfgang Stahl

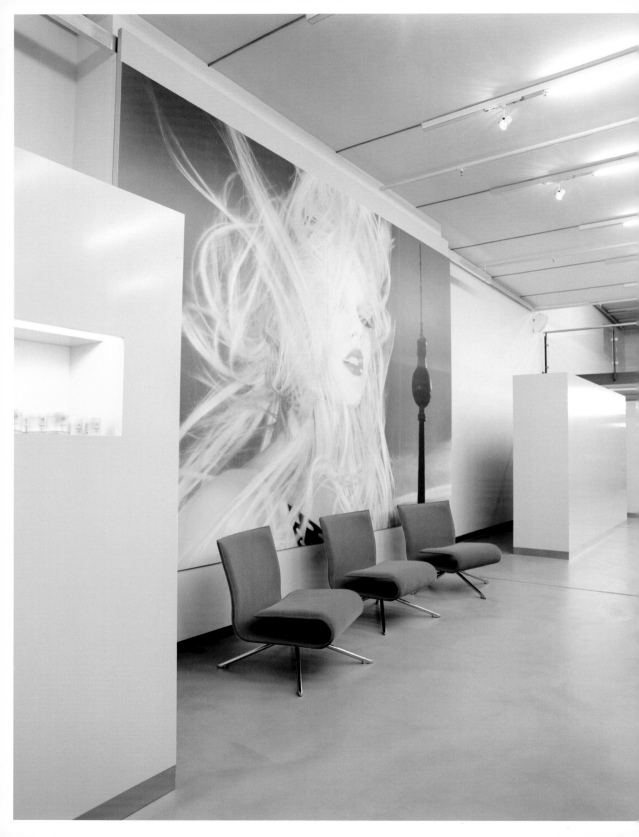

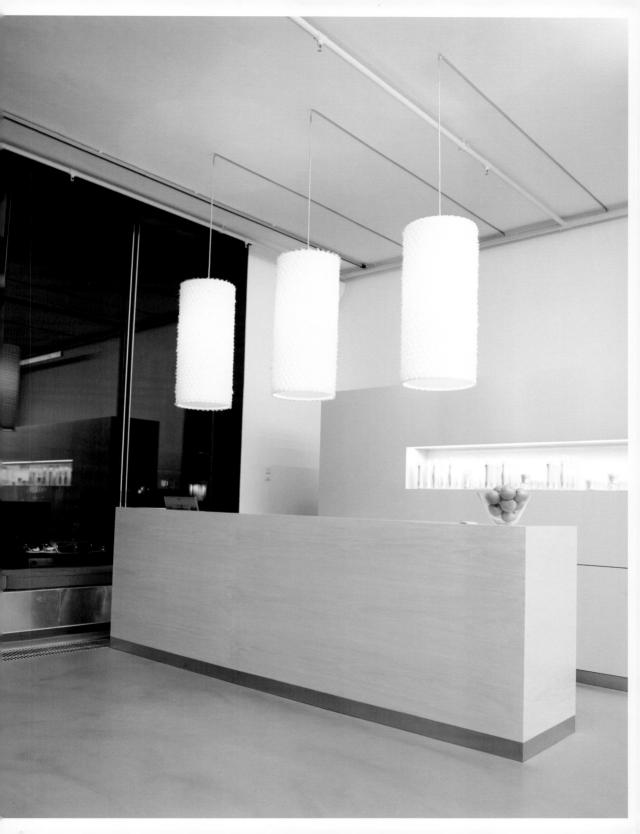

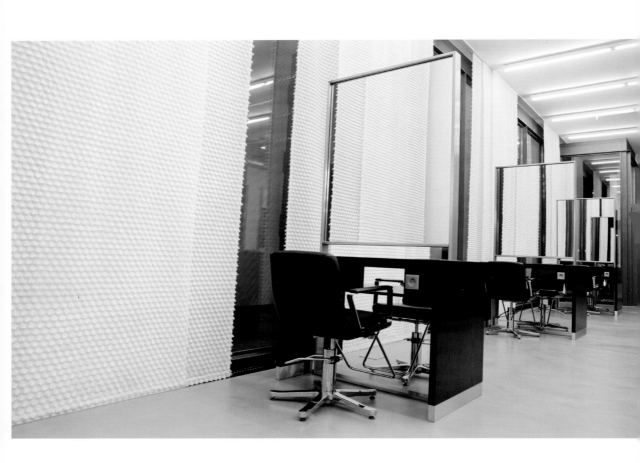

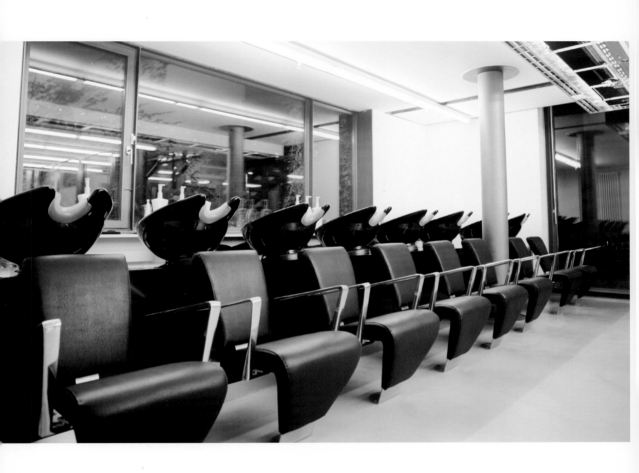

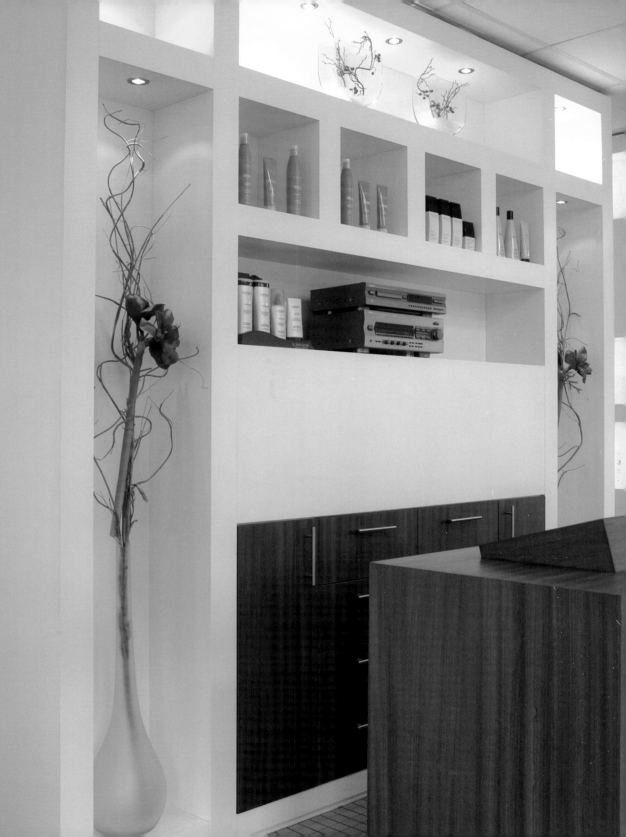

ARCHITEKTENBÜRO SAGER + KOSET WITH BERTHOLD IBING | LÜDENSCHEID
Coiffeur Murat Karadavut
Lüdenscheid, Germany | 2004
Photos: Murat Karadavut

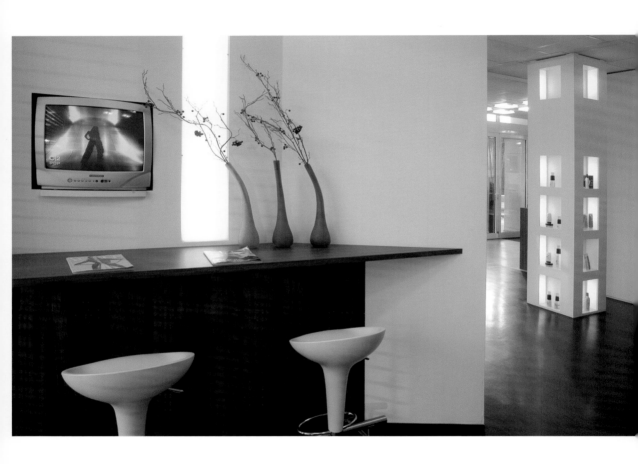

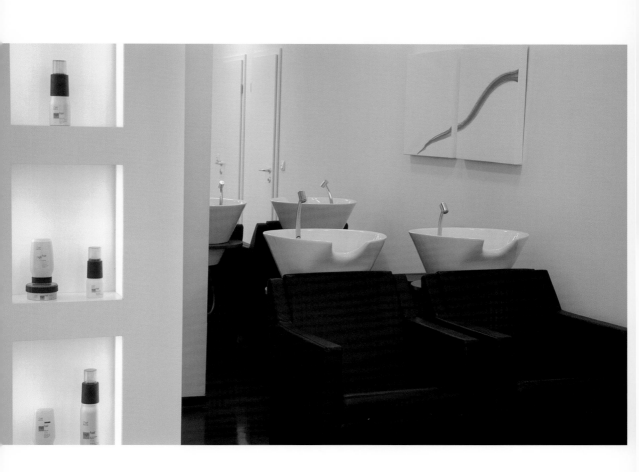

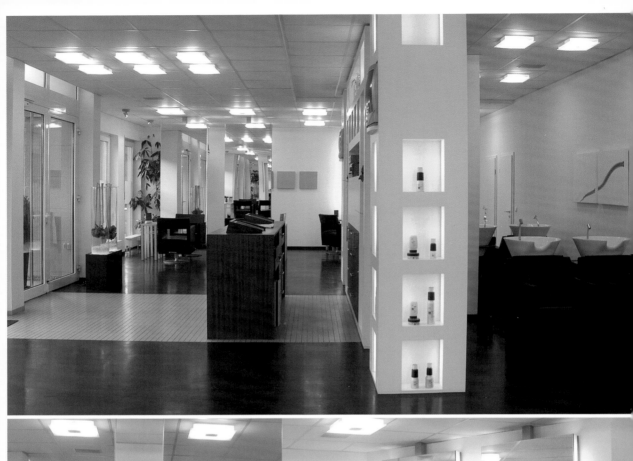
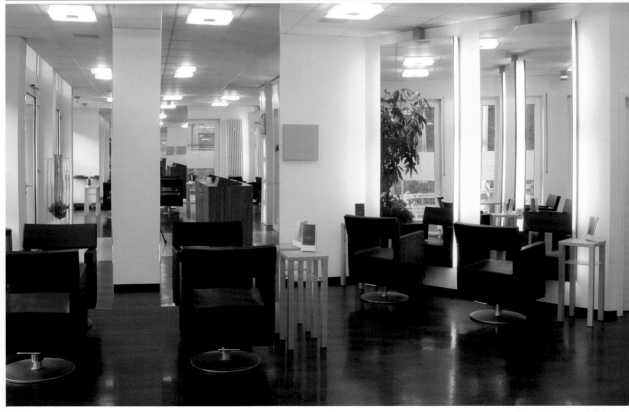

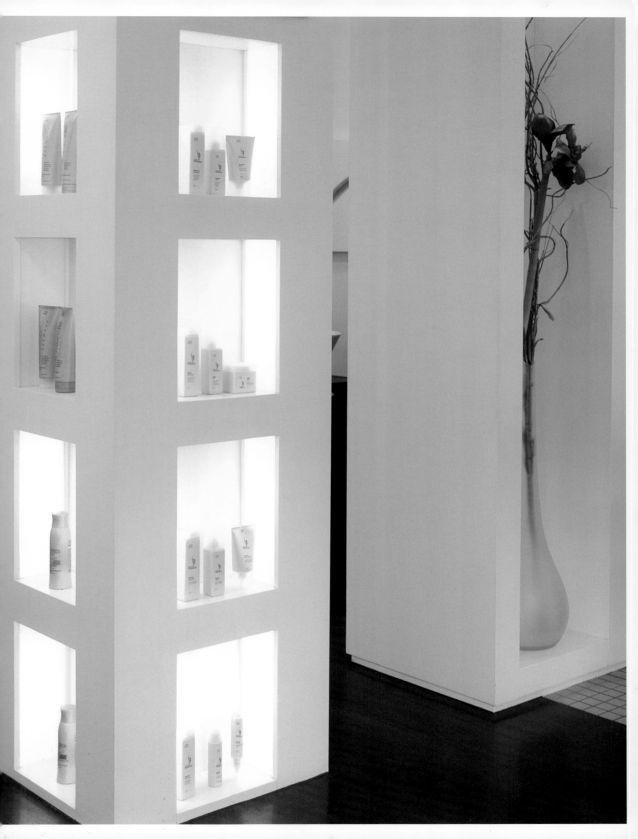

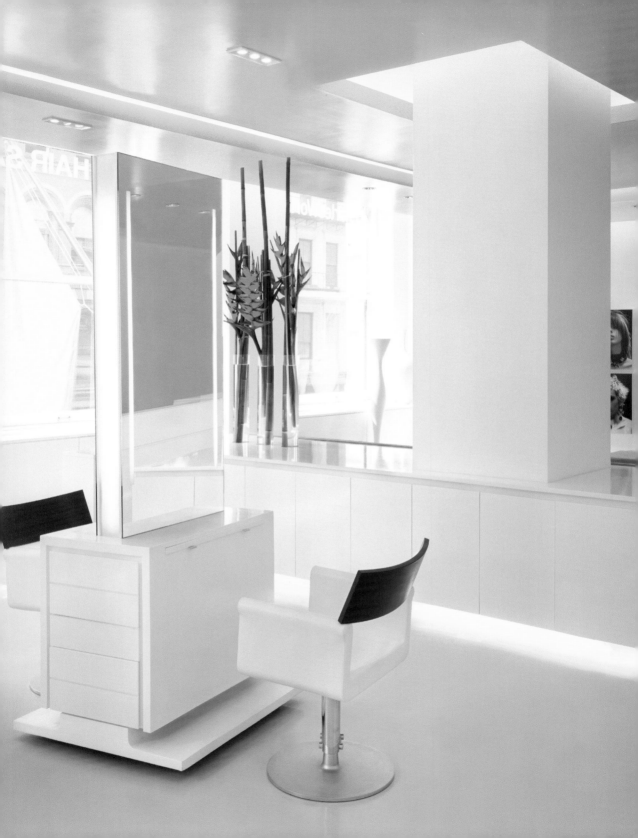

JOEL SANDERS ARCHITECT | NEW YORK
Charles Worthington Salon
New York, USA | 2003
Photos: Nikolas Koenig

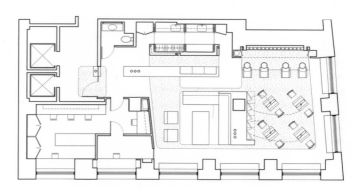

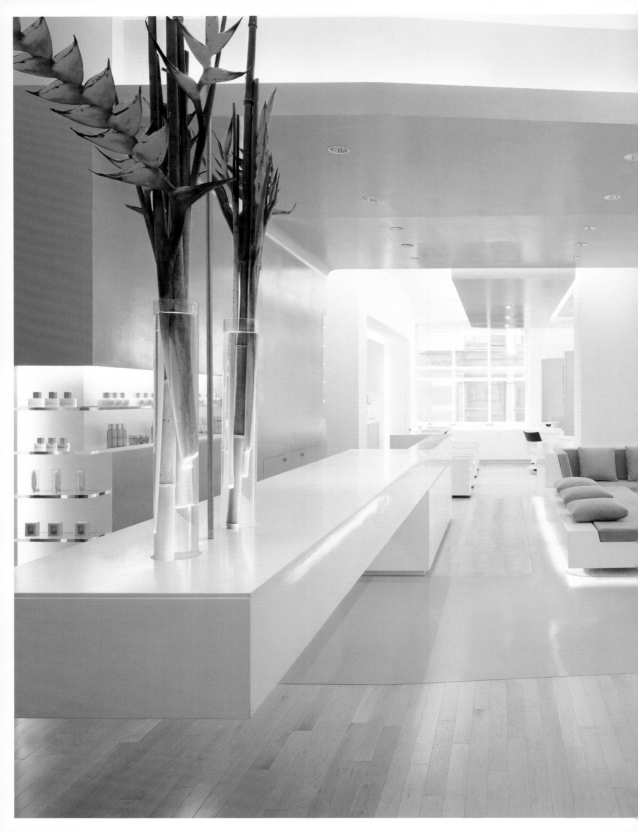

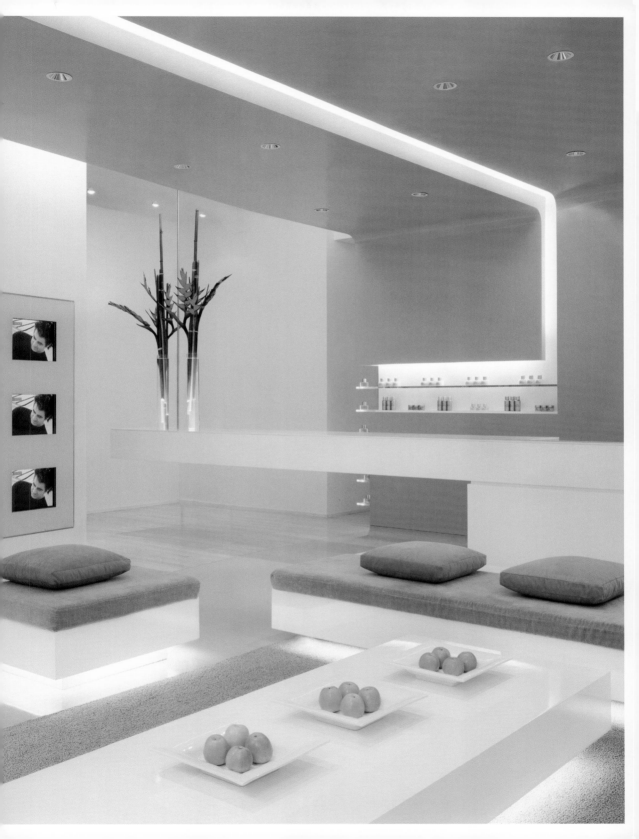

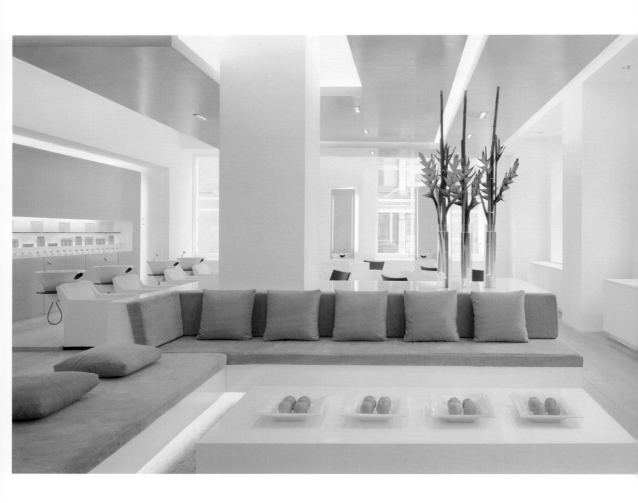

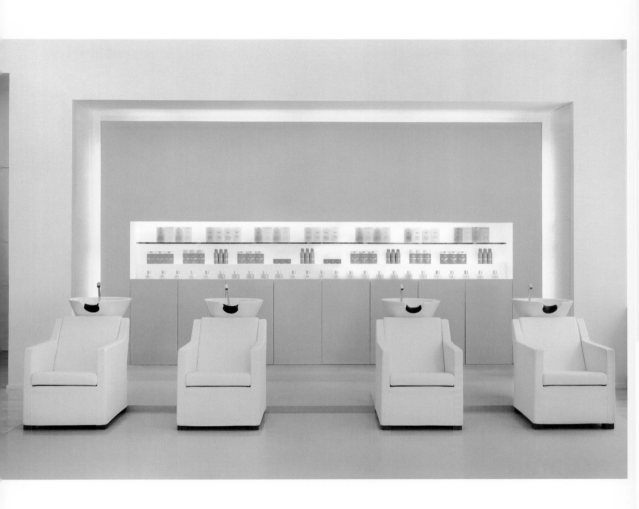

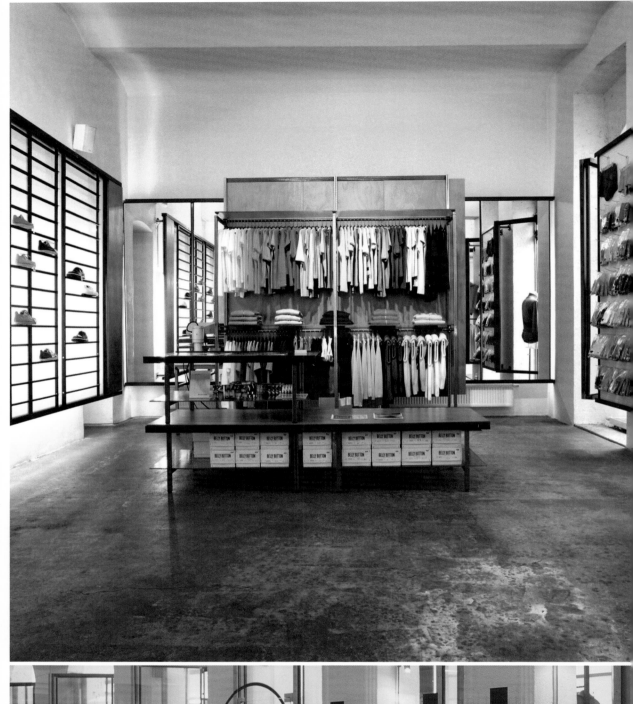

T-HOCH-N ARCHITEKTUR | VIENNA
be a good girl
Vienna, Austria | 2003
Photos: Andreas Wall, Julia Oppermann, Gerhard Binder

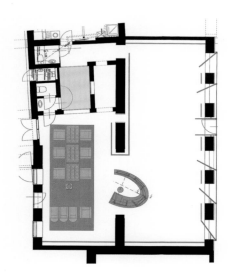

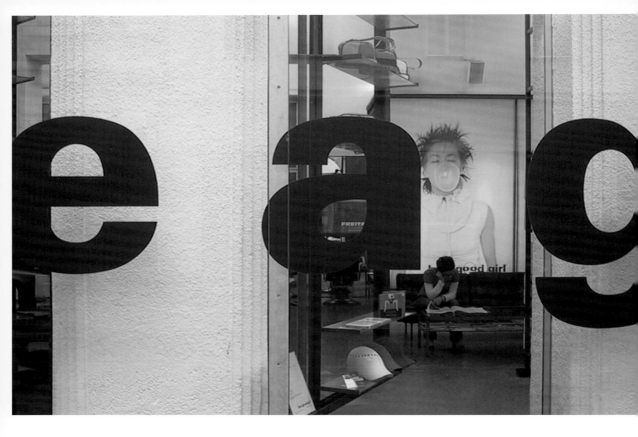

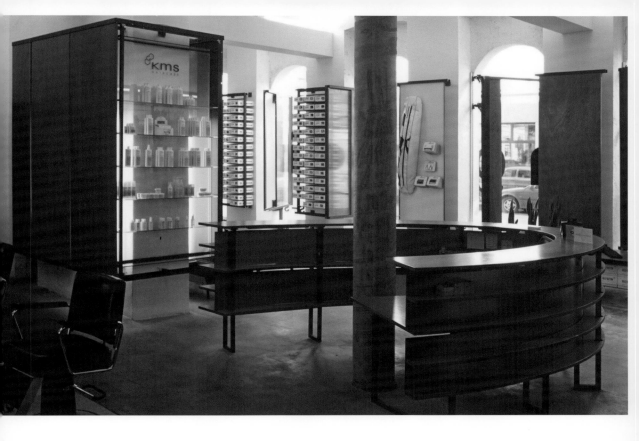

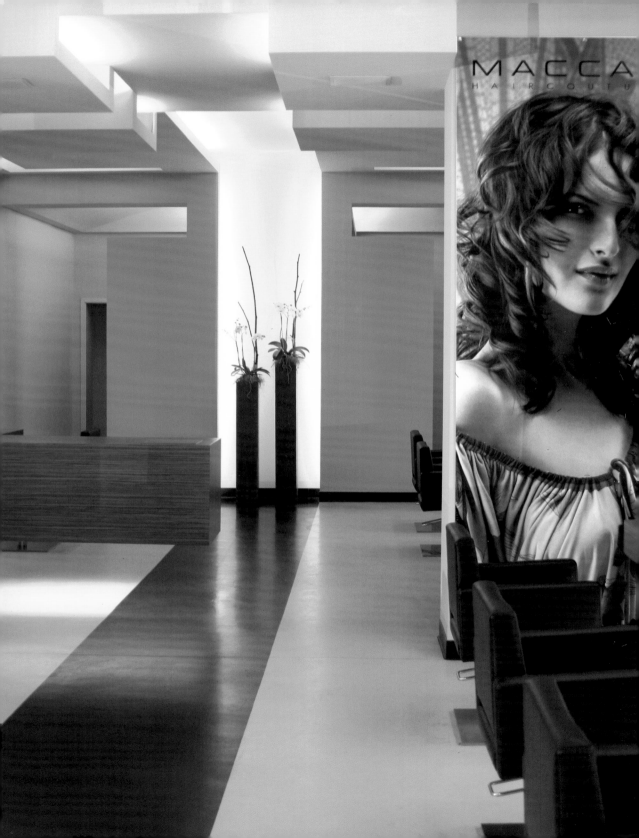

NORBERT WAGENER, CANER ÖZGÜNSUR | BERLIN
MACCAS Haircouture
Berlin, Germany | 2003
Photos: Laura Schleicher

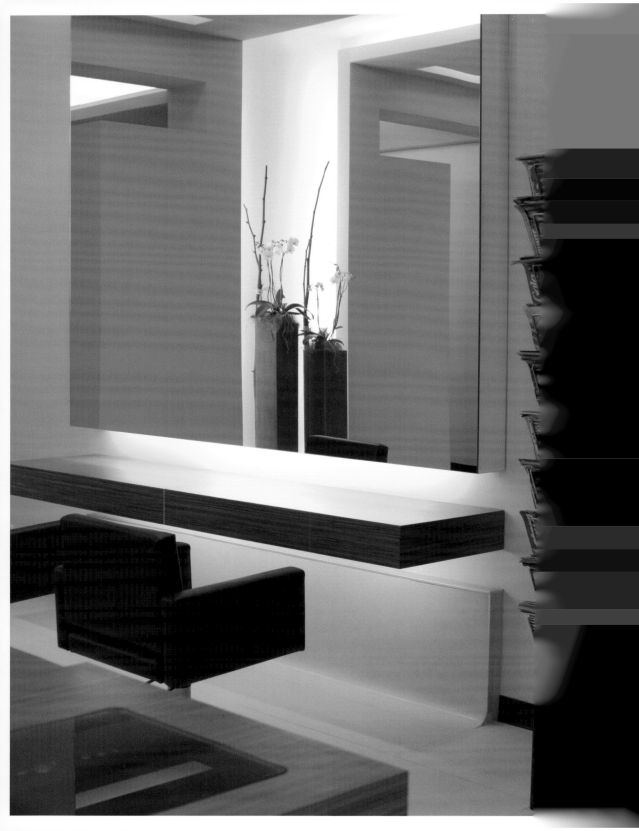

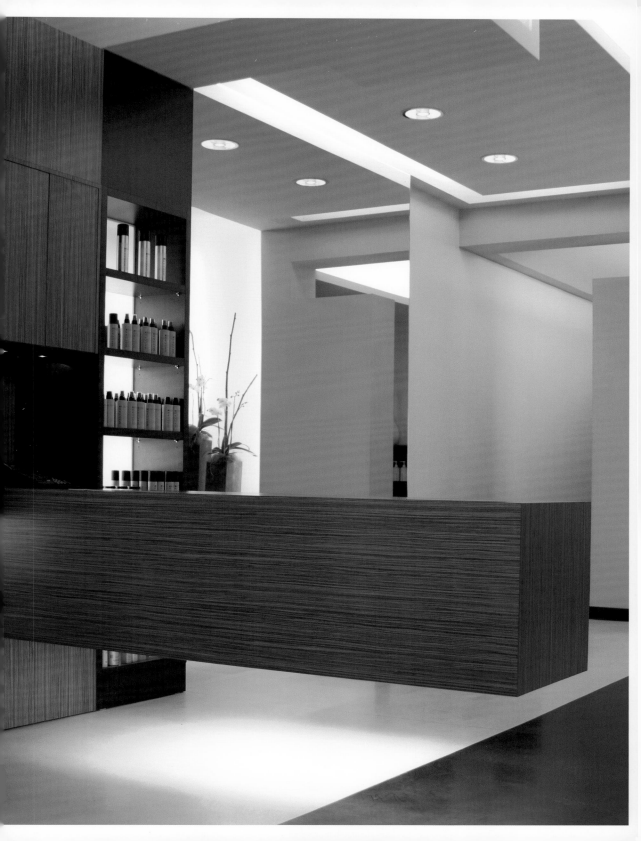

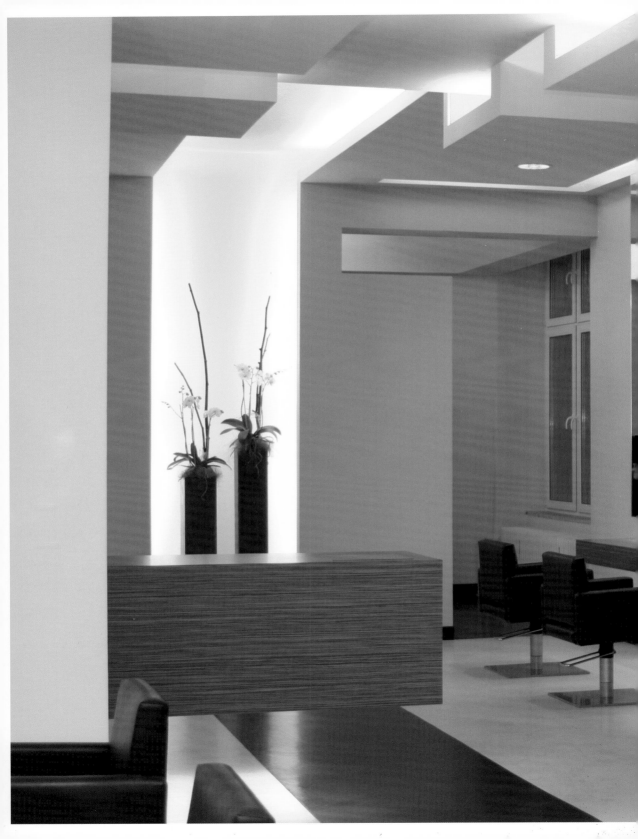

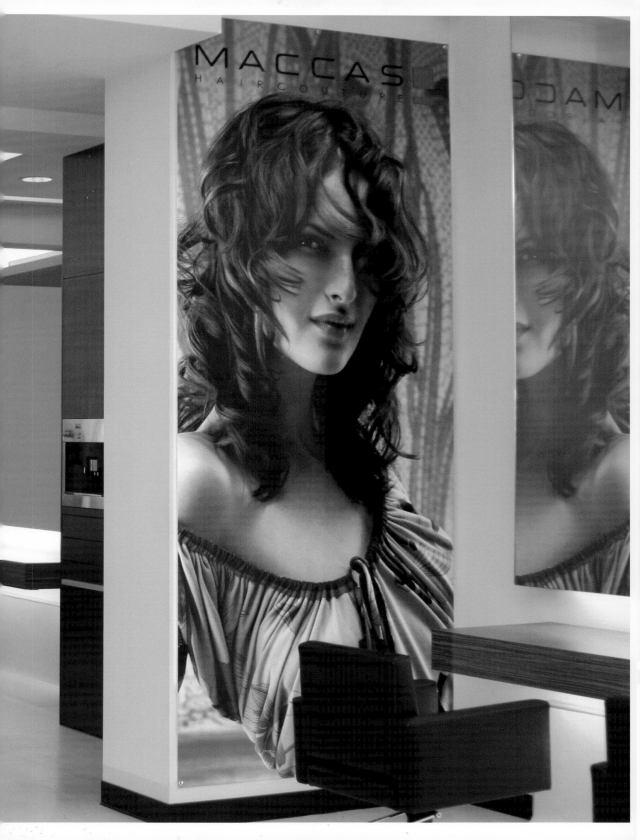

WELLA SALON FURNISHINGS | DARMSTADT
Salon Kuhn Intercoiffure
Zurich, Switzerland | 2005
Photos: Courtesy Wella AG

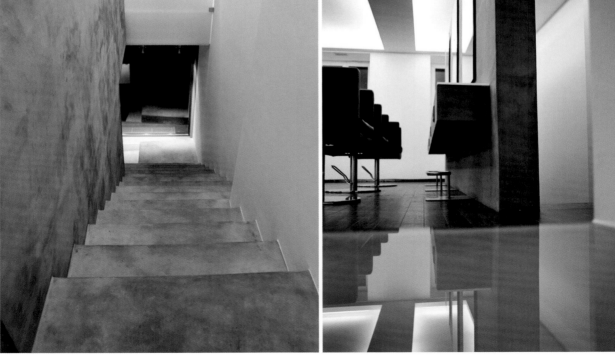

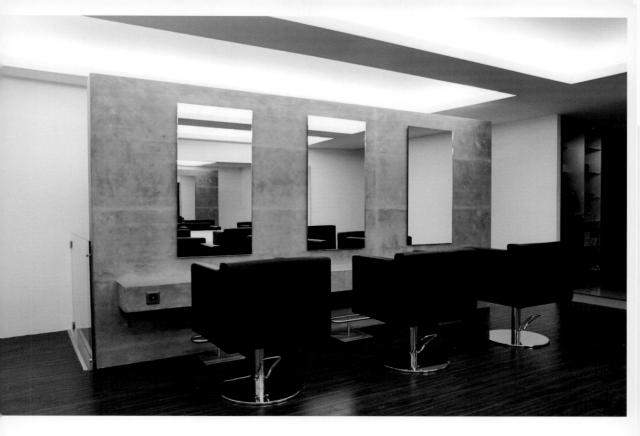

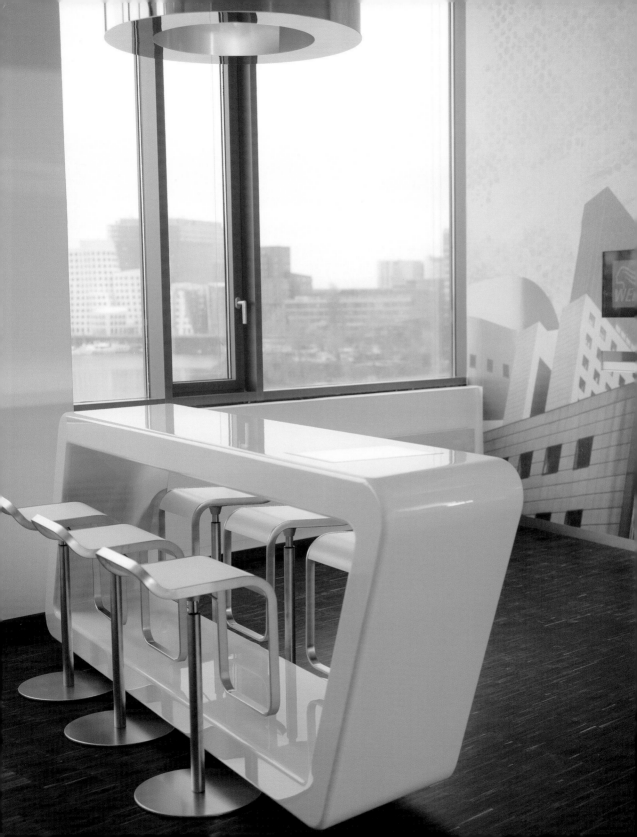

WELLA SALON FURNISHINGS | DARMSTADT
Wella Studio
Düsseldorf, Germany | 2005
Photos: Courtesy Wella AG

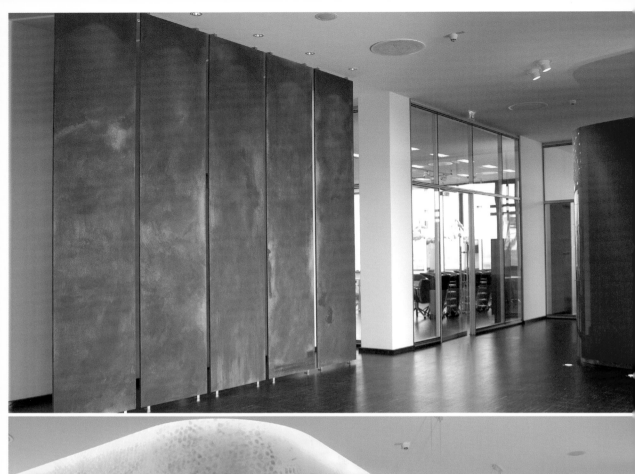

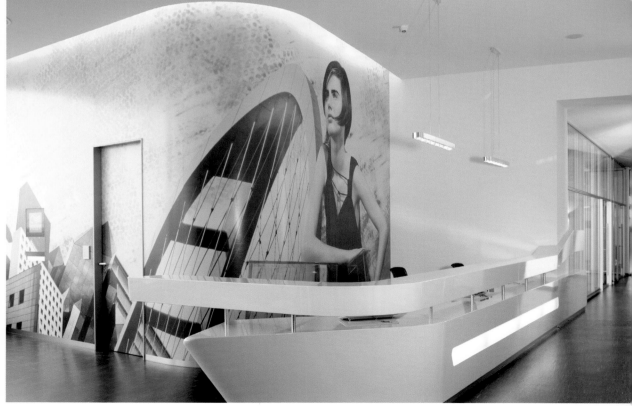

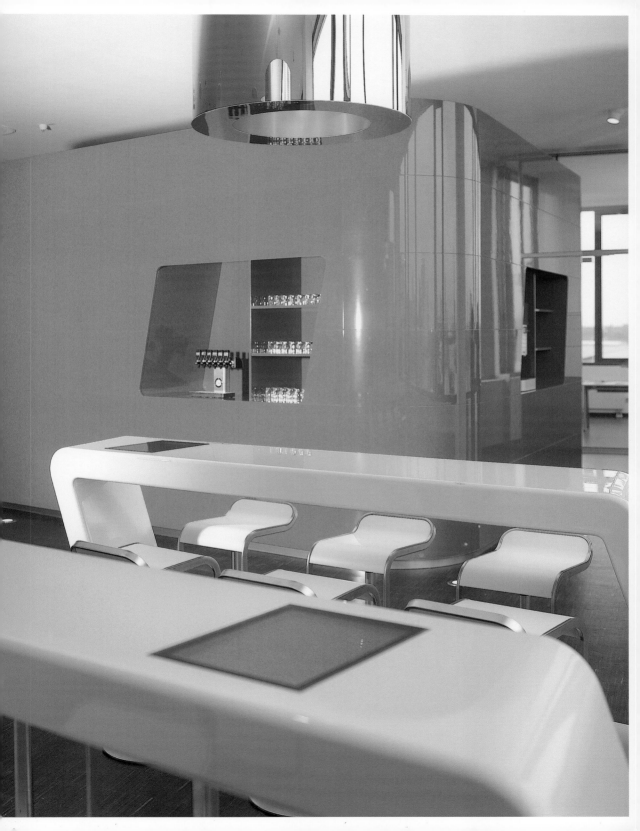

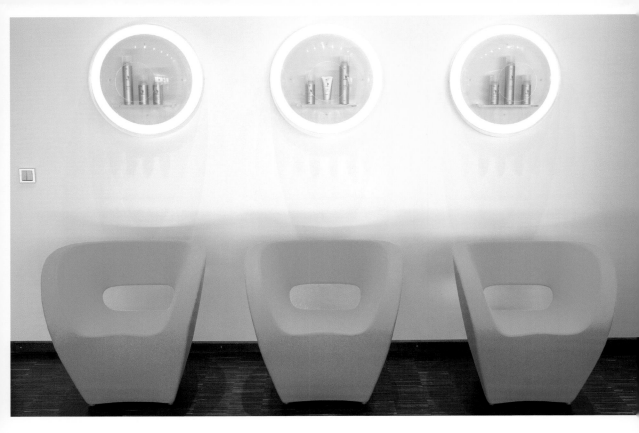

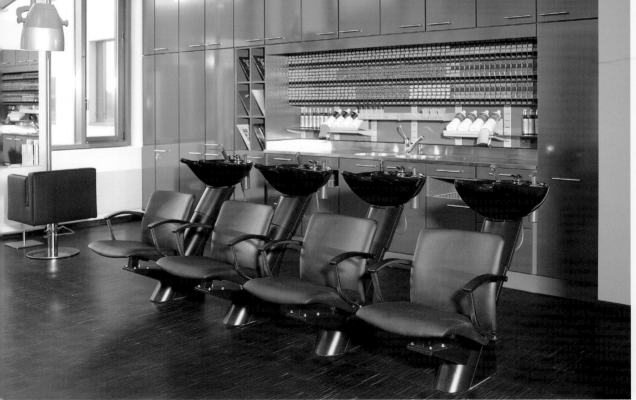

GYM

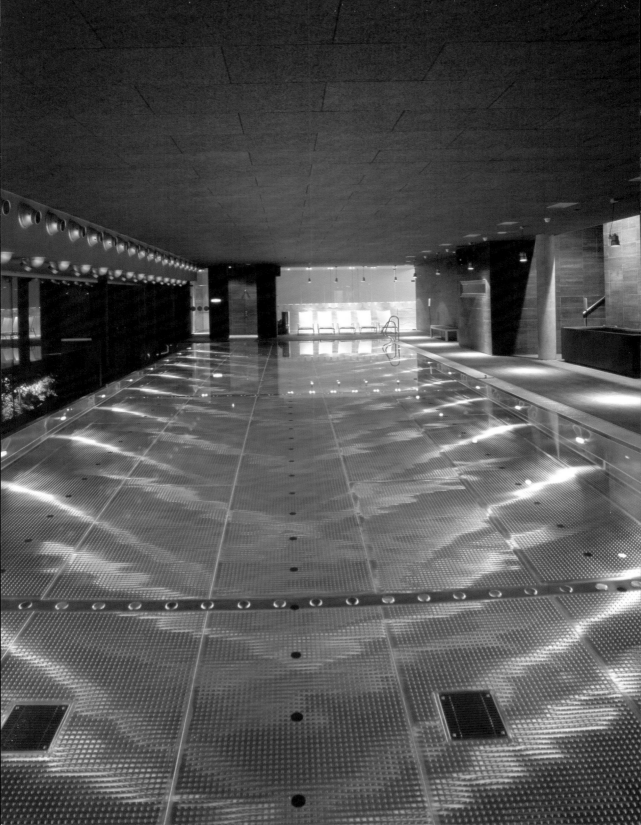

ALONSO BALAGUER ARQUITECTES ASSOCIATS | BARCELONA
CENTRO DEPORTIVO WELLNESS 0^2
Barcelona, Spain | 2002
Photos: Josep Mª Molinos

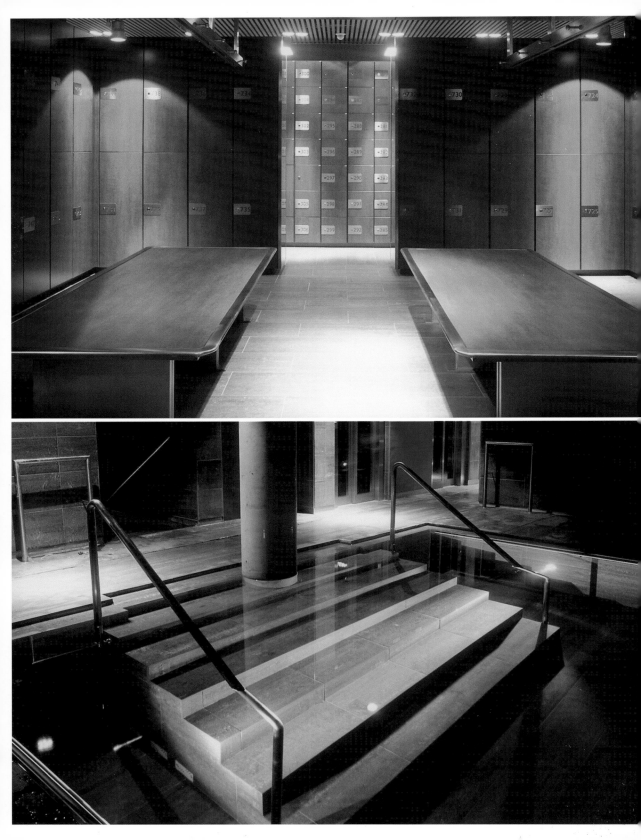

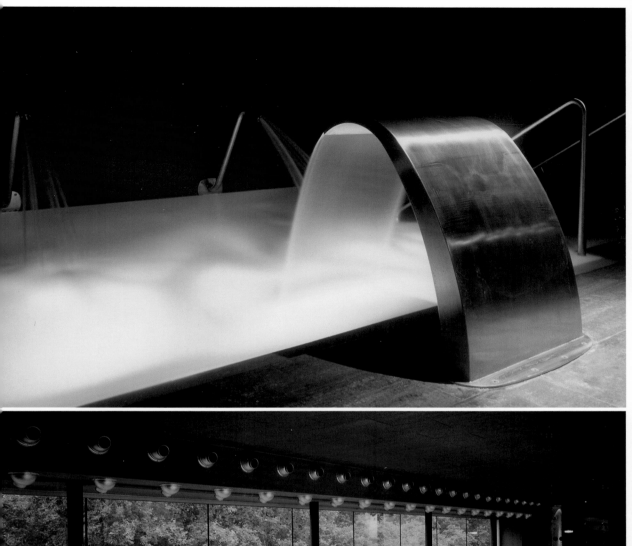
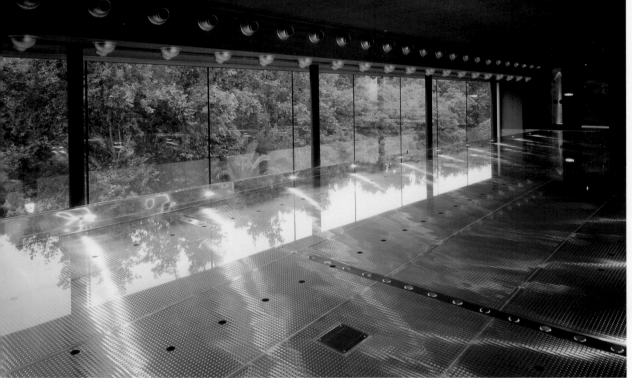

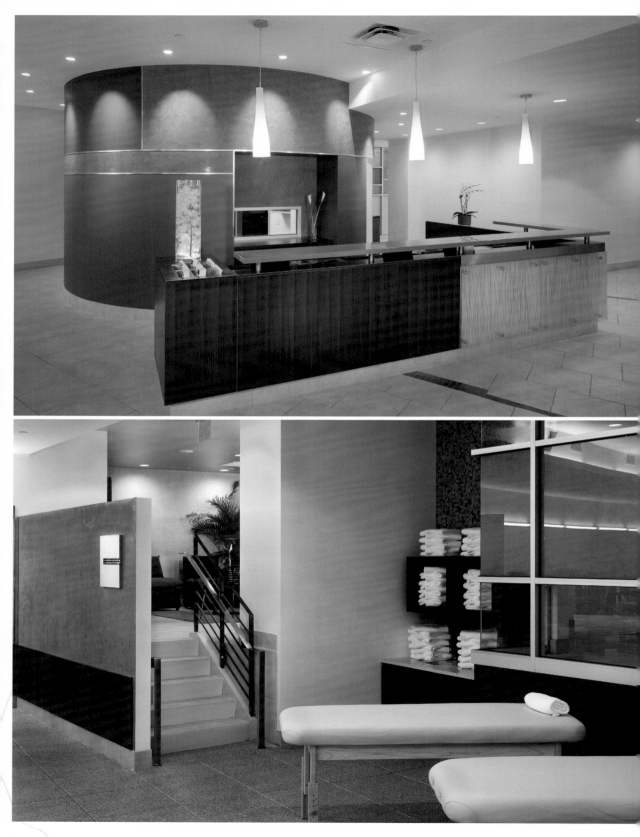

PLATT BYARD DOVELL WHITE ARCHITECTS LLP | NEW YORK
Equinox Fitness Club
Columbus Circle, New York, USA | 2004
Photos: Jonathan Wallen, archphoto

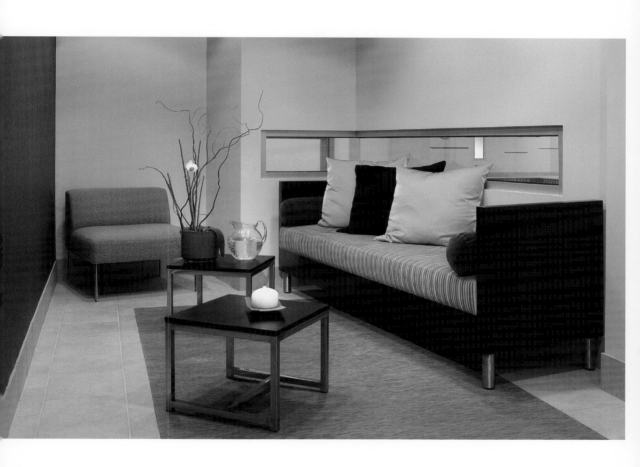

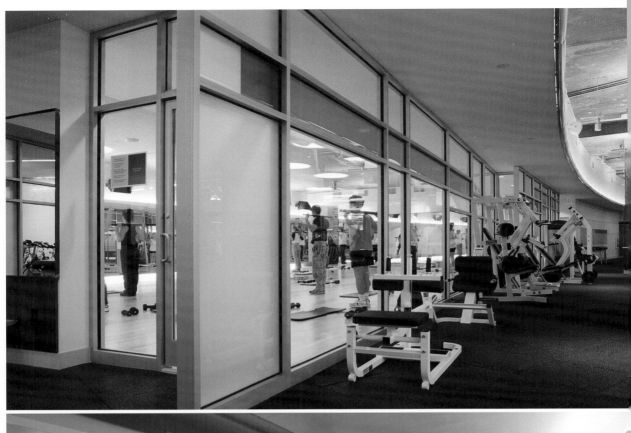

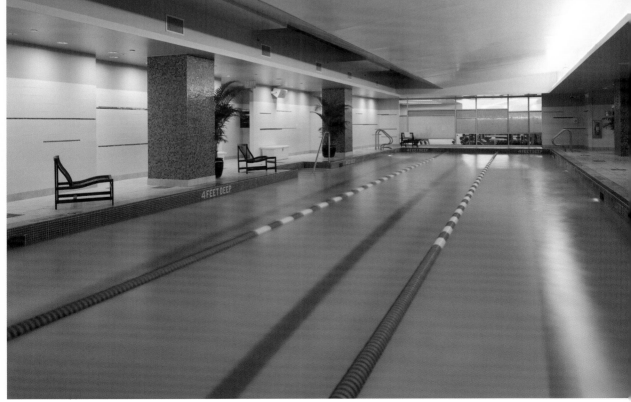

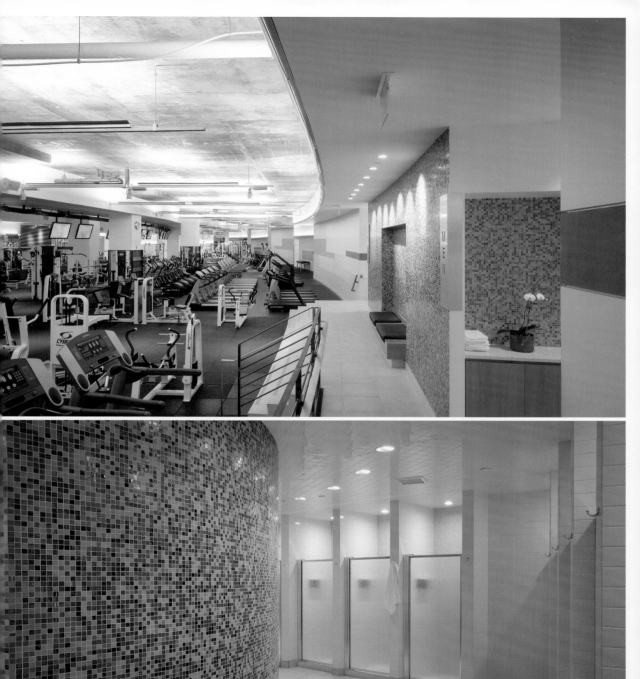

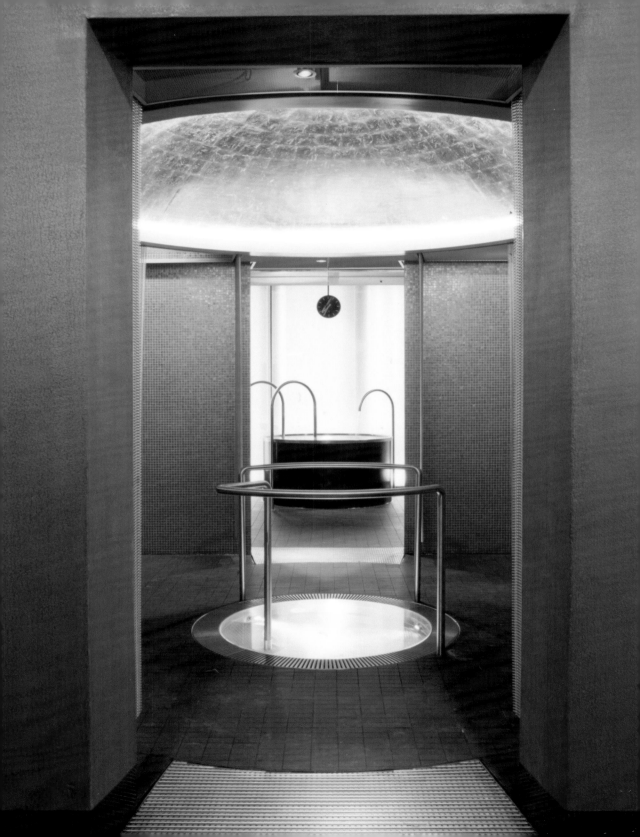

OBERHOLZER & BRÜSCHWEILER ARCHITEKTEN | KÜSNACHT
WITH USHI TAMBORRIELLO INNENARCHITEKTUR & SZENENBILD | MUNICH
Puls5 Migros Fitnesspark
Zurich, Switzerland | 2004
Photos: Jochen Splett, Bildwerk

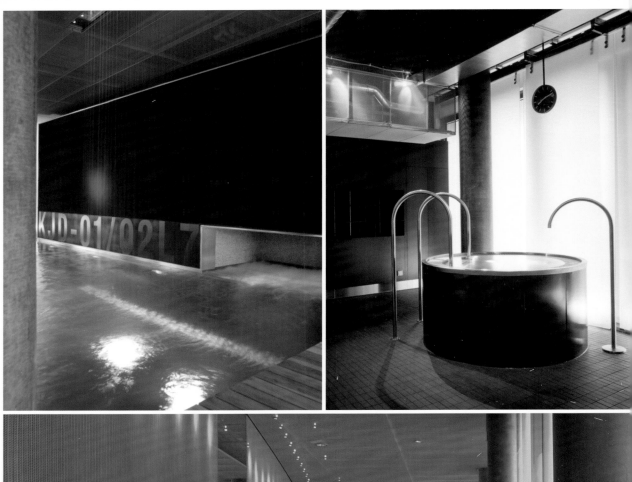
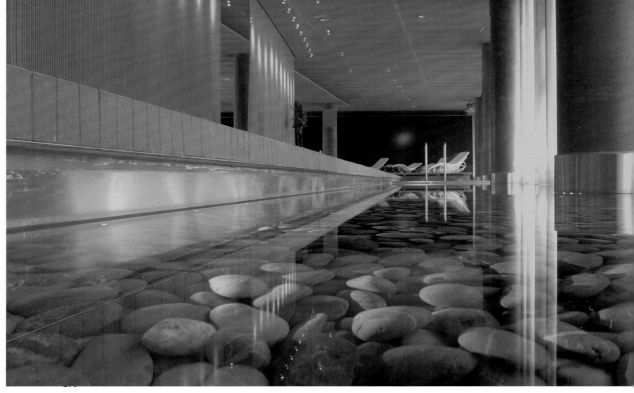

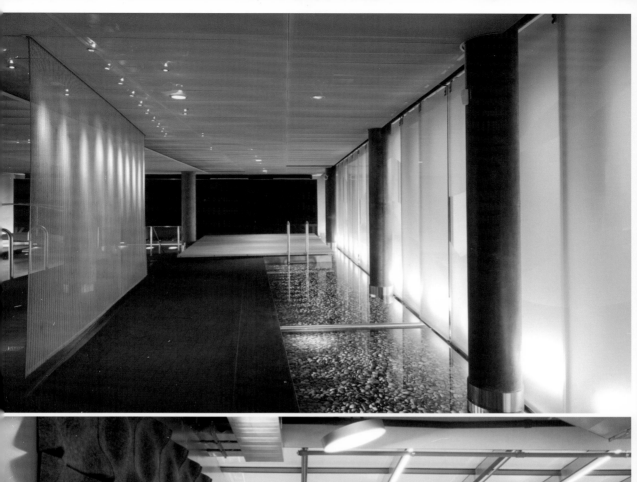
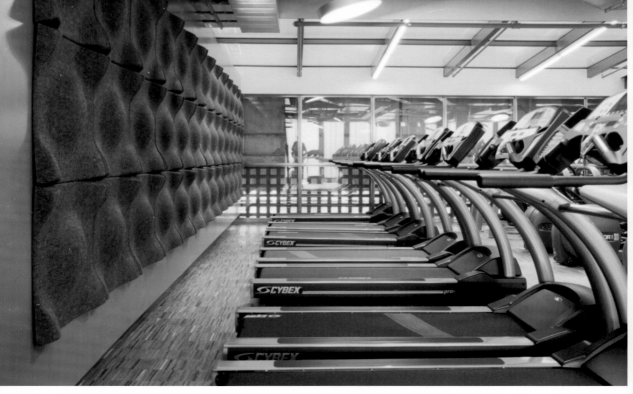

SEHW ARCHITEKTUR | VIENNA
Holmes Place
Innsbruck, Austria | 2004
Photos: Bettina Gutmann Fotografie

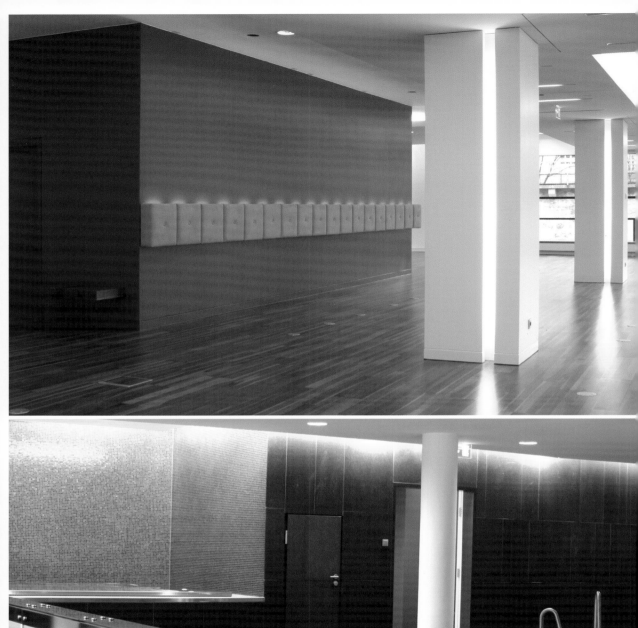
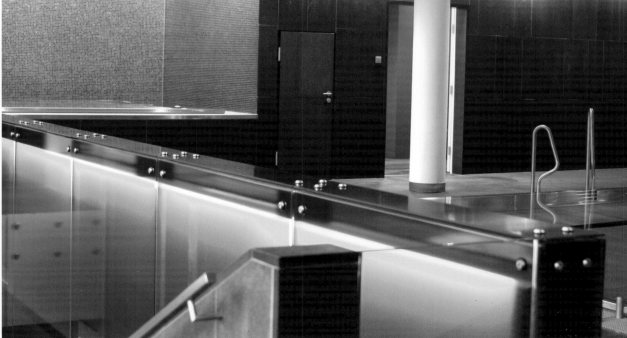

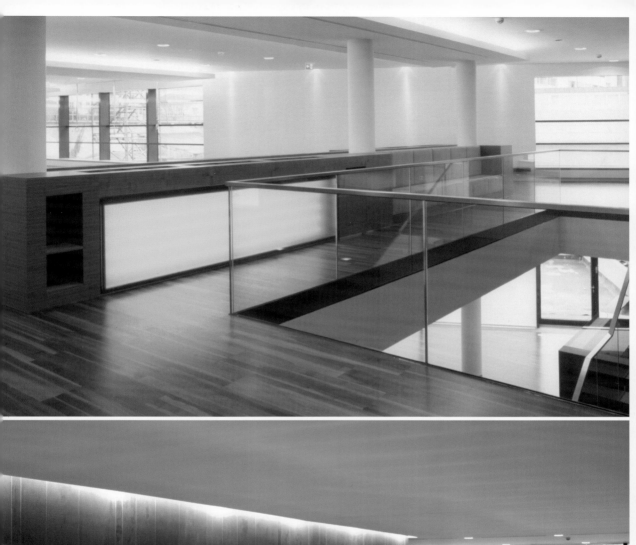
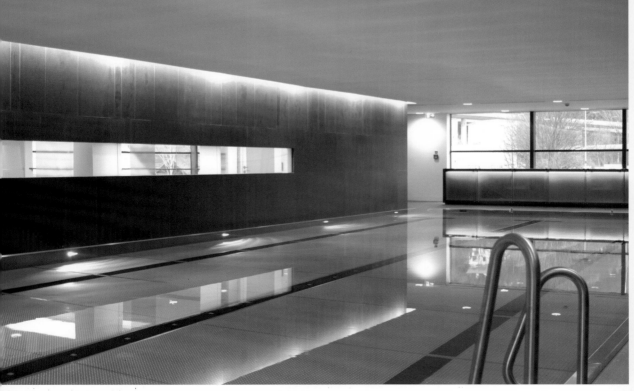

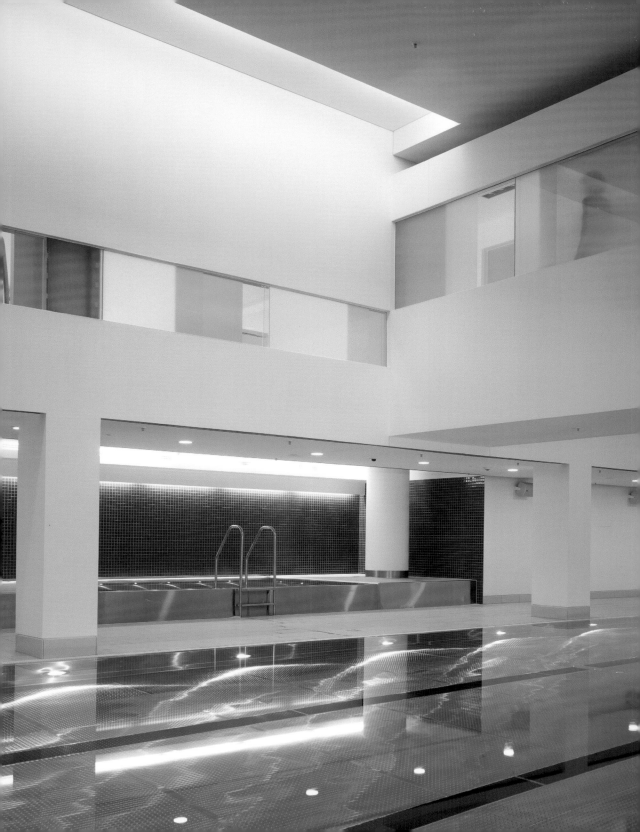

SEHW ARCHITEKTUR | BERLIN
Holmes Place
Cologne, Germany | 2004
Photos: Jürgen Schmidt

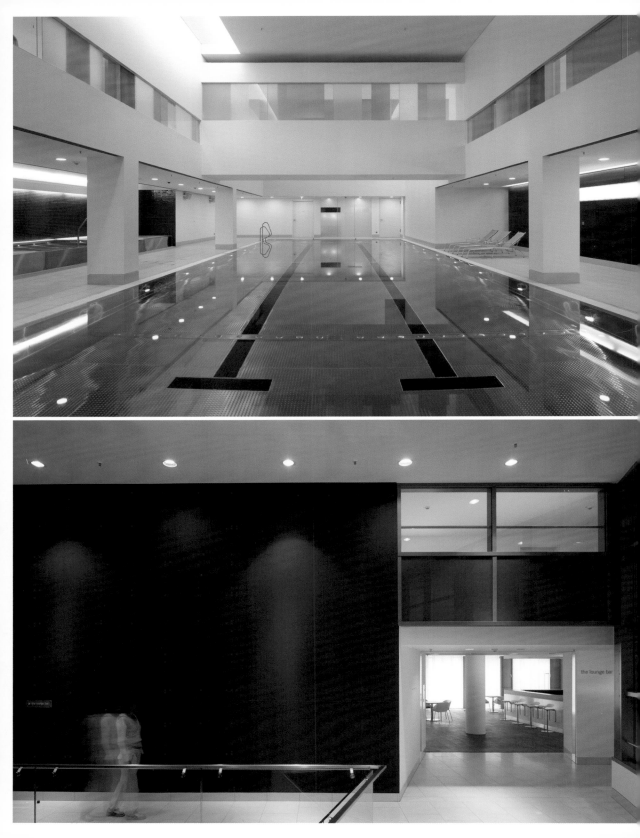

the lounge bar

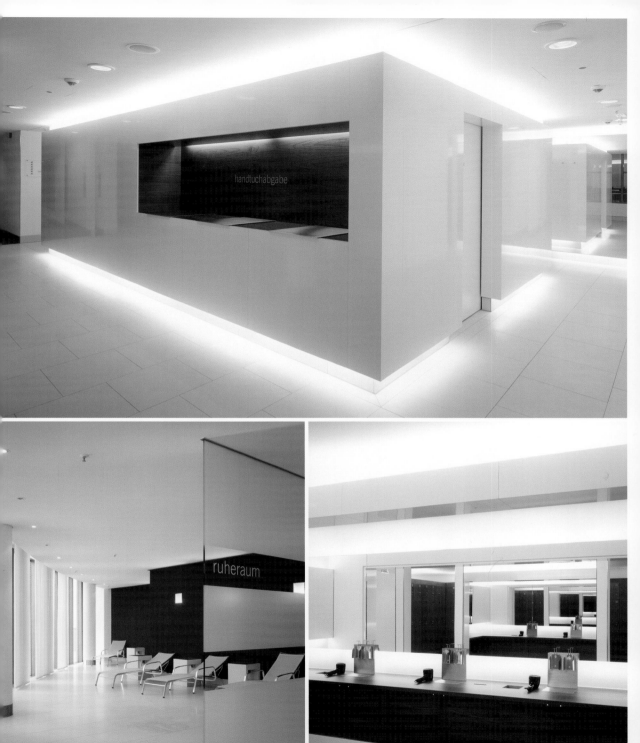

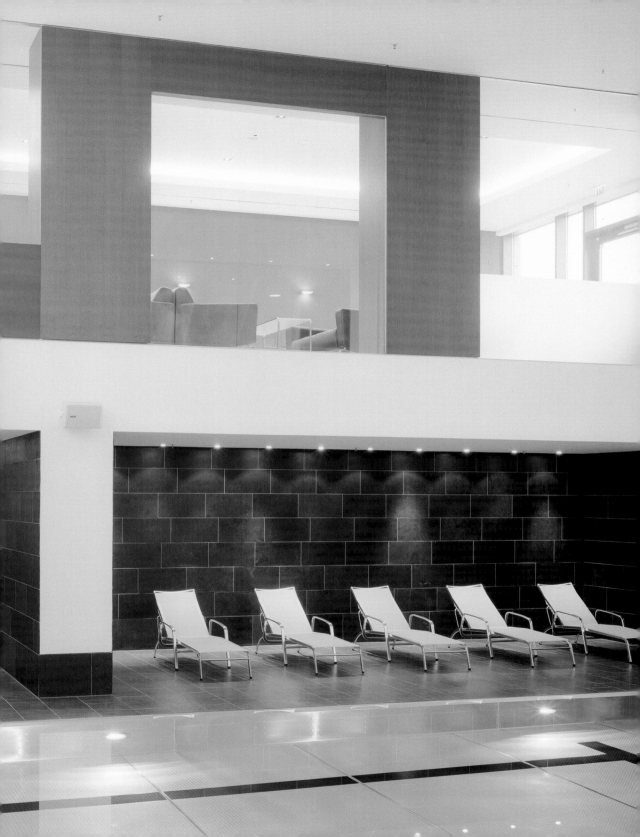

SEHW ARCHITEKTUR | BERLIN
Holmes Place
Lübeck, Germany | 2004
Photos: Jürgen Schmidt

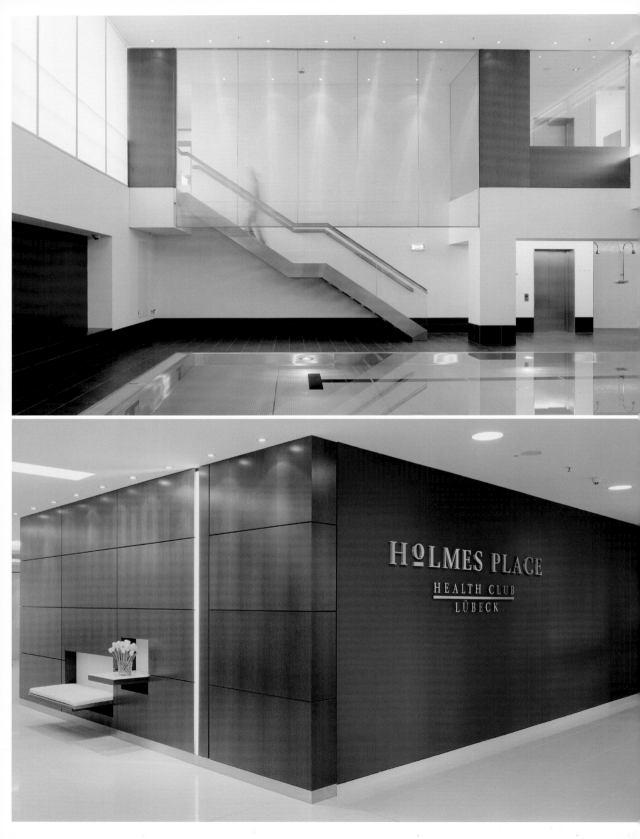

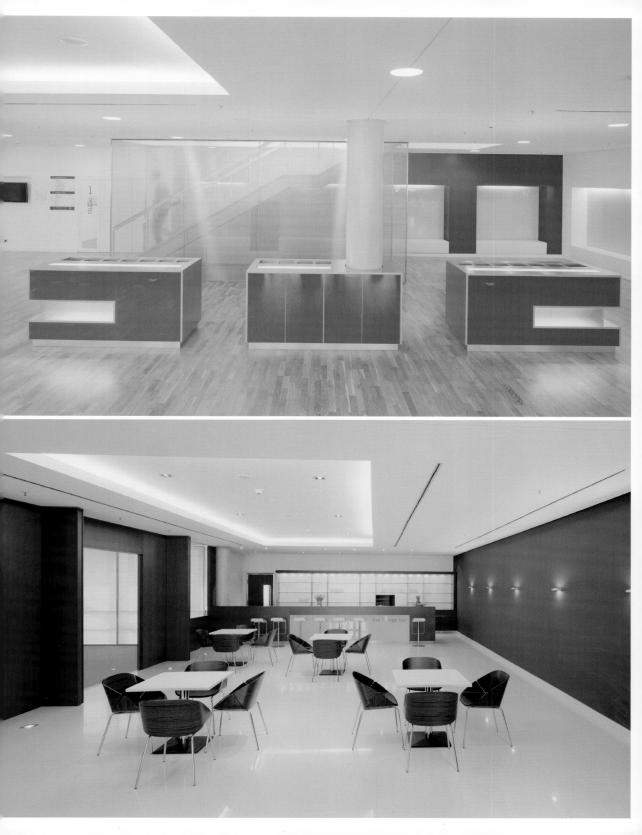

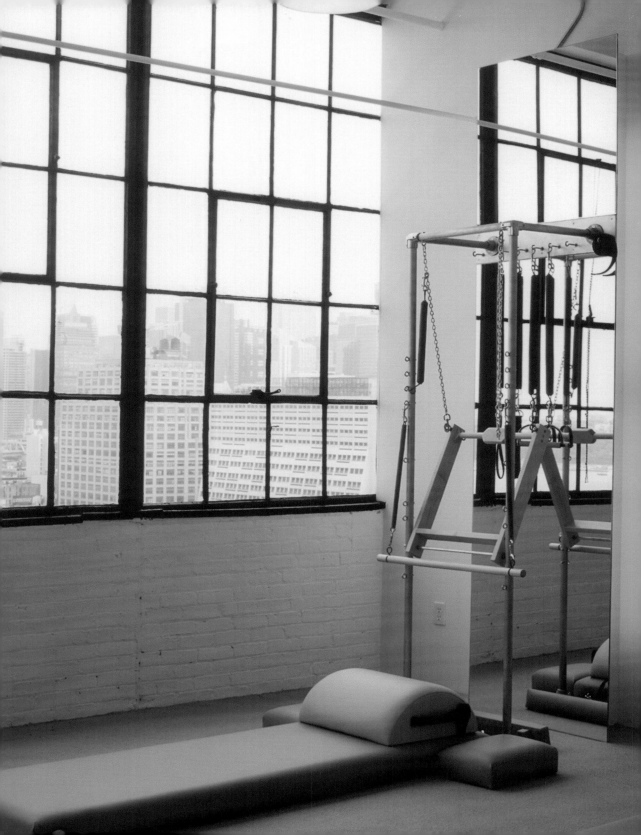

CHO SLADE ARCHITECTURE | NEW YORK
Stretch Pilates
New York, USA | 2002
Photos: Jordi Miralles

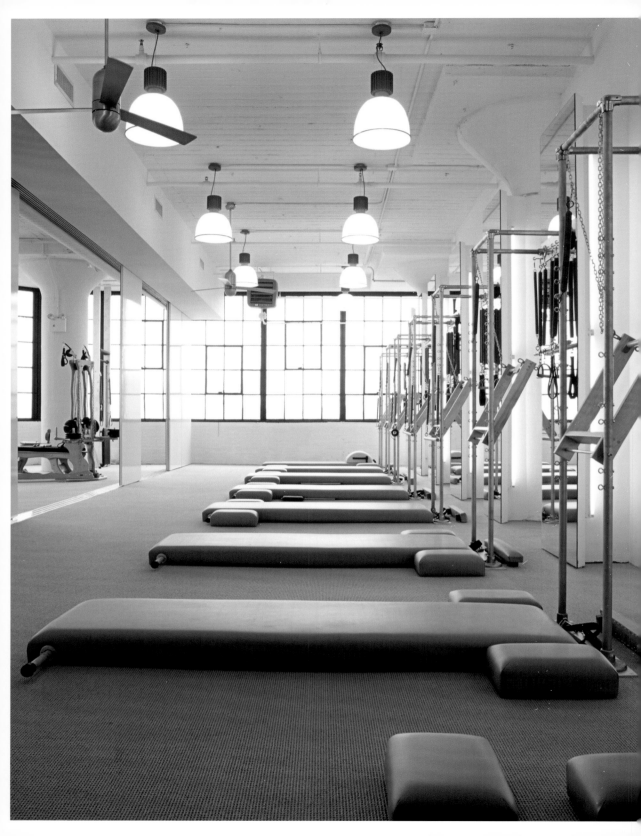

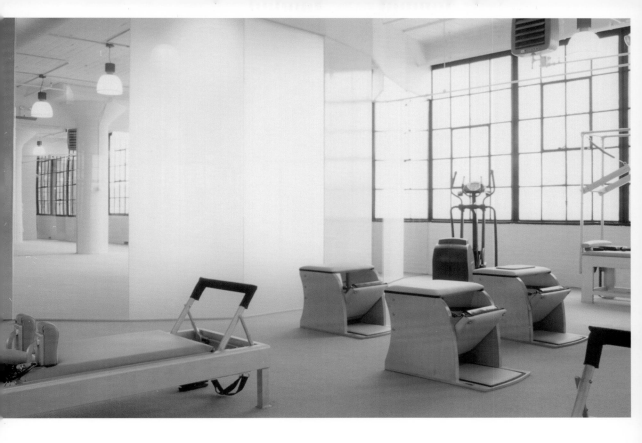

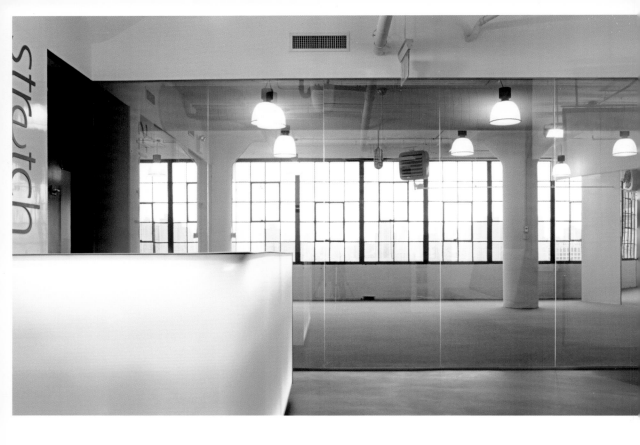

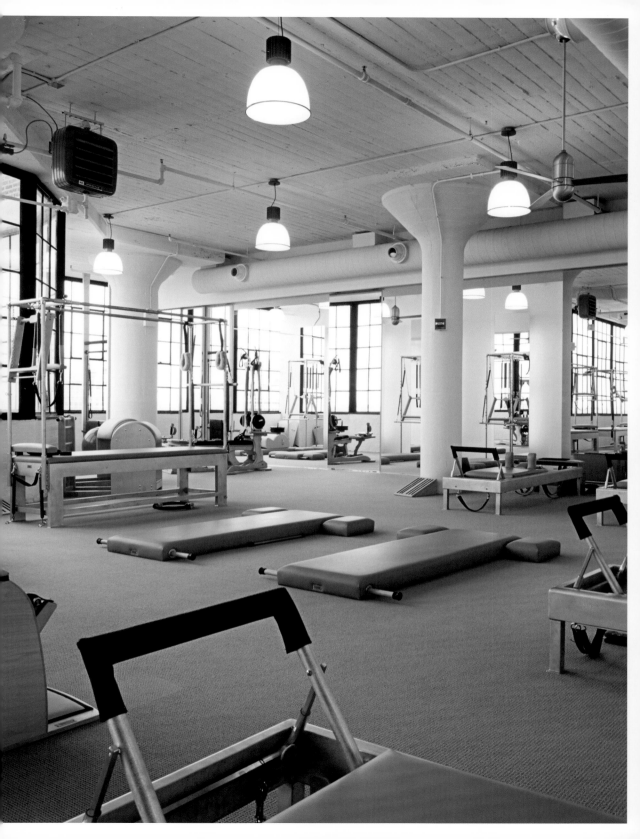

DAYSPA

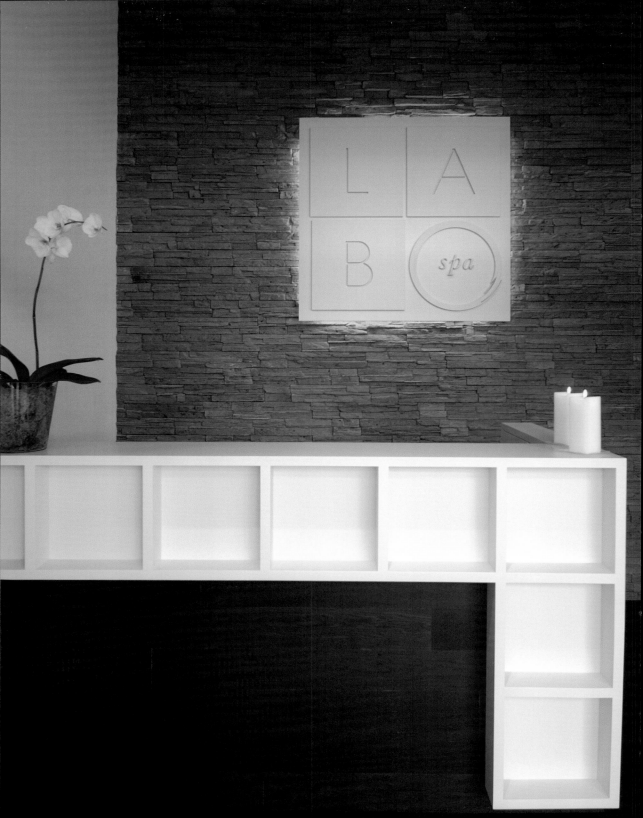

AROMA PRODUCTIONS AG | ZURICH
LABO SPA
Zurich, Switzerland | 2005
Photos: Zeljko Gataric

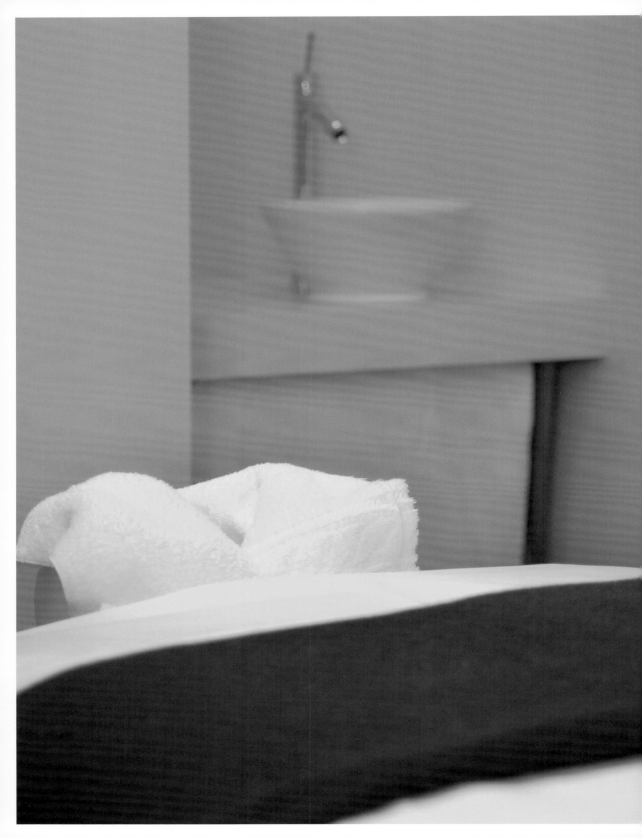

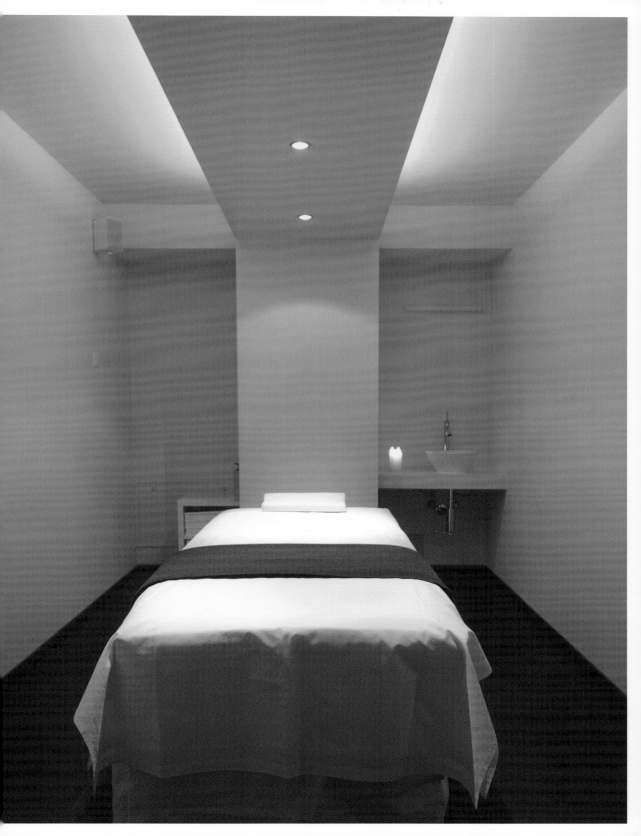

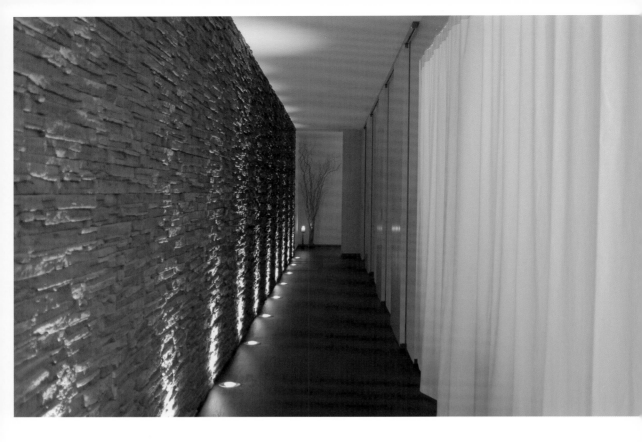

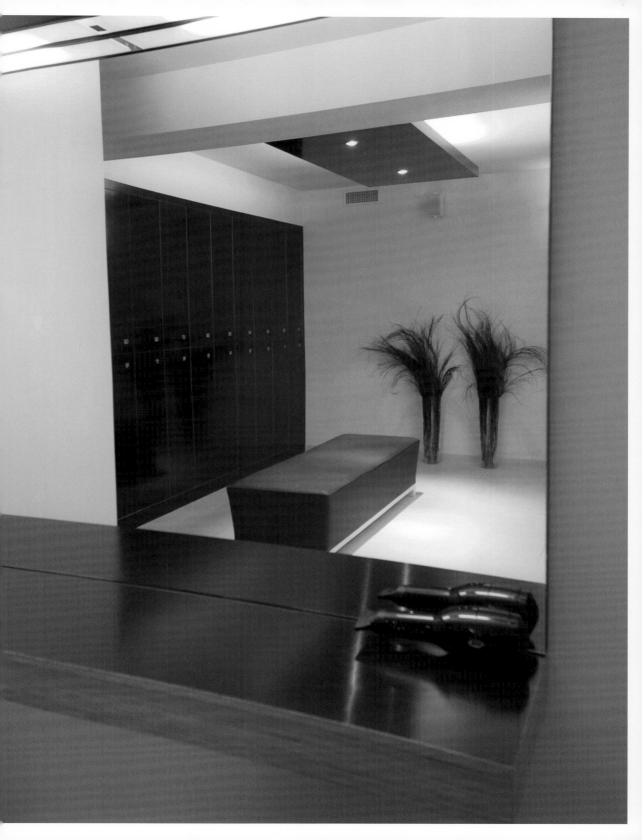

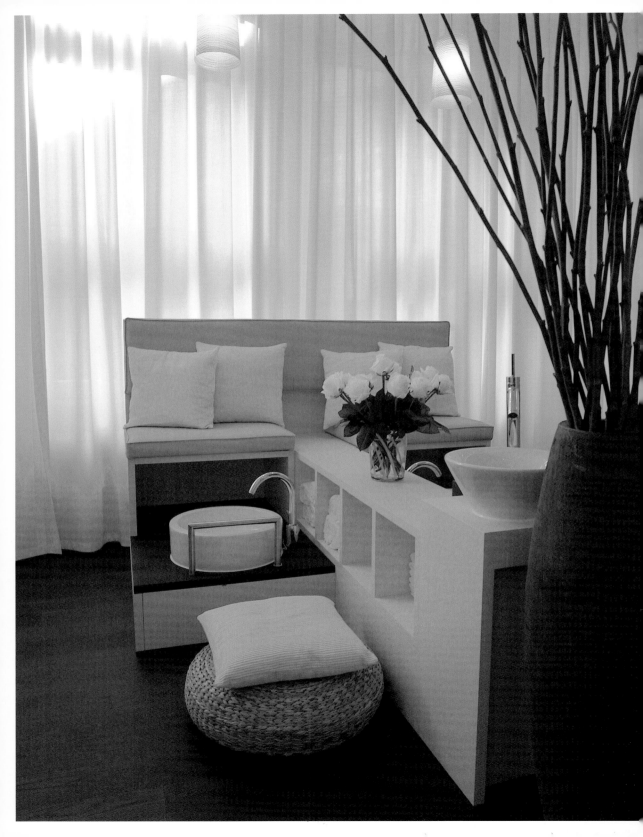

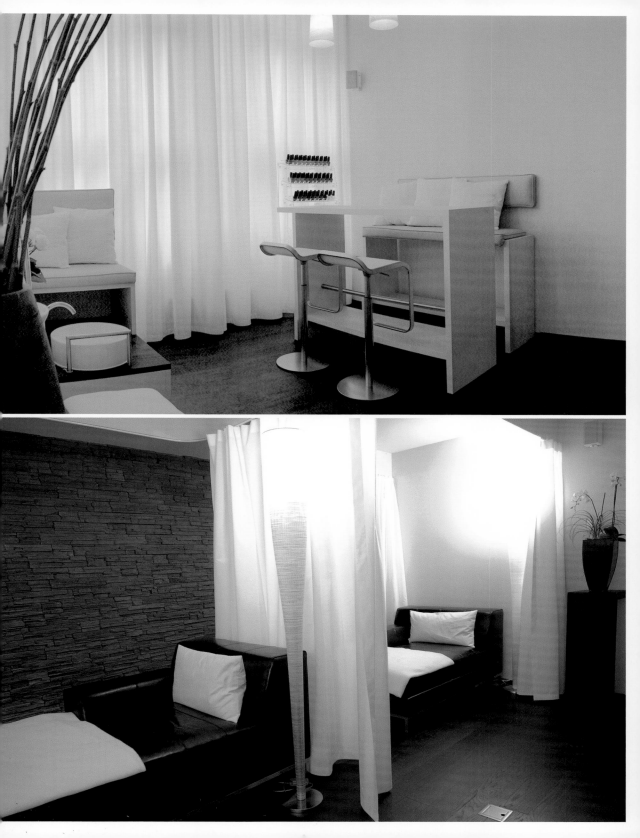

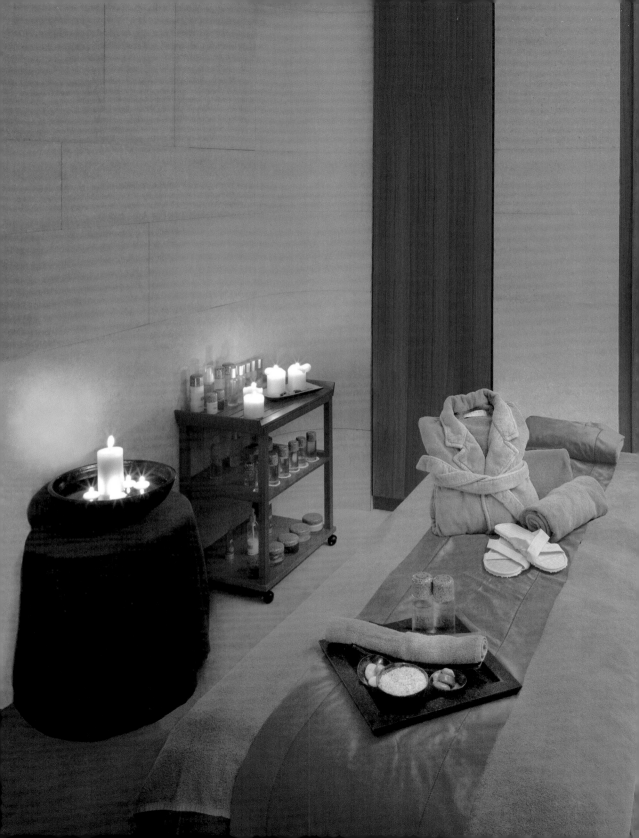

ANTONIO CITTERIO & PARTNERS | **MILAN**
The Bulgari Hotel Spa
Milan, Italy | 2004
Photos: Luca Campigotto

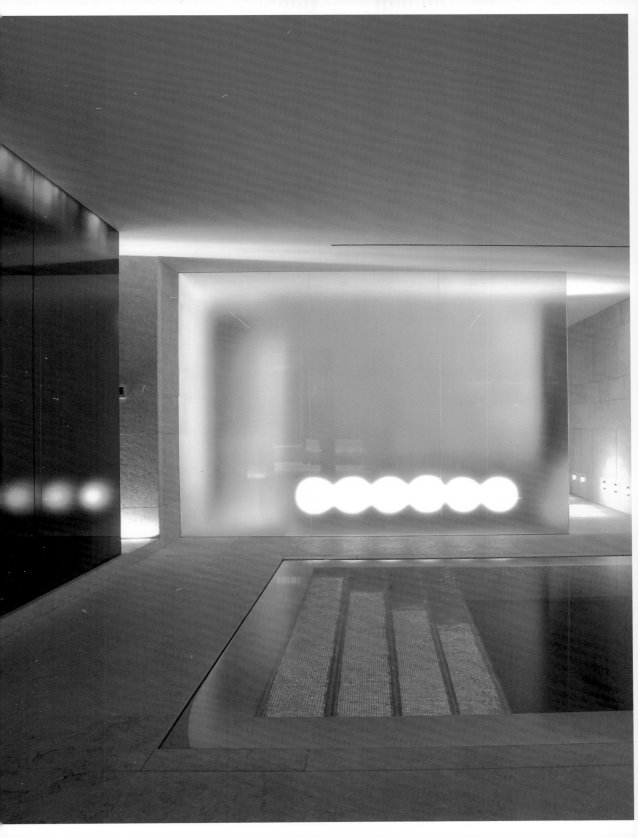

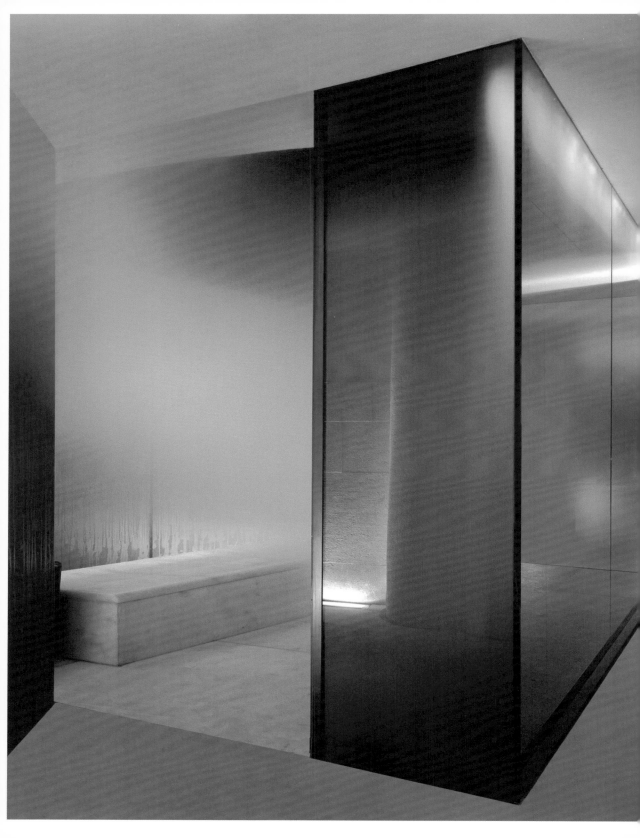

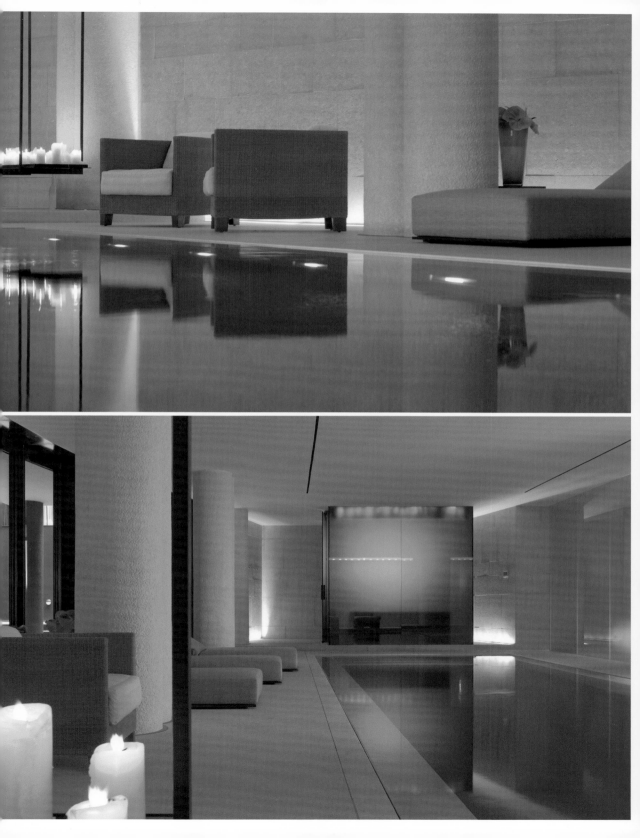

TONY COLLETT, COLLETT ZARZYCKI | LONDON
Sequoia by The Grove Hotel
Hertfortshire, United Kingdom | 2003
Photos: Courtesy The Grove

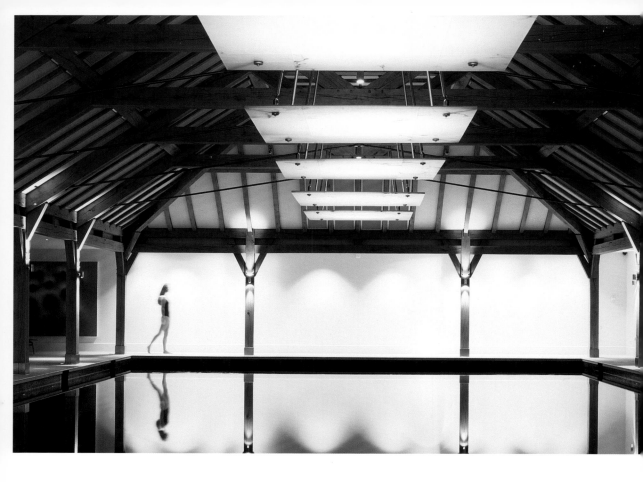

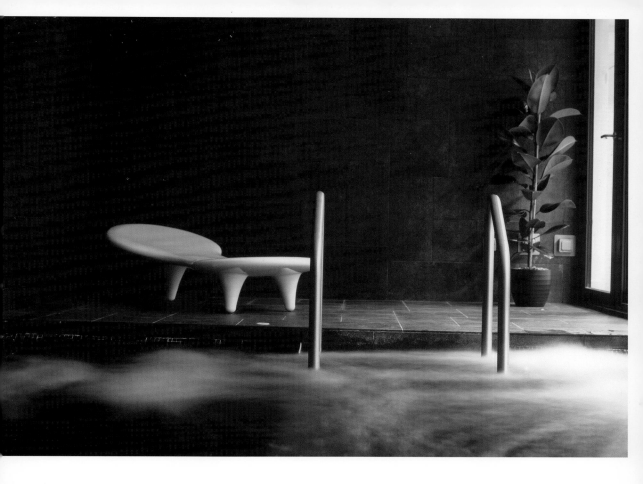

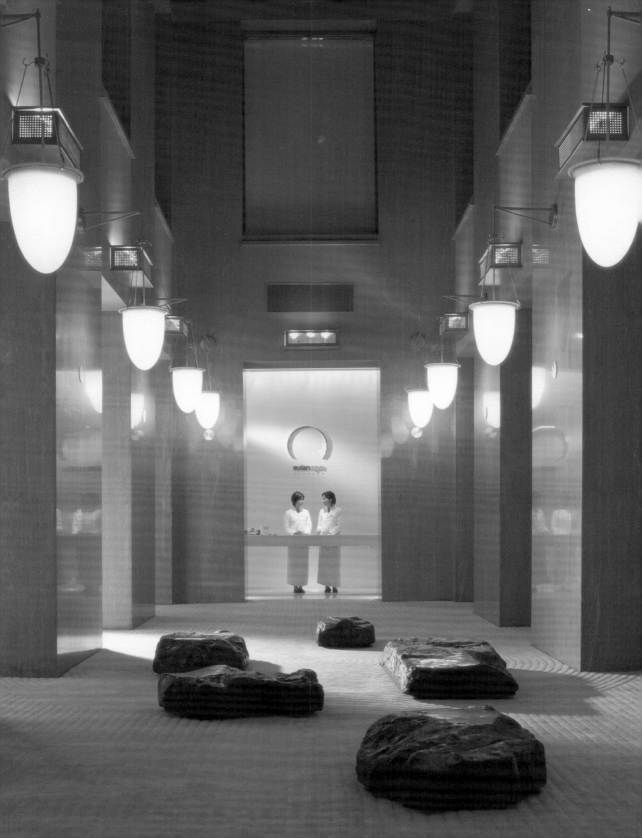

DWP CL3 ARCHITECTS LTD. | **SHANGHAI, ALAN CHAN DESIGN** | **SHANGHAI**
EvianSpa
Shanghai, China | 2004
Photos: Steve Mok, Impact Asia Three on the Bund

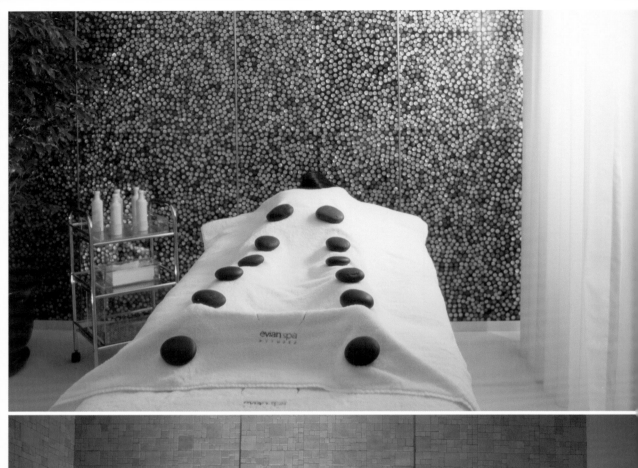
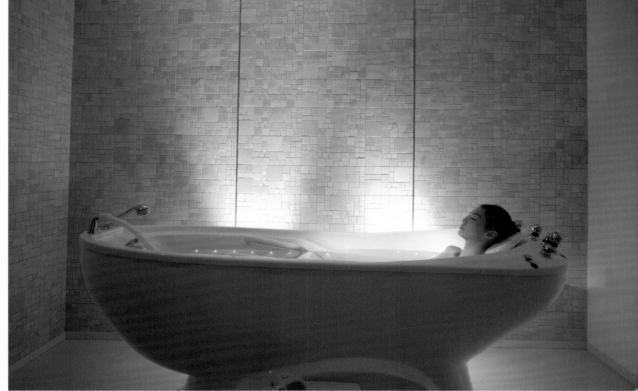

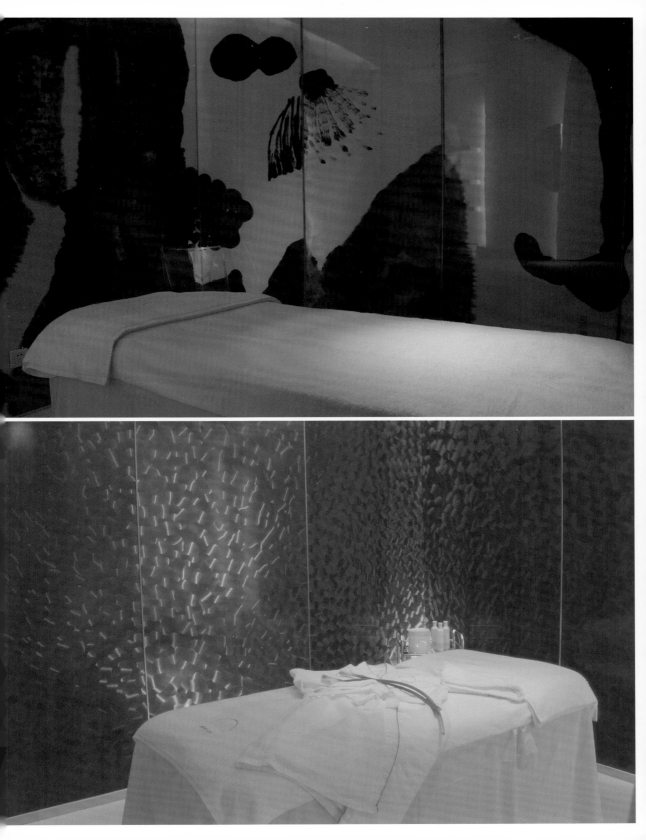

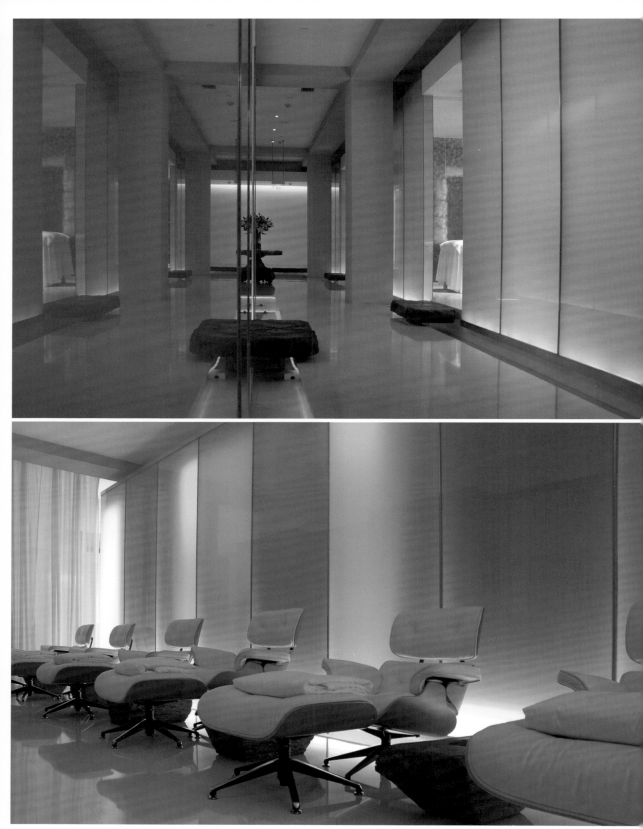

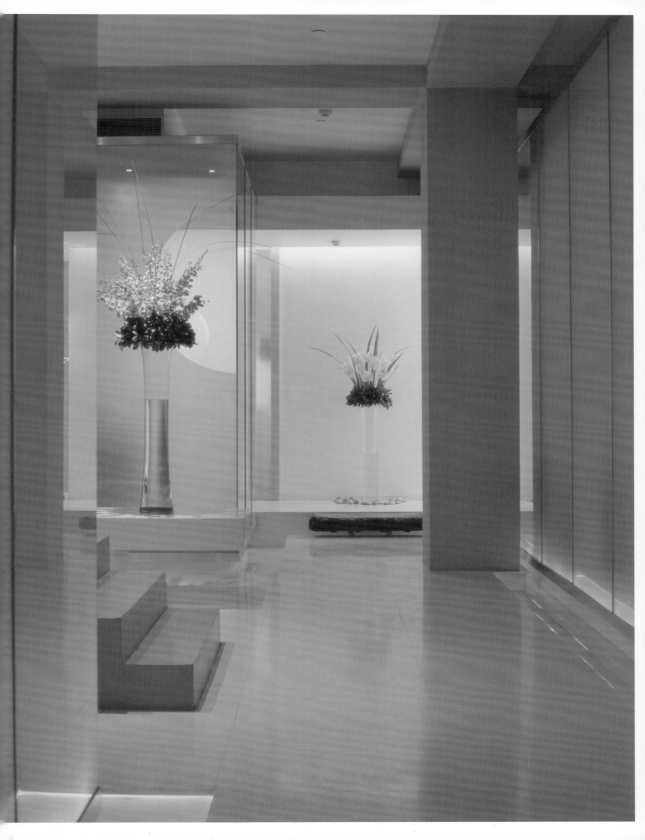

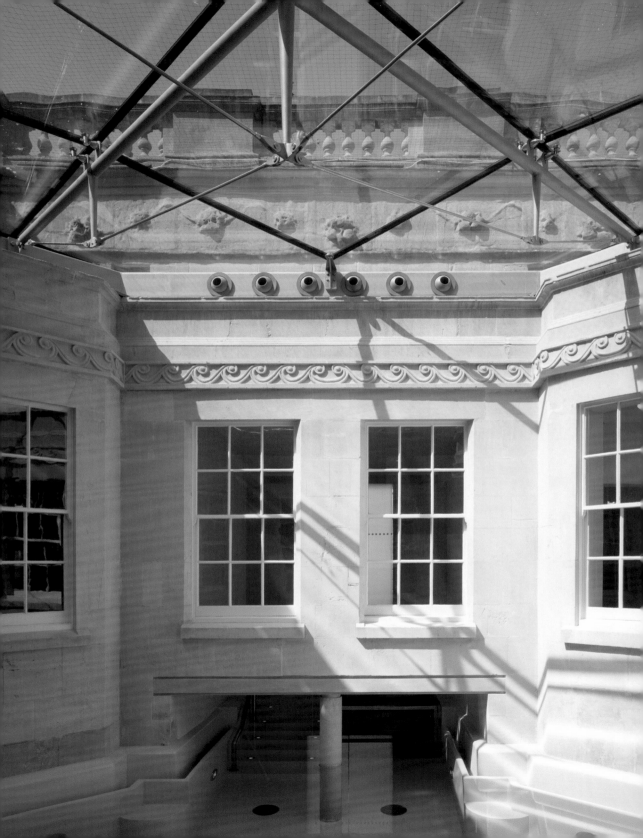

GRIMSHAW & PARTNERS | **LONDON**
Bath Spa
Bath, United Kingdom | 2002
Photos: Edmund Sumner, Matt Cardy

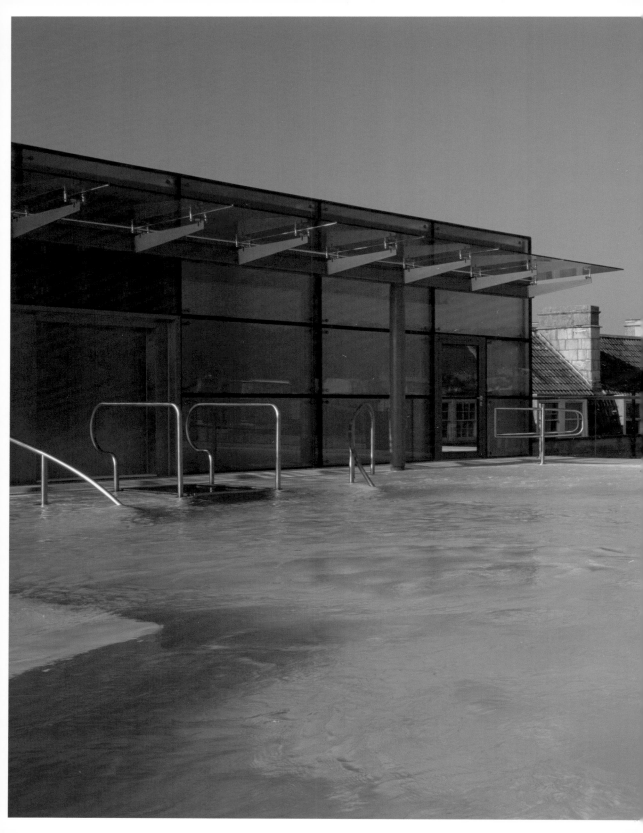

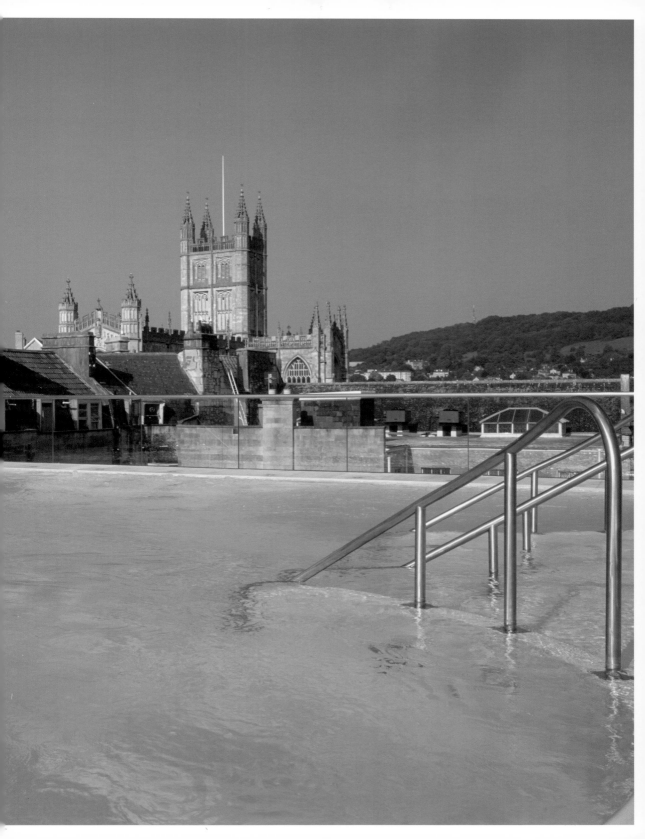

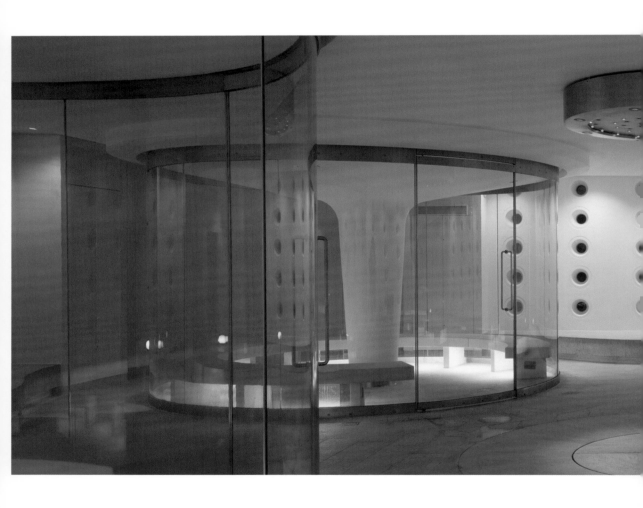

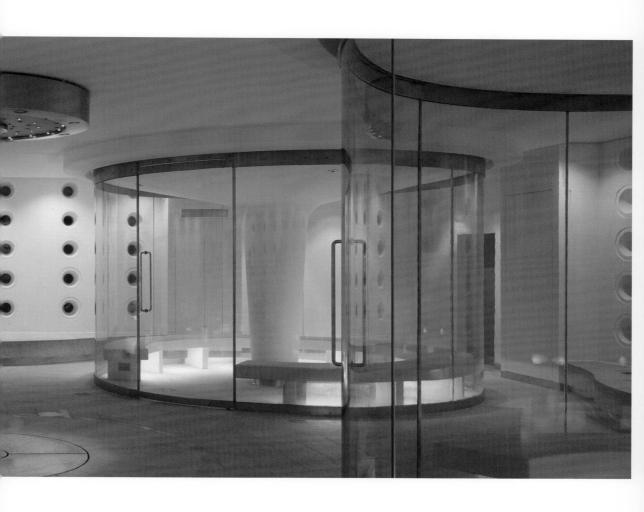

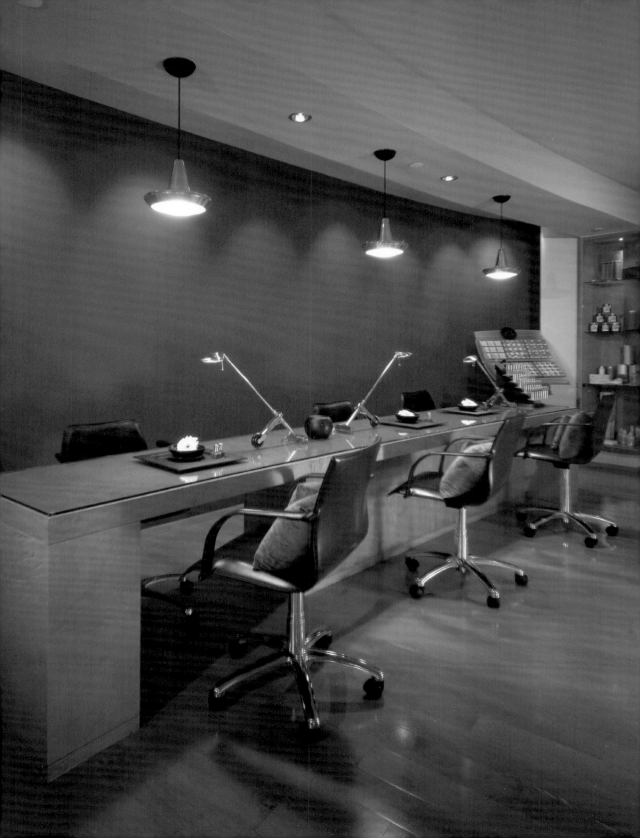

HCA DESIGN | **TORONTO**
Kara Spa at Park Hyatt Los Angeles
Los Angeles, USA | 2004
Photos: Henry Cabala

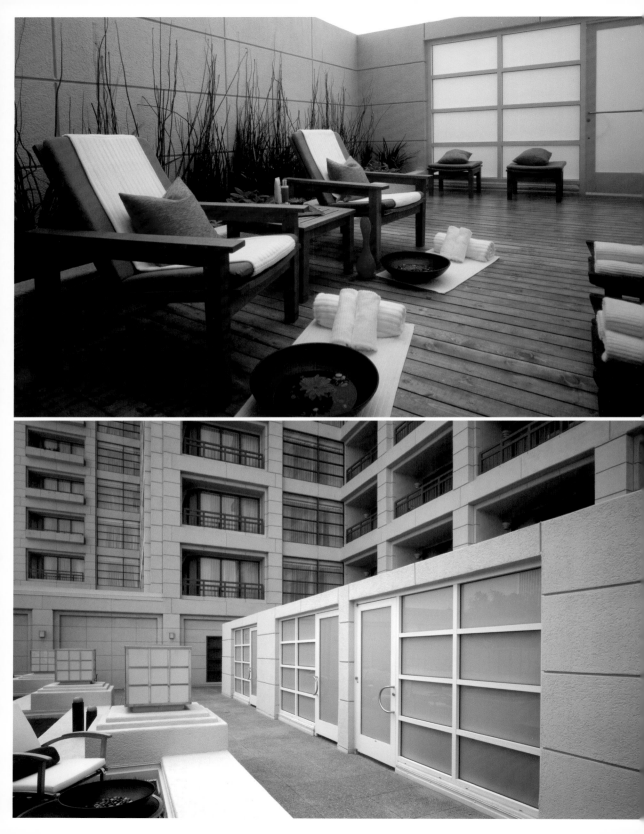

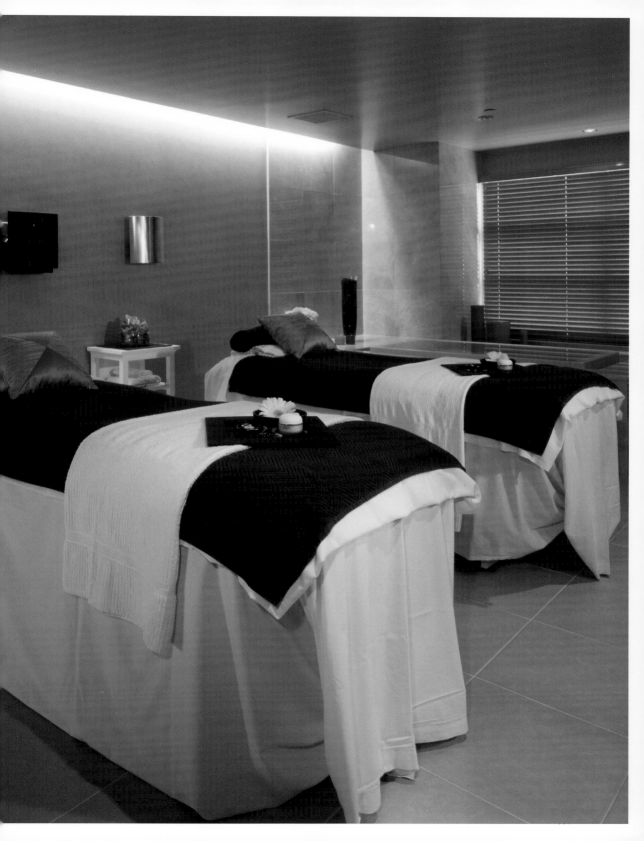

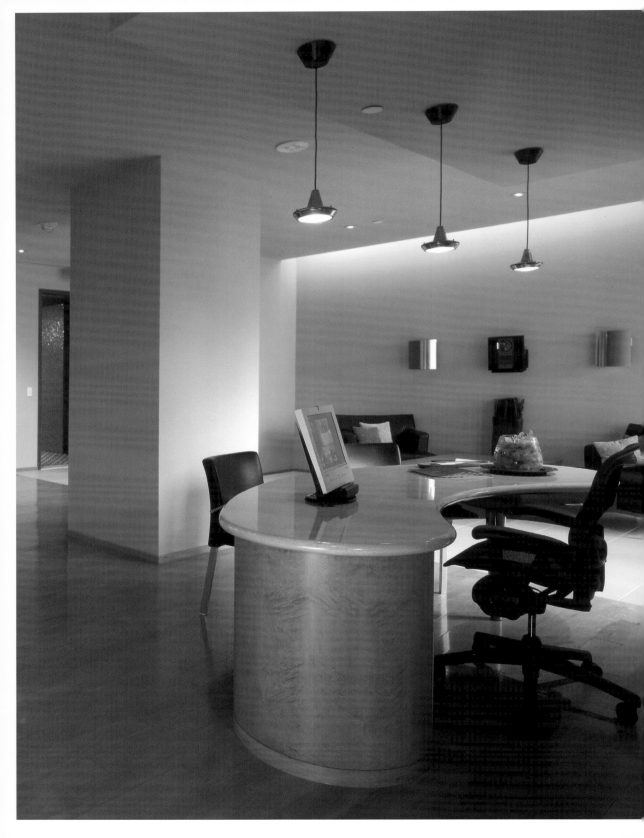

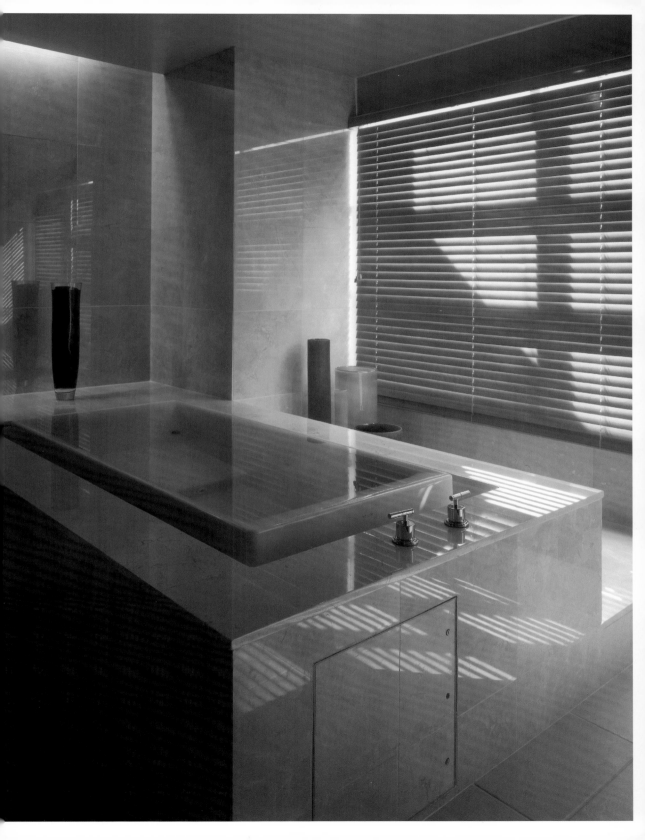

OSKAR LEO KAUFMANN ZT | DORNBIRN
Susanne Kaufmann SPA by Hotel Post
Bezau, Austria | 2002
Photos: Rasmus Norlander

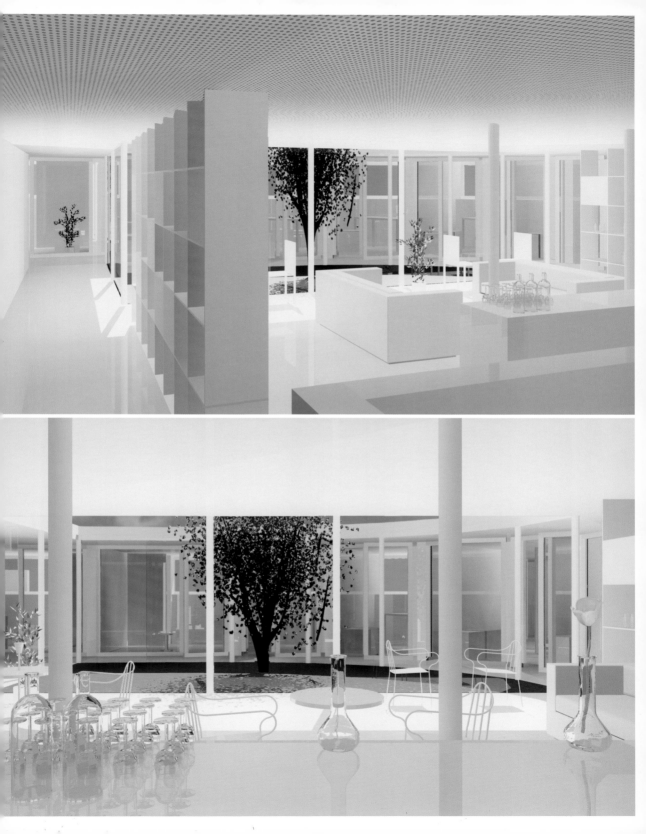

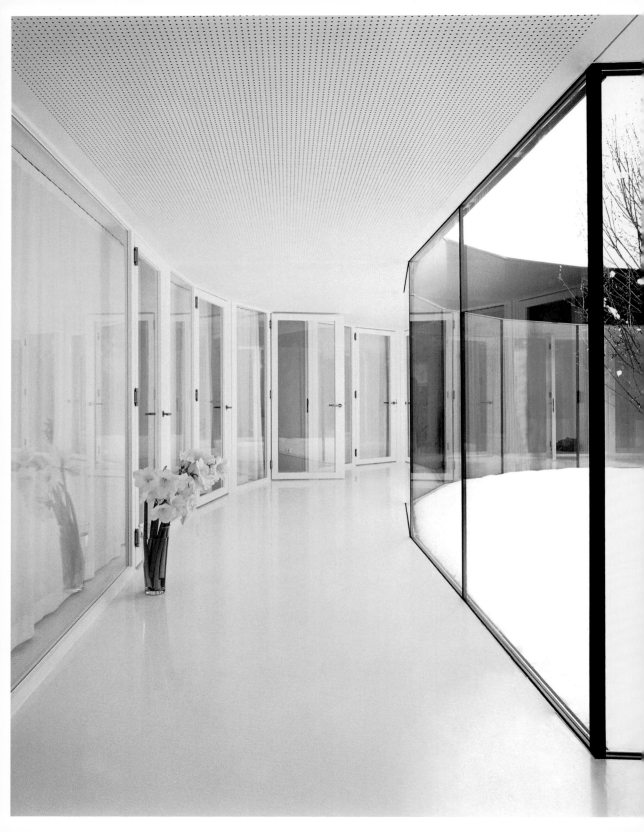

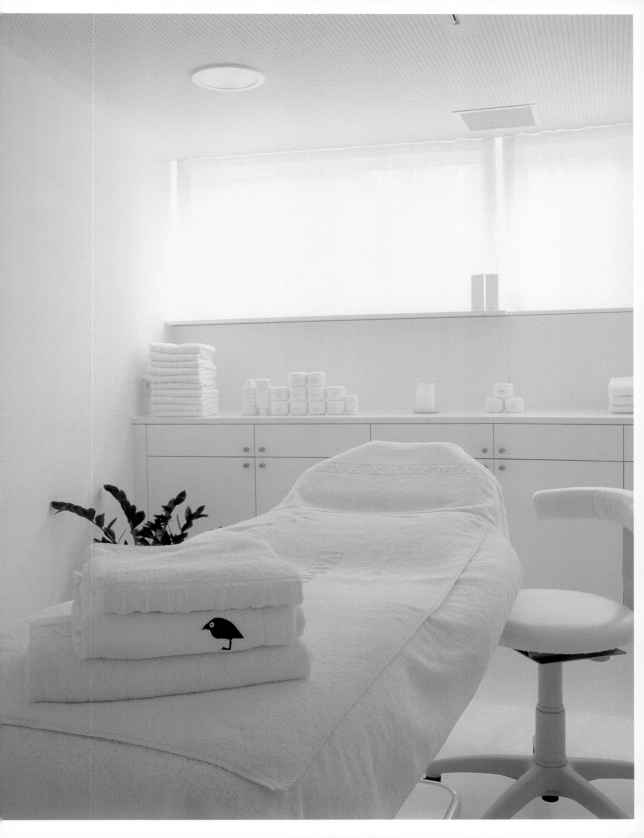

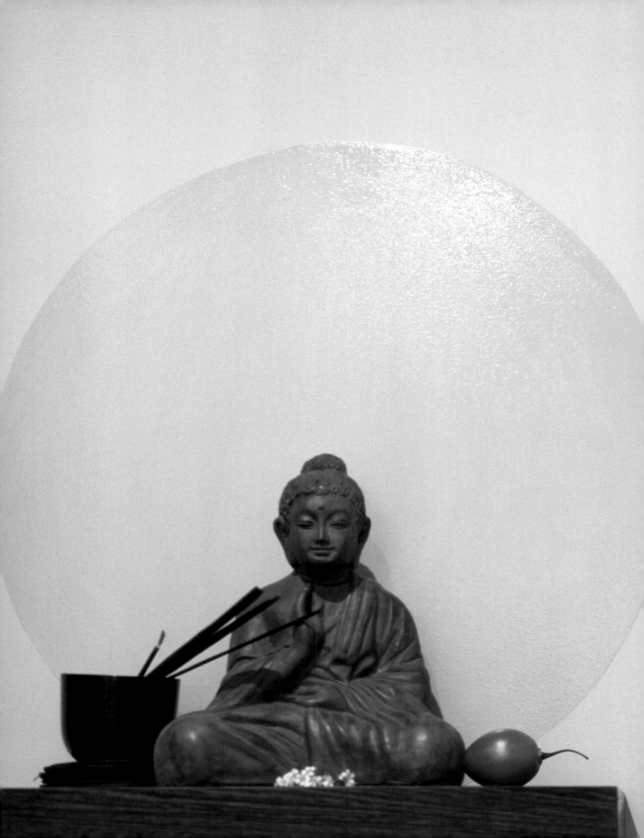

KESSLER + KESSLER | ZURICH
Wellbeing by Ku'101 Hotel
Berlin, Germany | 2005
Photos: Kessler + Kessler

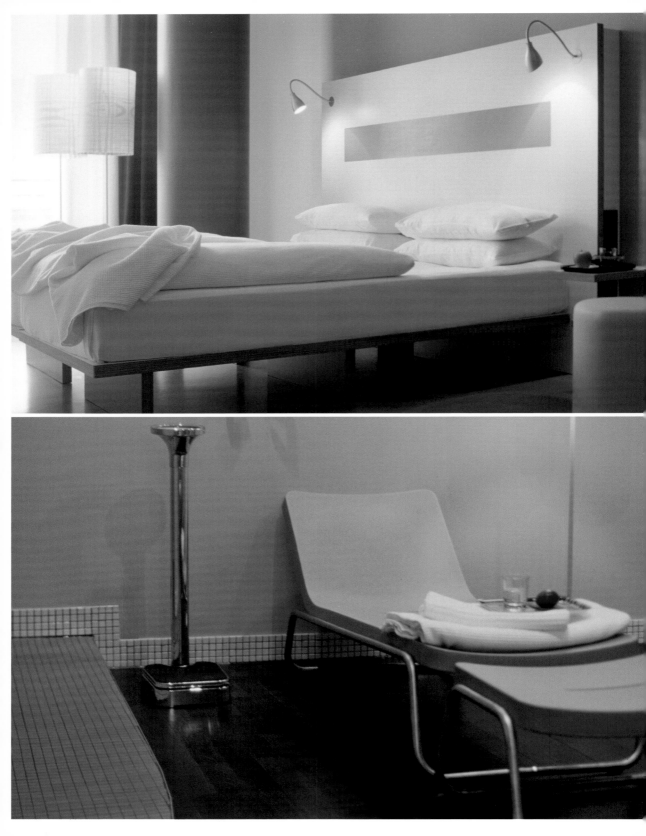

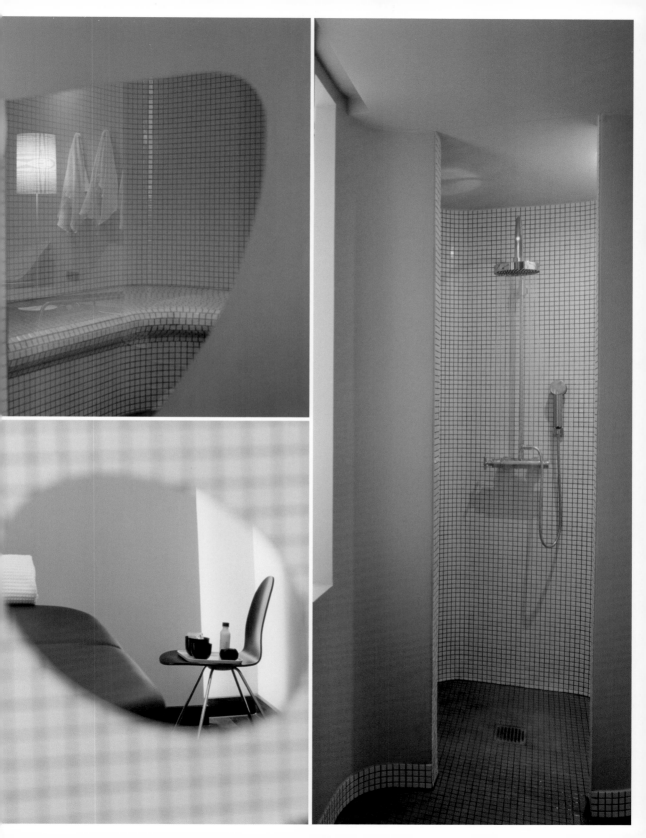

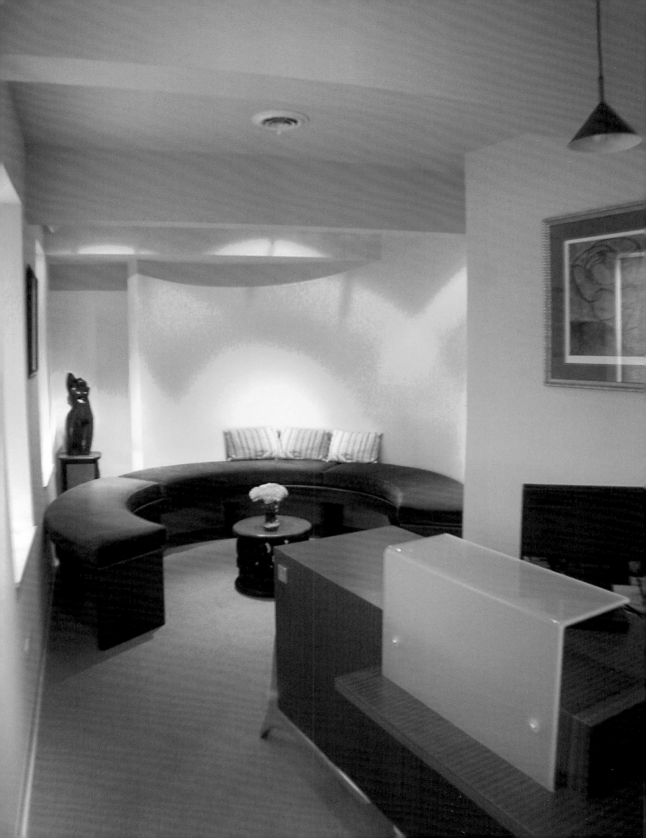

KUBE ARCHITECTURE | WASHINGTON
Soul Day Spa and Salon
Washington DC, USA | 2003
Photos: Coutsy KUBE Architecture

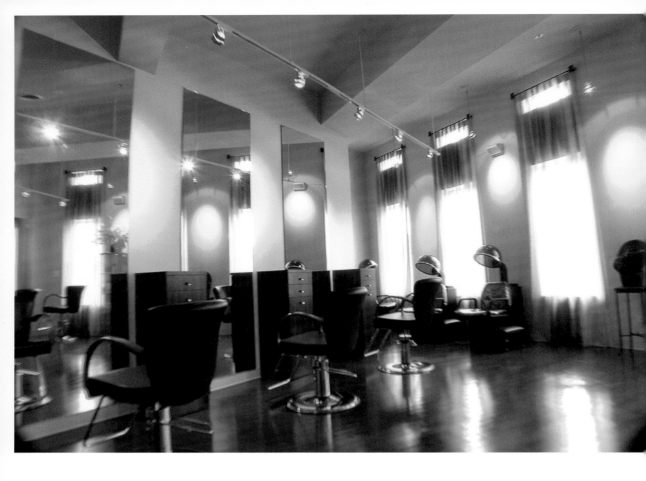

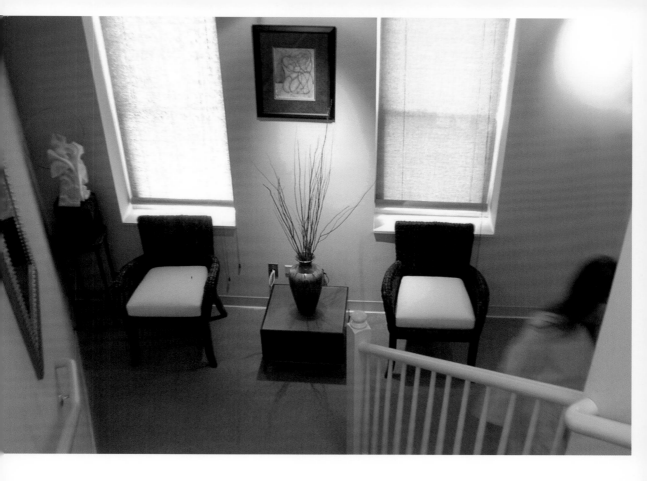

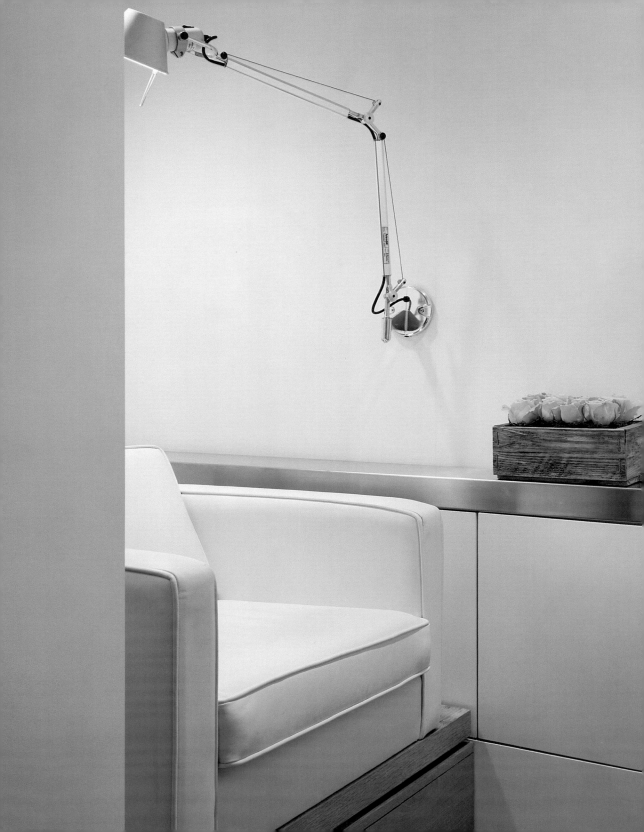

MESSANA O'RORKE ARCHITECTS | NEW YORK
Minardi Day Spa
New York, USA | 2000
Photos: Elizabeth Felicella

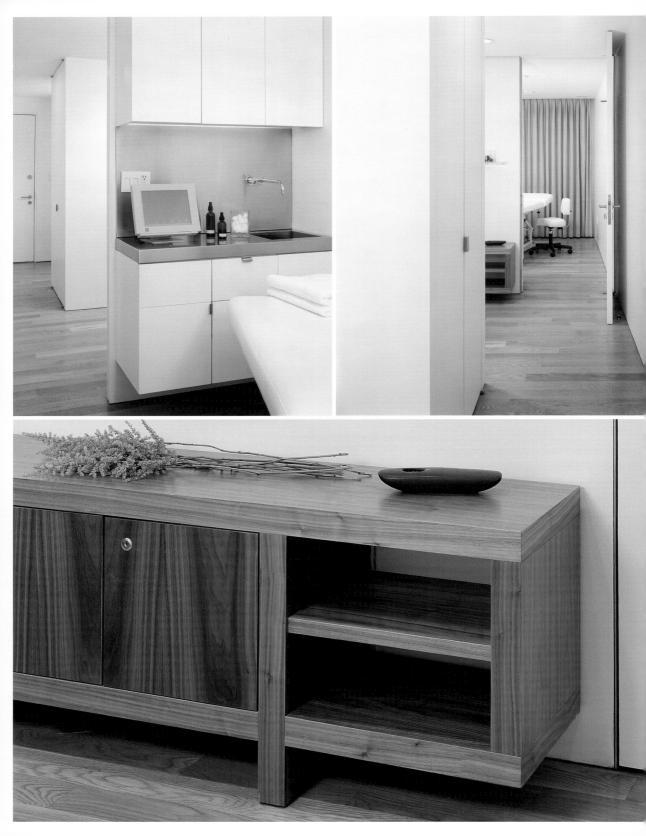

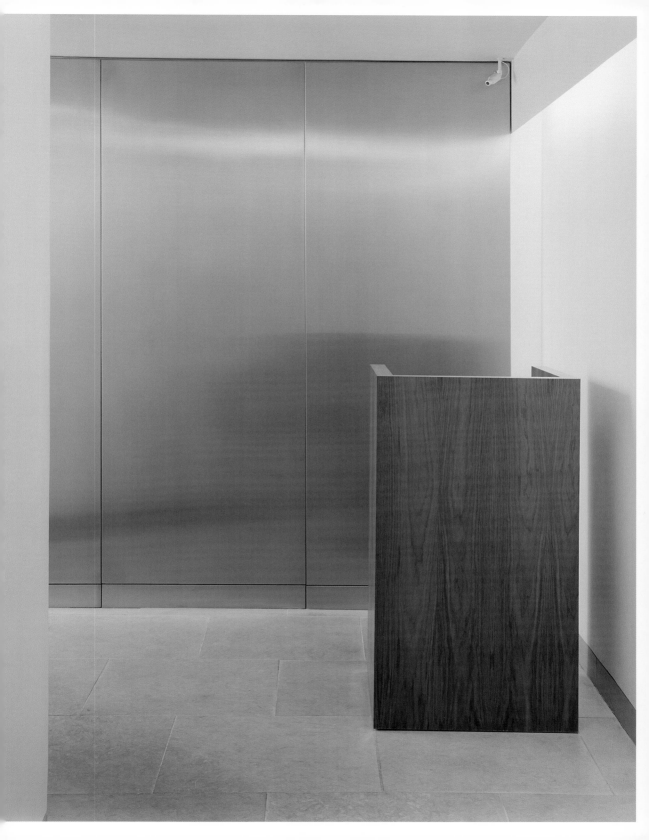

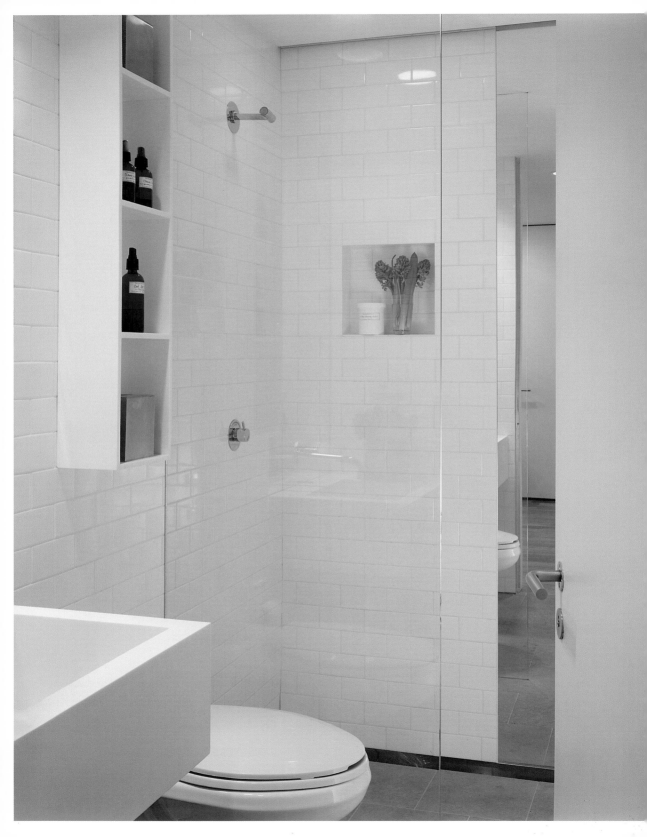

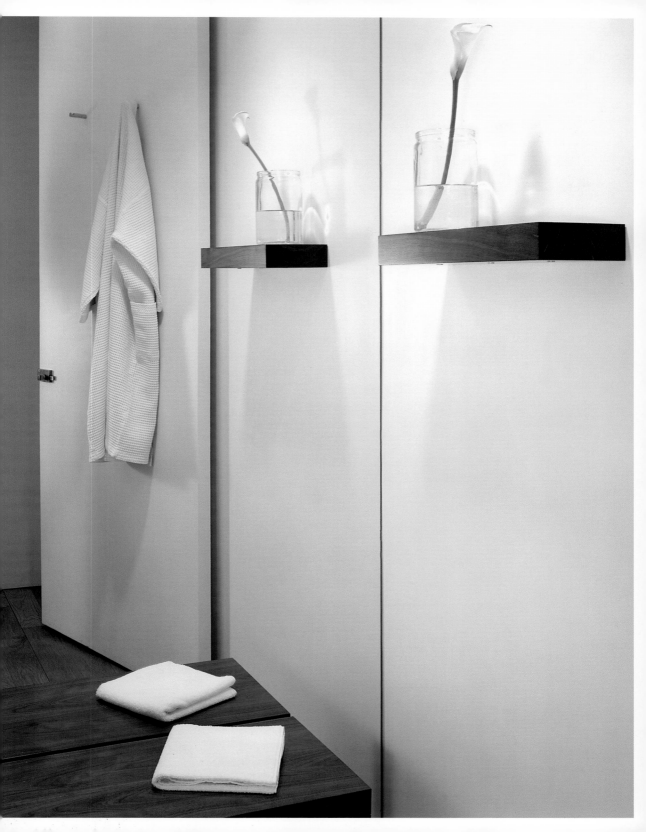

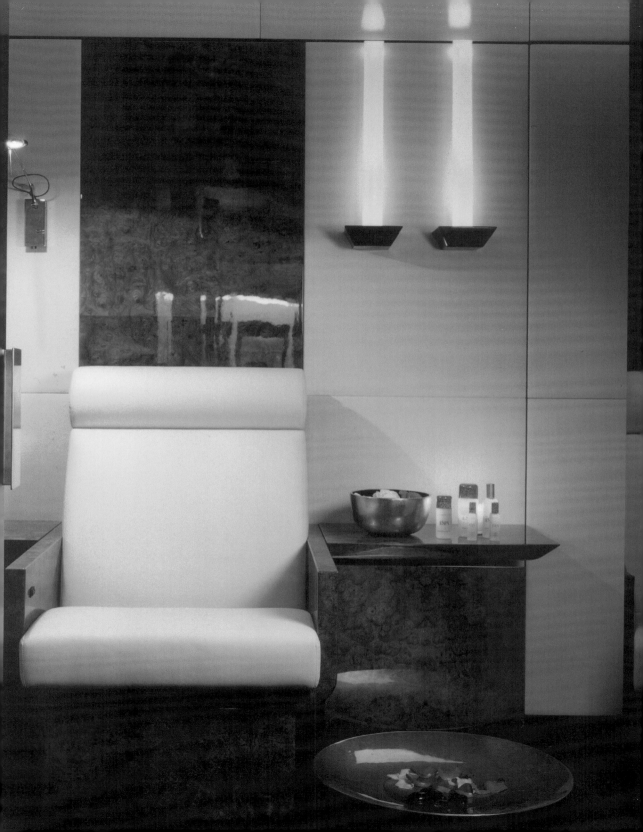

EZIO RIVA | MILAN
E'SPA at Gianfranco Ferré
Milan, Italy | 2002
Photos: Paola Di Pietri

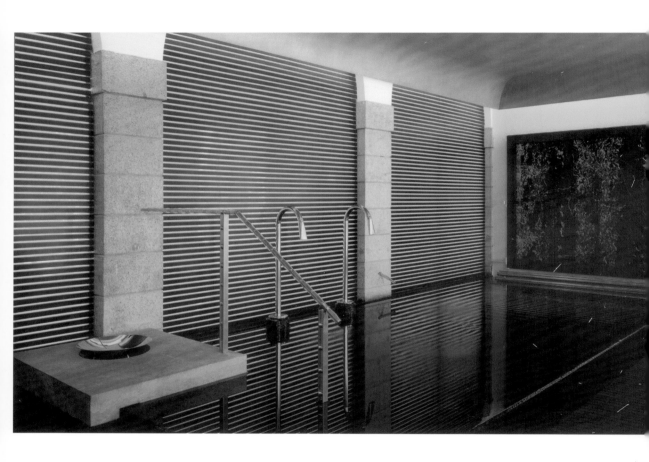

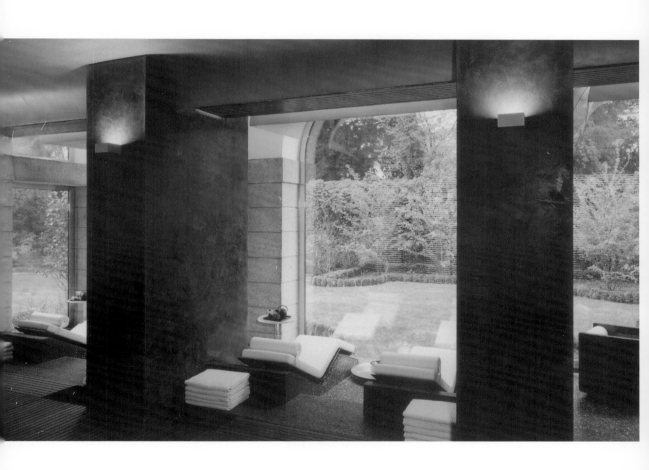

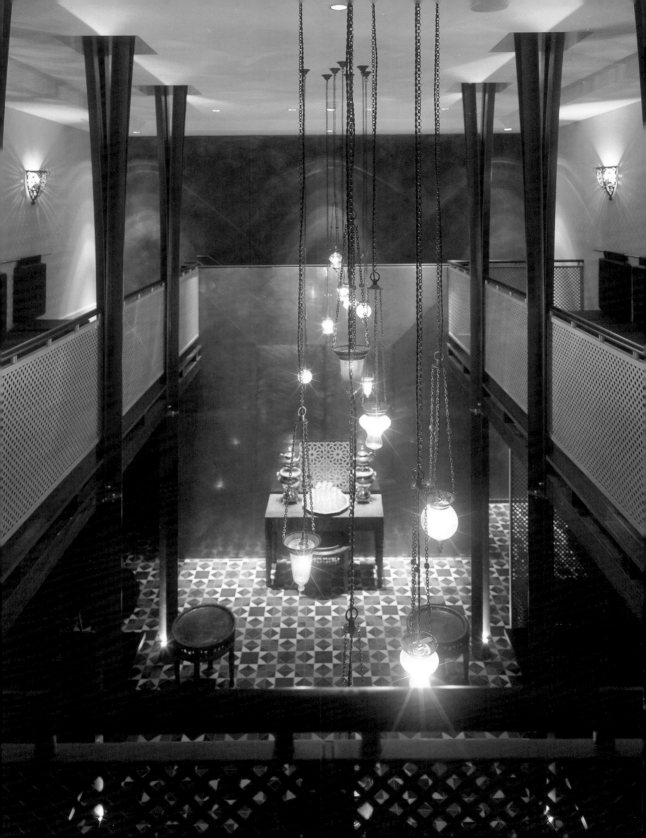

USHI TAMBORRIELLO INNENARCHITEKTUR & SZENENBILD | MUNICH
Hamam
Zurich, Switzerland | 2004
Photos: Jochen Splett

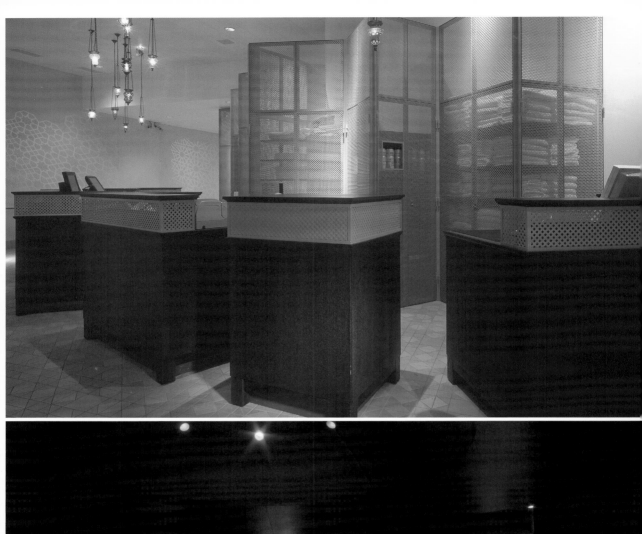
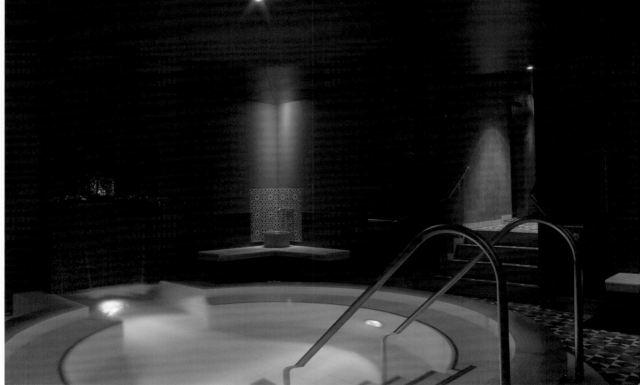

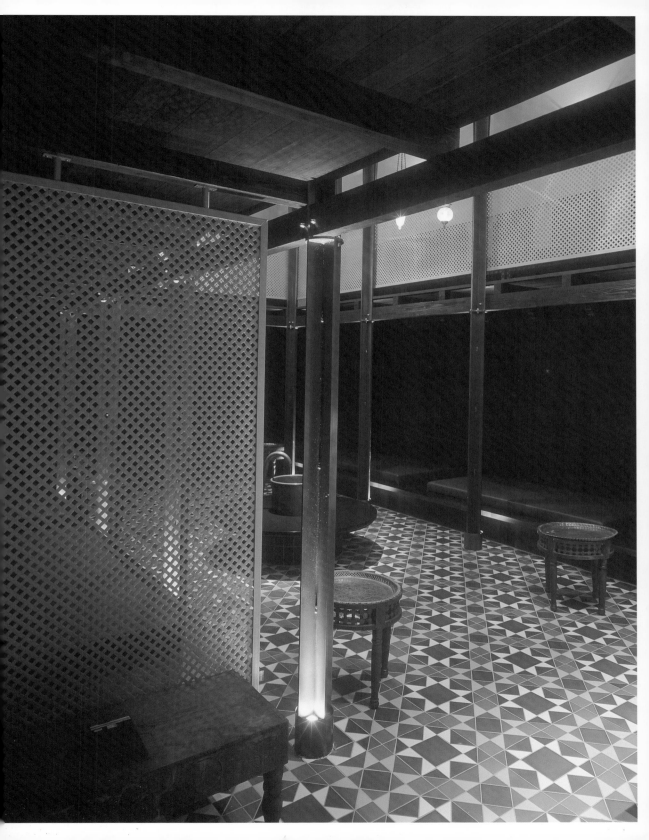

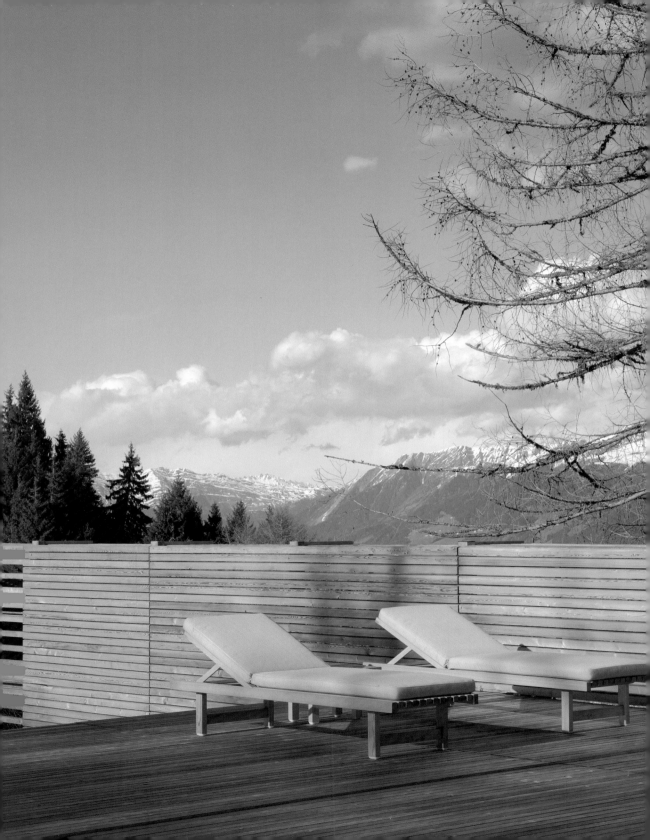

MATTHEO THUN | **MILAN**
Vigilius Day Spa by Vigilius Mountain Resort
Lana, Italy | 2003
Photos: Courtesy Vigilius Mountain Resort

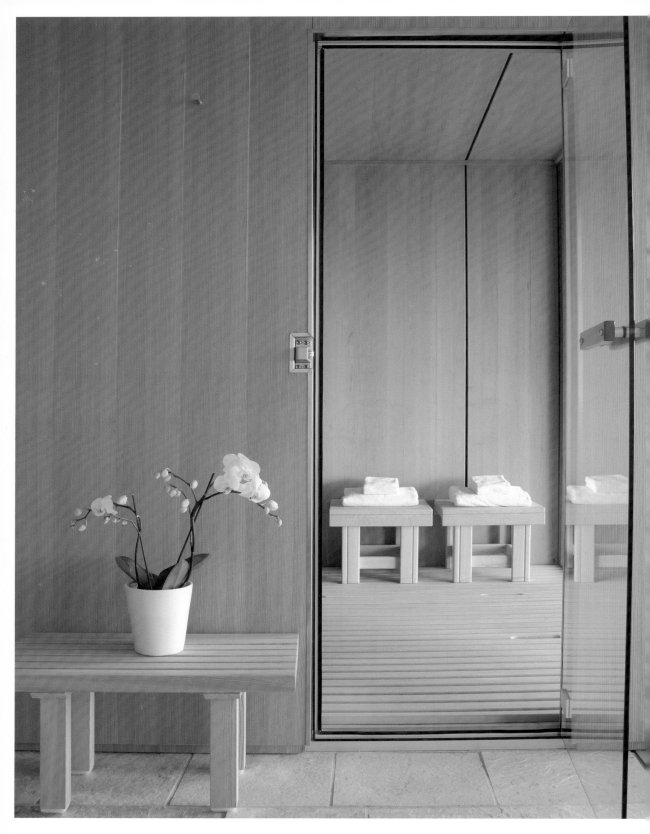

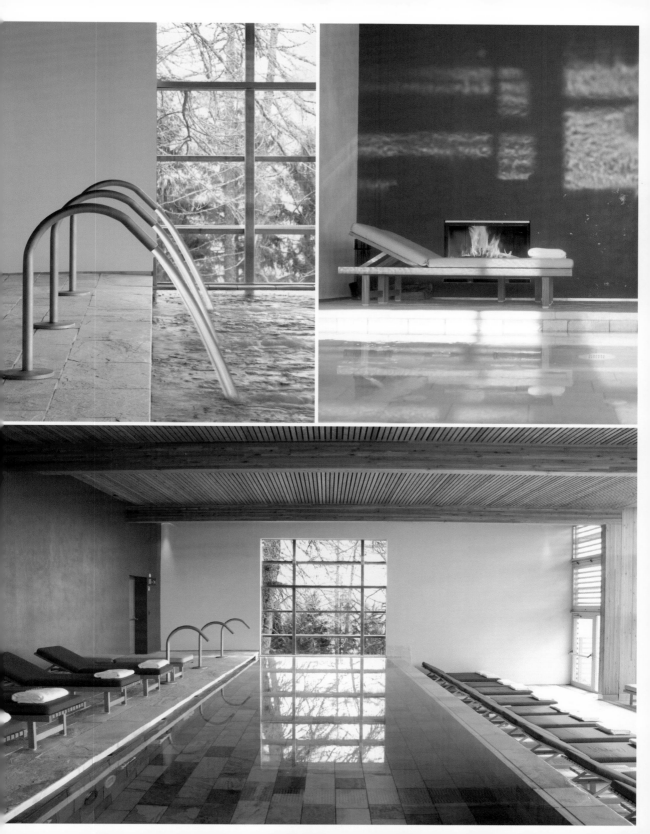

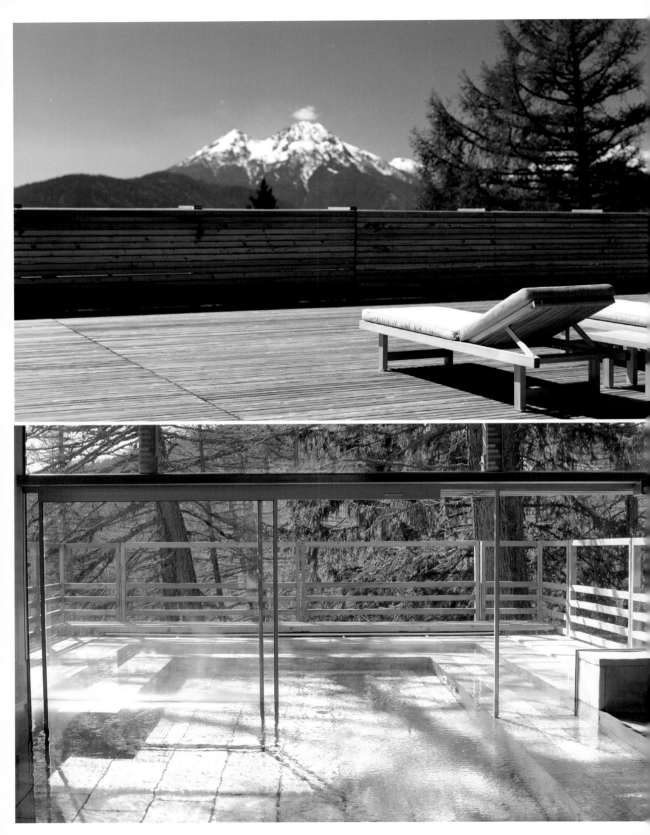

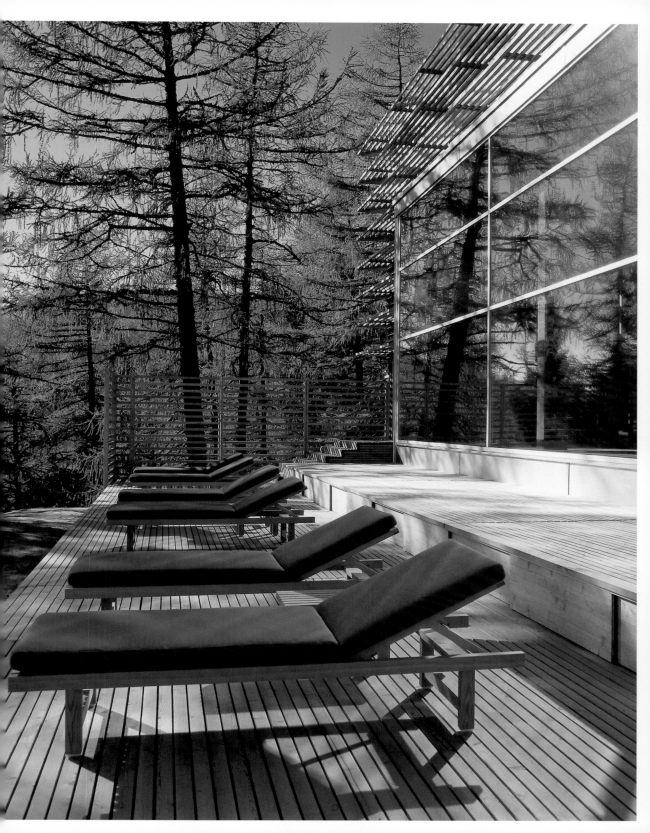

WALLFLOWER ARCHITECTURE & DESIGN | SINGAPORE
SPA Esprit
Singapore, Asia | 2003

Photos: Alex Heng

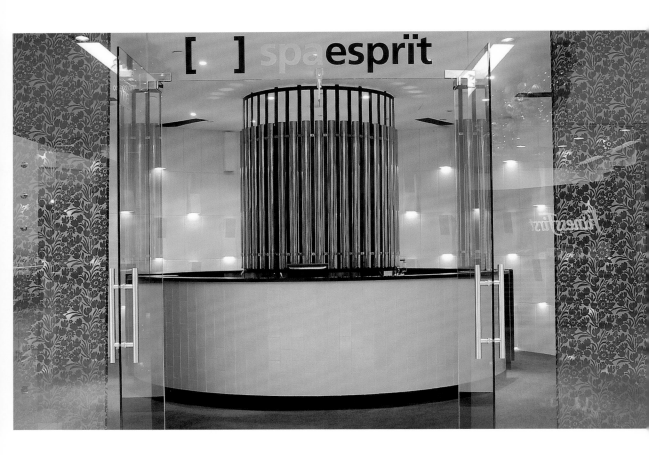

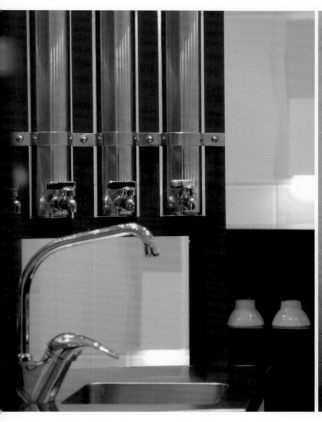

WEHDORN ARCHITEKTEN | VIENNA AND FRITZ SCHWAIGHOFER | INNSBRUCK
WITH REAL STUDIOS LIMITED | LONDON
John Harris Spa by Le Meridien Vienna
Vienna, Austria | 2003
Photos: Roland Bauer

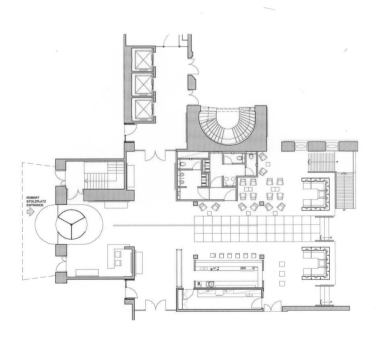

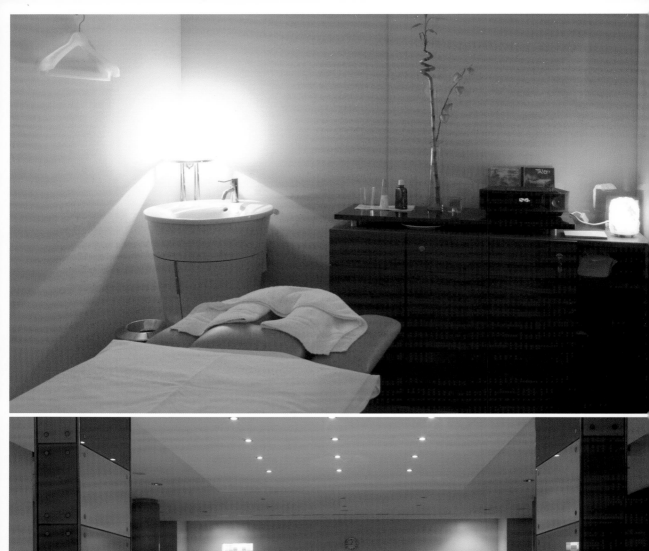
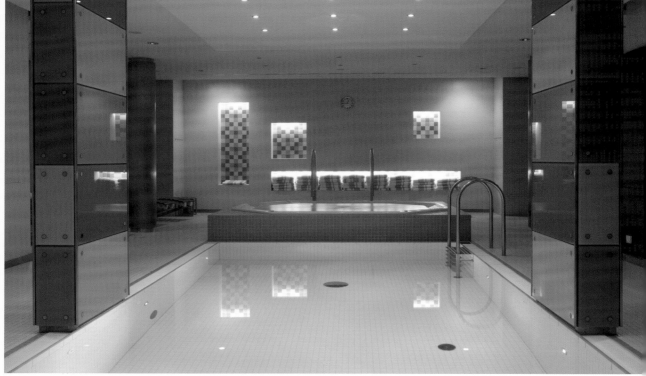

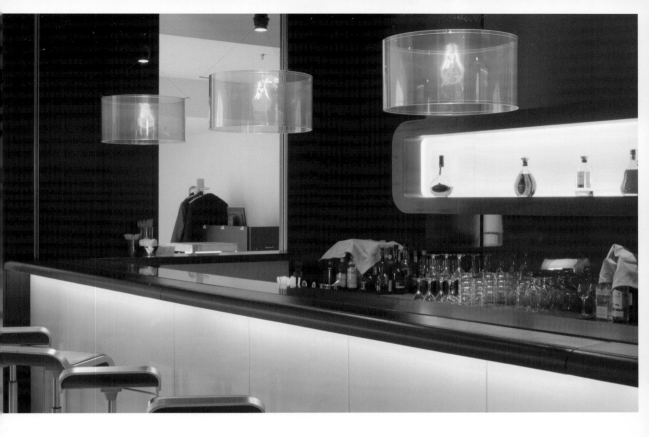

INDEX

© 2005 daab
cologne london new york

published and distributed worldwide by
daab gmbh
friesenstr. 50
d - 50670 köln

p +49-221-94 10 740
f +49-221-94 10 741

mail@daab-online.de
www.daab-online.de

publisher ralf daab
rdaab@daab-online.de

art director feyyaz
mail@feyyaz.com

editor joachim fischer
fischer@brand-affairs.de

editorial project by fusion publishing gmbh stuttgart . los angeles
editorial direction martin nicholas kunz
© 2005 fusion publishing, www.fusion-publishing.com

layout kerstin graf, papierform
imaging jan hausberg

© frontcover shinichi sato

introduction joachim fischer
english translation ade team, dr. andrea adelung
french translation ade team, jacelyne aborca
spanish translation ade team, margarita celdràn-kuhl
italian translation ade team, vincenzo ferrara

printed in spain
gràfiques ibèria, spain
www.grupgisa.com

isbn 3-937718-33-8
d.l.: B-36445-2005